Africanfuturism

Africa in World History

SERIES EDITORS: TODD CLEVELAND, DAVID ROBINSON,
AND ELIZABETH SCHMIDT

James C. McCann
Stirring the Pot: A History of African Cuisine

Peter Alegi
African Soccerscapes: How a Continent Changed the World's Game

Todd Cleveland
Stones of Contention: A History of Africa's Diamonds

Laura Lee P. Huttenbach
The Boy Is Gone: Conversations with a Mau Mau General

John M. Mugane
The Story of Swahili

Colleen E. Kriger
Making Money: Life, Death, and Early Modern Trade on Africa's Guinea Coast

Jared Staller
Converging on Cannibals: Terrors of Slaving in Atlantic Africa, 1509–1670

Todd Cleveland
A History of Tourism in Africa: Exoticization, Exploitation, and Enrichment

Kimberly Cleveland
Africanfuturism: African Imaginings of Other Times, Spaces, and Worlds

Africanfuturism

African Imaginings of Other Times, Spaces, and Worlds

Kimberly Cleveland

Foreword by Ainehi Edoro-Glines

OHIO UNIVERSITY PRESS ATHENS

Ohio University Press, Athens, Ohio 45701
ohioswallow.com
© 2024 by Ohio University Press
All rights reserved

To obtain permission to quote, reprint, or otherwise reproduce or distribute material from Ohio University Press publications, please contact our rights and permissions department at (740) 593-1154 or (740) 593-4536 (fax).

Printed in the United States of America
Ohio University Press books are printed on acid-free paper ∞™

Library of Congress Cataloging-in-Publication Data
Names: Cleveland, Kimberly, author.
Title: Africanfuturism : African imaginings of other times, spaces, and worlds / Kimberly Cleveland.
Other titles: Africa in world history.
Description: Athens : Ohio University Press, 2024. | Series: Africa in world history | Includes bibliographical references and index.
Identifiers: LCCN 2023042501 (print) | LCCN 2023042502 (ebook) | ISBN 9780821411483 (paperback) | ISBN 9780821441268 (pdf)
Subjects: LCSH: Africanfuturism—History and criticism. | Arts, African—21st century—History and criticism.
Classification: LCC PR9344 .C54 2024 (print) | LCC PR9344 (ebook) | DDC 823.087620996—dc23/eng/20230911
LC record available at https://lccn.loc.gov/2023042501
LC ebook record available at https://lccn.loc.gov/2023042502

CONTENTS

	List of Illustrations	vii
FOREWORD	The Future in African Literature *Ainehi Edoro-Glines*	ix
	Acknowledgments	xv
INTRODUCTION	Afrofuturism and Africanfuturism *Same Difference?*	1
ONE	From Africa in Western Speculative Expression to Africanfuturist Imaginings	19
TWO	Exploring Space and Time	40
THREE	Creating Worlds	62
FOUR	Technology and the Digital Divide	85
FIVE	Sankofa and Remix	107
SIX	Mythmaking	132
	Epilogue	159
	Notes	165
	Bibliography	179
	Index	197

ILLUSTRATIONS

FIGURES

2.1	Gerald Machona, *Ndiri Afronaut (I Am an Afronaut)*, 2012	47
2.2	Jacque Njeri, *MaaSci*, 2017	49
2.3	Masiyaleti Mbewe, *Tove the Guardian*, 2018	55
3.1	Bodys Isek Kingelez, *Ville Fantôme*, 1996	73
3.2	Mary Sibande, *They Don't Make Them Like They Used To*, 2008	77
4.1	Andile Dyalvane, *Docks Table*, 2013	91
4.2	Elias Sime, *TIGHTROPE: (4) While Observing . . .*, 2018	94
4.3	Eddy Kamuanga Ilunga, *Abandonnés*, 2015	98
5.1	Vortex Comics, *Sannkofamaan—Pet the Beast #1*, 2016	114
5.2	Kéré Architecture, Primary School, Gando, Burkina Faso, 2001	117
5.3	Sammy Baloji, *Untitled #17* from *Mémoire*, 2006	120
5.4	Joana Choumali, *Untitled* from *Ça va aller*, 2016	125
6.1	Leti Arts, *Ananse: The Origin #1*, 2013	143
6.2	Athi-Patra Ruga, *Invitation . . . Presentation . . . Induction*, 2013	147
6.3	Fabrice Monteiro, *Untitled #1* from *The Prophecy*, 2013	151

FOREWORD

The Future in African Literature

AINEHI EDORO-GLINES

"The future is a site that does not yet exist but which one can already shape within a mental space," writes the Senegalese philosopher Felwine Sarr in *Afrotopia* (2019). The future is an order of time that encompasses what is yet to happen. It is a favorite topic among philosophers perhaps because it is so elusive and opens infinite avenues for speculation. Even though the future is yet to come, it shapes our experience in profound ways. It defines what the past means to us and how we bring it into our present moment. The future also involves a practice of knowledge making. Many African cultures have complex predictive systems in the form of geomantic divination that helped our deep-time ancestors and continue to help contemporary African communities use the future to inform their lives. There is the kind of future structured as a collective dream for a better world. This is the future at the utopian foundations of liberation movements. On the other end of the spectrum of liberation is the idea of the future that informs capital. Think of the financial machineries of speculation used to abstract money into something that endlessly, magically, and violently grows to infinity. When we speak of future in science fiction, we are talking about an aestheticized future, one as art, something we create using a set of compositional rules that arise from literary tradition and convention. It is also a future we use as experimental spaces to try out possible worlds against the background of examining the faults of our current reality.

In spite of being a construct, literary representations of the future capture some of the contradictions that define our world. This is why the term *Africanfuturism* is as fascinating as it is contested and why its history and impact are important to document, as Kimberly Cleveland does in this book. In October 2019, fiction writer Nnedi Okorafor inaugurated the term *Africanfuturism* in a blog post published on her website. But the concerns that the term addresses predate the post, as outlined in the Africanfuturism entry in *The Historical Dictionary of Science Fiction.* In 2013, the term (as two separate words) was used by the artist Pamela Phatsimo Sunstrum to specify a strain of Black science fiction, as distinct from Afrofuturism. Over the years, in the midst of heated debates about the politics of naming and the complexities of Blackness at the intersection of Afro-diasporic cultures and the African continent, the term has gained considerable traction among African writers and scholars as a helpful means of defining what African literature brings to the sci-fi genre.

It makes sense to define Africanfuturism as a distinct idea of the future for the simple reason that the future, both in its lived objectivity and artistic imagination, is never the same for everyone. It is easier to understand this in the context of history. While historians often emphasize the subjective nature of perceiving and experiencing the past, the diversity of perspectives on the future can be less apparent, particularly when it comes to portraying Black futurity. In this context, cultural commentators tend to assert a monolithic Black future that is presumed to apply to all Black worlds. But this idea of one future for all is problematic in that it evokes the Western idea of a homogenous future—one that is the same for everyone.

We know from African cosmologies that our experience of time is more complicated than that. In Yoruba cosmology, for example, time takes place across areas of existence centered on the living, the ancestors, and the unborn, as well as the in-between spaces that house a vast array of animal, plant, and spirit beings. The Yoruba concept of reincarnation also implies that each individual has multiple origins linked across timelines that intersect in ways unique to that individual. This suggests that even at moments when it appears we have a shared temporal experience, each individual is keyed into other orders of time that can irrupt within the present. This is to say that in African indigenous knowledge systems, life is a complex web of interlocking temporalities.

If our experience of time is so complex, it is all the more so when time becomes an aesthetic object. Just as there is no one future for everyone, there is no one Black future for all Black worlds. Africanfuturism, as a distinct category from Afrofuturism, gestures toward the multiplicities of futures that define Black experiences today. It speaks to the complexity of Afro-diasporic culture in a globalized world. With Black worlds being so close to each other with the advent of digital culture and technology, the question of how Blackness is deployed to establish a context for cultural forms becomes a contested issue that is vital to engage with. Ultimately, these debates demonstrate the need to embrace the differences that define global Black experiences. The differences in our history shape the kind of art forms we create and how we use art to address aspects of our lived experiences. Blackness is a complex category that names worlds with varied, though interconnecting, histories. Even though we are all invested in a future defined by Black liberation, how that future inspires imaginative worlds will be, of necessity, different in diverse respects. The debates around Africanfuturism and Afrofuturism powerfully capture the distinct but connective tissues that link Black literary traditions globally. Ryan Coogler's *Black Panther* and Okorafor's *Lagoon* offer different ways of constructing a utopian Black world where Africa has broken the hold of colonialism; however, their visions are complementary and contribute to the growing archive of narratives through which the African world as a global imaginary is situated at the intersection of a "preferred future" and "becoming present," as Kodwo Eshun writes in "Further Considerations on Afrofuturism."

African science fiction is not just about terminology. It is also about addressing the concept of the future within the broader context of African literature. In my engagement with the discourse surrounding African science fiction, I have noticed the tendency for scholars to speak of sci-fi as an advanced stage of a literature founded on the archaism of realism—as though contemporary African writers invented the future as an object of literary inquiry. I want to push against that idea by pointing out that futuristic elements are intrinsic to African intellectual traditions, encompassing both indigenous and contemporary contexts of knowledge. The future has always been important to African storytellers and writers. While science fiction, as a genre, is relatively new in African literature, the future as a context of aesthetic and formal exploration is not new. The need to invent alternate

worlds is evident in everything from indigenous African epics like Sundjiata and Ozidi Saga to the magic-infused realisms of Ben Okri.

One place to observe this closely is in the use of mythology as a key element of world-building in African sci-fi. Insofar as science fiction is an attunement to otherworldliness, African literature has been a fertile ground for planting seeds of alternate realities. Built on cosmological and mythological thinking predicated on accessibility to other worlds, African literature already is defined by a sense of space that accommodates the imagination of other worlds and the desire for these worlds. It is no surprise that in adapting science fiction conventions for African storytelling, African writers relied on an existing archive of images drawn from indigenous cultural forms. This link between mythology and the future might seem contradictory, but if the question of the future in literature is defined by utopian longing, African mythology is full of images that articulate dreams of a better world—for example, the ancestral masks that play a significant role in Chiagozie Fred Nwonwu's "Masquerade Stories" and Deji Olukotun's *After the Flare*. In adapting the masquerade to sci-fi, Nwonwu and Olukotun do not infuse images from Africa's premodern world with futuristic possibilities but instead recapture the futuristic quality of these images that was lost with the epistemological violence of the colonial encounter. They reactivate a sense of the future that has long been embodied in these images but that had been consigned to the past. In tracing the history of African science fiction, we should be careful not to impose an evolutionary logic that suggests science fiction introduced futurity into African writing. Science fiction is instead the most recent attempt, in a long history of African storytelling, to build fictional worlds around questions of the future.

Africanfuturism: African Imaginings of Other Times, Spaces, and Worlds examines similar problematics. In addition to being an introductory study of Africanfuturism, it contributes to a growing body of scholarly work in African science fiction that includes Louisa Uchum Egbunike and Chimalum Nwankwo's "Science & Speculative Fiction—What Is *Past* and *Present*... and What Is *Future?*" (2021); Isaac Vincent Joslin's *Afrofuturisms: Ecology, Humanity, and Francophone Cultural Expressions* (2023); Jenna N. Hanchey's 2020 examination of Africanfuturism through the lens of queer and feminist paradigms, "Desire and the Politics of Africanfuturism"; the special issue on African science fiction in *Paradoxa* (2013); and Alena

Rettová's remarkable exploration of Swahili and Shona sci-fi, "Sci-Fi and Afrofuturism in the Afrophone Novel: Writing the Future and the Possible in Swahili and Shona." Cleveland presents the debates around the inception and development of the term *Africanfuturism* and surveys key texts and trends in African science fiction in relation to the broader context of African literature and topics in mythology, theories of history, and digital culture and questions of space and time.

ACKNOWLEDGMENTS

I want to express my gratitude to the following individuals, galleries, and companies: Somtochukwu Ajuluchukwu, Sammy Baloji, Maria Pia Bernardoni, Akinseye Brown, Joana Choumali, James Cohan, Victoria Cooke, Andile Dyalvane, Gallery 1957, Goodman Gallery, Tendai Huchu, Eddy Kamuanga Ilunga, Francis Kéré, Kéré Architecture, Leti Arts, Gerald Machona, Masiyaleti Mbewe, Fabrice Monteiro, Jacque Njeri, October Gallery, Jean Pigozzi Collection, Athi-Patra Ruga, Mary Sibande, Elias Sime, SMAC Gallery, Southern Guild, Eyram Tawia, Twenty Nine Studio, Vortex Inc., and WHATIFTHEWORLD.

I also want to thank the anonymous readers who provided feedback on the book manuscript. Their insightful comments and questions made this a better publication. I am inspired by Ainehi Edoro-Glines's work and am honored to have her thoughts on the future in African literature shared here in the foreword.

At Ohio University Press, I extend my appreciation to Beth Pratt, Tyler Balli, Rick Huard, Sally Welch, Kristin Harpster, James Fisher, Addie Hedges, Anna Garnai, Laura André, and Africa in World History series editors Betsy Schmidt and Dave Robinson for helping bring this book to fruition.

Lastly, I am forever grateful to Karen Cleveland for her unwavering support and encouragement.

Introduction

Afrofuturism and Africanfuturism: Same Difference?

WITH THE release of the film *Black Panther* (2018), Afrofuturism became a buzzword in the United States. The movie features the fictional African country of Wakanda, a nation replete with technological innovation in which Blacks thrived and had never been subjected to European colonization. The film is conceptually and visually remarkable. Its African-themed setting, otherworldly design, and superhuman characters suggest that the label *Afrofuturism* was all but self-explanatory for mainstream theatergoers. The first time much of the American public had ever heard the term was in relation to the film and suddenly it seemed as if it was everywhere. Those who are familiar with the etymology of Afrofuturism, however, know that it is a decades-old international academic area of inquiry with wide-ranging social, methodological, and economic implications.

The term *Afrofuturism* was coined by American author and cultural critic Mark Dery in his 1993 seminal essay on science fiction literature, "Black to the Future," which included an interview with African American writers Samuel R. Delany, Greg Tate, and Tricia Rose. Dery wondered why there weren't more African American science fiction authors, since this genre's frequent inclusion of unfamiliar species and encounters with foreigners would likely resonate with a population that, itself, had long been viewed and treated as "other" by much of White America. Similarly, because science fiction was considered a lesser category in the hierarchy of Western literature, it made it an especially fitting form of expression. In Dery's mind,

African American writers were uniquely suited to craft narratives about the future that reflected a Black point of view. This aspect would distinguish their stories from those produced by White male writers, who not only dominated the field of science fiction but also tended to feature White male characters.

In an attempt to name a subgenre of science fiction writing, Dery tentatively defined Afrofuturism as speculative fiction that displayed the following traits: "treats African-American themes and addresses African-American concerns in the context of 20th century technoculture—and, more generally, African-American signification that appropriates images of technology and a prosthetically enhanced future."[1] By the time *Black Panther* was released twenty-five years later, studies and discussions of Afrofuturism had grown to encompass African American production from different disciplines and time periods. Scholars had also broadened their geographic scope to identify examples deriving from multiple sites across the diaspora, as well as from the African continent.

While many intellectuals in the United States now include African speculative expression in their examinations of a wider body of Afrofuturism, a growing number of Africans and Africanists have voiced concerns about this approach. They do not take issue with the concept of Afrofuturism in the US context but rather with extending the Afrofuturist label to African creative work without distinction. Some Africans and Africanists have pointed out that this tendency glosses over cultural, environmental, and racial factors relevant to the African work; fails to take into account that Afrofuturism centers the Western imagination and gaze; and frames its discourse on US-originated and US-oriented terminology. In light of what they believe are Afrofuturism's limitations, Africans and Africanists have emphasized a need for dedicated consideration and analysis of African production. This publication is an introductory study of Africanfuturism—a body of African speculative expression that is distinguishable from, albeit unquestionably related to, Afrofuturism with its roots in the United States.

THE DEVELOPMENT OF DISCOURSE ON AFROFUTURISM IN THE UNITED STATES AND ITS EXPANDING SCOPE

Soon after Dery's essay was published, academics from a variety of fields began to investigate and discern what might be considered

Afrofuturist production, as well as expound on Afrofuturism's meaning. In 1998, while still a doctoral student at New York University, sociologist Alondra Nelson started the AfroFuturism listserv (www.Afrofuturism.net) to explore futurist themes and technological innovation in Black cultural production. In 2000 she authored the article "AfroFuturism: Past-Future Vision" for the (then print) magazine *Colorlines*, in which she asserted, "AfroFuturism has emerged as a term of convenience to describe the analysis, criticism, and cultural production that addresses the intersections between race and technology. Neither a mantra nor a movement, AfroFuturism is a critical perspective that opens up inquiry into the many overlaps between technoculture and black diasporic histories."[2]

Some of the topics discussed on the listserv were developed into academic essays that appeared in a special issue on Afrofuturism of the journal *Social Text* (2002), organized by Nelson. In the issue's introduction, she states that Afrofuturism "can be broadly defined as 'African American voices' with 'other stories to tell about culture, technology and things to come.'"[3] Nelson's essays for *Colorlines* and *Social Text* constitute some of the earliest examples of an individual offering their own interpretation of Afrofuturism in a more formalized and permanent scholarly format.

A few additional articulations give a sense of how other academics have approached Afrofuturism. American-studies scholar Ruth Mayer explored diasporic creatives' use of Middle Passage imagery and the contemporary experiences of displacement and migration within and beyond the genre of science fiction in her article "'Africa as an Alien Future': The Middle Passage, Afrofuturism, and Postcolonial Waterworlds" (2000). In her essay, Mayer loosely defines Afrofuturism as "an artistic and theoretical movement which has become a vital part of contemporary black diasporic (pop) culture."[4] In her article "An Afrofuturist Reading of Ralph Ellison's *Invisible Man*" (2005), literary science fiction specialist Lisa Yaszek identifies Afrofuturism as an "international aesthetic movement concerned with the relations of science, technology, and race [that] appropriates the narrative techniques of science fiction to put a black face on the future."[5] Art historian Jared Richardson explores Black women artists' utilization of the abject Black female body in his article "Attack of the Boogeywoman: Visualizing Black Women's Grotesquerie in Afrofuturism" (2012). According to Richardson, "Afrofuturism offers

a racialized science fiction that reimagines black temporality vis-à-vis technology, galactic elsewheres, disjunctive time, and speculative narratives stemming from either utopic or antithetical visions."[6] Lastly, in her book *Afrofuturism: The World of Black Sci-Fi and Fantasy Culture* (2013) author and filmmaker Ytasha Womack states, "Both an artistic aesthetic and a framework for critical theory, Afrofuturism combines elements of science fiction, historical fiction, speculative fiction, fantasy, Afrocentricity, and magic realism with non-Western beliefs."[7]

These examples demonstrate how the American scholarly community has continued to reinforce and expand Dery's concept of Afrofuturism in the years since he coined the term. As such, there is no definitive definition, and the term remains open to interpretation. However, intellectuals are generally in agreement on two points: first, that 1993 can be understood as the origin date for the term though not the beginning of Afrofuturist expression itself; and second, although Dery should be given credit for coining the word, African American creatives should also be recognized as progenitors of what would later be called Afrofuturism.

The scope of Western scholarly explorations of Afrofuturism has also been flexible, growing from exclusively African American works to those by African creatives active within and outside the United States by the early twenty-first century. This development was part of the investigation of a "second wave" of Afrofuturist expression that followed the "first wave" of the decades 1960s–80s and which included such works as the music of Sun Ra and Parliament Funkadelic, the writing of Octavia E. Butler and Samuel R. Delany, and the films *Space Is the Place* and *Brother from Another Planet*. Illustrations of Nigerian-born and United States–based artist Fatimah Tuggar's digital photomontages from the mid to late 1990s, for example, appeared in Nelson's Afrofuturist issue of *Social Text*. Yaszek (2013) identified a strain of "Global Afrofuturism" that had started to develop in the 1980s outside the United States. Those creatives, like their American colleagues, published with Western magazines and presses, and participated in networks of exchange and collaboration with online venues. Authors Bill Campbell and Edward Austin Hall included science fiction–themed stories by Africana writers in their edited volume *Mothership: Tales from Afrofuturism and Beyond* (2013). That same year, Naima J. Keith and Zoé Whitley curated the

international, interdisciplinary exhibition *The Shadows Took Shape* at the Studio Museum in Harlem, which included African production. In their 2016 edited volume, communications studies and Afrofuturism expert Reynaldo Anderson and Africana studies scholar Charles E. Jones articulated a shift in emphasis from the West to a more Pan-African scope of production as a defining characteristic of "Afrofuturism 2.0." Across disciplines, Americans were including African creative expression in their Western-originated and Western-organized Afrofuturist projects.

AFRICAN PRODUCTION AS AFROFUTURISM: POINTS OF CONTENTION

Since expanding the range of their studies beyond the United States, Western scholars have often presented and discussed African works alongside African American ones as Afrofuturist expression. Some Africans and Africanists believe this approach is flawed. Because Dery conceived of Afrofuturism specifically in relation to African American production, they find it problematic to locate African speculative expression under its umbrella. In voicing their concerns and objections, Africans and Africanists have raised a number of points related to everything from Afrofuturism's inherent diasporic perspective to confusion over the term itself.

One point of contention is that Afrofuturism's racial ties in the US context do not always translate to African populations. When Dery provisionally outlined a literary subgenre called Afrofuturism, he identified an African American point of view as a fundamental characteristic that distinguished the writing from that by White American authors. Postcolonial literature specialist James Hodapp has argued that subsequently, American scholars increasingly equated Afrofuturism with Blackness simultaneous to widening their geographic scope of inquiry. He points out how publications such as Womack's *Afrofuturism: The World of Black Sci-Fi and Fantasy Culture* (2013) and Anderson and Jones's *Afrofuturism 2.0: The Rise of Astro-Blackness* (2017) appear to lend themselves to inclusion of African speculative expression through the shared element of race, and "yet routinely fail to address the perspective of the majority of Black people in the world who overwhelmingly live in Africa."[8] To date, Western Afrofuturist discourse remains overwhelmingly based on a Black *diasporic* experience and outlook. Therefore, to indiscriminately categorize

African speculative expression as Afrofuturism simply because of the creative producer's race is to treat Blackness and the Black experience as universally homogenous. Furthermore, when US academics apply the Afrofuturist label to examples from the African continent in a generic manner, they expose its race-related limitations. Alan Muller, a scholar of South African literature, asserts that Westerners' utilization of Afrofuturism, which in the United States denotes "African descent and blackness . . . becomes problematic in cases of Africans who are not black."[9] Such is the case of Egyptian author Ahmed Khaled Towfik, whose writing I discuss in chapter 5.

Africans and Africanists have also pointed out that the predominant American approach toward Afrofuturism fails to acknowledge that Afrofuturist production, with its roots in the United States, centers the Western gaze and imagination. African American creatives have long made Africa and Africans prominent features of their Afrofuturist expression. Author Pauline Hopkins portrayed a fictionalized ancient utopian African civilization in *Of One Blood: Or, The Hidden Self* (1903). Midcentury, musician and composer Sun Ra combined references to Egyptology and outer space, wore dress in the style of the ancient pharaohs, and adopted the name of the Egyptian god of the sun. Womack explains that American Afrofuturists have been particularly drawn to African cultures whose mythologies combine elements of science fiction and mysticism: "Afrofuturist artists site Egyptian deities, the Dogon myths, water myths, and Yoruba orishas more than any other African cosmology in their art, music, and literature. From the costumes of Earth, Wind & Fire to Lee Scratch Perry's Black Ark to the idea of the mothership itself, the Dogon's star bond with Sirius and ancient Egyptians' unexplained technologies are the basis for Afrofuturist lore, art, and spectacle."[10] African American creatives who incorporate African subjects and references in their Afrofuturist production view and portray the continent and its peoples from their positions in the West and through the lens of their Western imaginations. They may choose to adopt an Afrocentric element, theme, or storyline for their Afrofuturist work. However, for Africans, Afrocentrism is self-referential, and Africa is the permanent default. As speculative fiction author Mohale Mashigo declares, in contrast to US Afrofuturism, "We [Africans] actually live on this continent, as opposed to using it as a costume or a stage to play out our ideas."[11]

Additionally, the American scholarly inclination to focus on similarities between production from the United States and Africa in their Afrofuturist discourse discourages exploration of cultural and environmental factors that inform and influence the African work. In 2013, multidisciplinary artist Pamela Phatsimo Sunstrum expressed interest in identifying an "African sensibility" embodied in African speculative production based, in part, on African creatives' tendency to engage with "postcolonialism, neocolonialisms, transglobal identities, [and] transcultural identities."[12] Artist and curator Tegan Bristow emphasized that likeness with US Afrofuturist mechanisms aside, African individuals were "working from very different contexts and producing work for very different reasons," a position she had hinted at in her exhibition catalog essay for the Studio Museum in Harlem's *The Shadows Took Shape*.[13] Poet and writer Sofia Samatar questioned how some contemporary African artists had been "absorbed seamlessly into the flow of Afrofuturism without a discussion of how their relationship to the African continent... informs their engagement with the field."[14] These comments indicate the need for nuanced exploration of commonalities *and* differences between African and African American speculative expression.

Lastly, some Africans and Africanists have objected to including African examples in discussions and studies of Afrofuturism because they believe the term itself is problematic. When Dery coined the word in his 1993 essay, he used the prefix *afro* to indicate African descent. However, writer Namwalli Serpell contends that the *afro* designation of Dery's thinking does not account for individuals who fit Taiye Selasi's idea of the Afropolitan, nor does it apply to a creative producer such as speculative fiction writer Nnedi Okorafor, whom Serpell asserts bridges Afrofuturist expression from the United States and Africa.[15] Okorafor is the US-born child of Nigerian parents and has spent much of her life in both countries. Other individuals argue that the Afrofuturist label has negative implications for African creatives. Filmmaker Phetogo Tshepo Mahasha maintains that rather than encourage Africans' imaginative possibilities, the *afro* of *Afrofuturism* may have the opposite effect by relegating them to a shadow mentality: "A prefix modifies a word/statement.... It does not promote the generation of wholly new ideas and manifestos, but only the modification of the creativity of others. The prefix 'afro-' has acquired a parasitic character.... It has the capacity to arrest the African

imagination, so that the African imagination only follows other manifestos, only to attach itself to them and never coming up with an original of its own."[16] Curator and art critic Oulimata Gueye feels that media related to the widespread distribution of *Black Panther* contributed to the misconception that Afrofuturism is a portmanteau of the words Africa and futurism, and that in reality, "Afrofuturism is a term, a concept, that has a history and content that cannot be applied to all output concerning the African continent that is directly or indirectly connected with imagined futures."[17] For these reasons, the term *Afrofuturism* is demonstrably ill-suited for African production.

In turn, and in contrast to US scholars who have continued to produce multiple interpretations of Dery's Afrofuturism, a small number of Africans and Africanists have devised their own terminology for African-centered speculative expression. In 2013, Phatsimo Sunstrum employed *African Futurism* for African production in different mediums characterized by a number of common themes and features, though she also clarified that categorizing the work in this way did not indicate mutual exclusivity from Afrofuturism.[18] Bristow suggested that Phatsimo Sunstrum's ideas and language might be improved upon with *Post African Futures*, utilizing *post* to even further differentiate African production of the type that Western critics and researchers had been quick to envelop as a "version of African American Afro-futurism."[19] Okorafor has placed her own work in a subcategory of science fiction called Africanfuturism and explained its relationship to Afrofuturism in a posting on her blog: "Africanfuturism is similar to 'Afrofuturism' in the way that blacks on the continent and in the Black Diaspora are all connected by blood, spirit, history and future. The difference is that Africanfuturism is specifically and more directly rooted in African culture, history, mythology and point-of-view as it then branches into the Black Diaspora, and it does not privilege or center the West."[20] She also indicated that a work could be both Africanfuturist and Afrofuturist, depending on how it was read. Muller has suggested replacing the homogenizing prefix *afro* with country-specific descriptors: "Ghanaian futures, Namibian futures, Cameroonian futures, South African futures, etc.," although this, too, has its limitations, since "language and culture frequently cross physical borders and transcend distinctions of nationality."[21]

A growing number of Africans and Africanists use either or both *African Futurism* and *Africanfuturism* in their discussions.[22] In

contrast to the US-originated Afrofuturism, Africans have put forth these two terms to recognize future-related speculative expression that centers Africa and is intimately tied to the continent. Certainly, some African intellectuals and creatives (continue to) use *Afrofuturism* in reference to African production while others eschew all labels, regardless of origin. Nonetheless, particularly those who are familiar with Okorafor's writing and thoughts on the differences with US Afrofuturism, appear to look upon *Africanfuturism* more favorably.

In this book, I utilize the term *Africanfuturism* in keeping with this increasingly common move among Africanists and Africans. I use *Africanfuturism* as an intellectual lens to identify and analyze creative expression across disciplines that is unified by the foregrounding of African perspectives, strategies, and concepts, including those related to time, technology, and the fantastical, which are applicable to that which might lie ahead. The production embodies any combination of possibilities, challenges, and concerns that are revealing of an African-oriented yet to come, even when the respective work does not exclusively deal with a future existence. Therefore, it may be directly or indirectly speculative in nature. In articulating my own interpretation of Africanfuturism, my aim is not to outline a static, narrow category for the purposes of exclusion. Instead, I use it to connect the contemporary contributions of African creatives across forms of expression and geographic spaces to the larger body of speculative production.

ENGAGING AFRICANFUTURISM

I became familiar with scholarship on Afrofuturism and Africanfuturism through my own research and in identifying readings to use in my academic courses. As an Africanist art historian who takes a strong interdisciplinary approach, I found that although there are a multitude of edited volumes on Afrofuturism that include African production, the individual contributions contained within those publications reflected the respective author's area of expertise, thereby offering examinations that were insightful and yet also limited to a singular field such as art, literature, or film.[23] Additionally, the chapters' disparate nature prohibited usage in a cohesive manner. Special editions of journals dedicated to Afrofuturism, as well as individual articles, were often equally restricted by disciplinary boundaries.[24] Further, though Afrofuturist discourse has remained weighted

toward the United States, there was a growing number of individuals who expressed a need for more nuanced consideration of African works.

The primary objective of this publication is to offer a study of Africanfuturism through analysis of production by African creatives, the majority of whom live on the African continent, from different areas and in different mediums. In bringing together and exploring a variety of examples, this text prioritizes an *African* perspective that sheds light on the interests, concerns, and tendencies of contemporary African cultural producers related to an African yet to come. In largely following the parameters of the African Speculative Fiction Society (2016), I define *African* in this context as an individual who was born and raised in Africa or who spent at least some of their formative years there, citizens and noncitizens of African countries, and individuals who have at least one African parent.[25] Many African descendants in the United States feel a sense of affiliation with the continent. Nonetheless, Africa and Africans are the heart of this investigation.

Second, this study adds to the existing scholarship on Afrofuturism by prompting individuals to think critically about the predominant Western scholarly tendency to locate African production in this category. Intellectuals have proven Afrofuturism to be a useful tool for the analysis of African American work. This exploration of Africanfuturism neither negates Afrofuturism's validity nor significance with regard to African American speculative expression. Rather, foregrounding how African creatives represent ideas, concerns, and topics related to Africanfuturist projections helps to make apparent a body of production that is distinguishable from, nevertheless similar in certain ways to, Afrofuturism from the United States.

This publication is not intended to be exhaustive or definitive. It is meant to serve as an introductory resource for those who want to learn about Africanfuturist expression by African creative producers. The book was written with undergraduate students, nonspecialist academics, and general Afrofuturism enthusiasts in mind. As such, I have organized the chapters by some of Africanfuturism's most common themes instead of by medium of expression or geographic region. Additionally, I privilege analysis of the examples included in this book over critical engagement with other scholarly interpretations of them. Individuals who are interested in becoming more

familiar with the creative producers and works featured in this publication may avail themselves of the additional suggested materials found at the chapter ends. Readers will also find questions intended for group discussion or simply food for thought.

Because this publication is aimed primarily at audiences in the United States, the selected works examined herein were originally produced in English or have been translated into English. As a result, examples from Anglophone Africa are represented more heavily than other areas of the continent. Further, in addition to the illustrations included in the publication, most of the films, artworks, videos, novels, short stories, comic books, song lyrics, and architecture discussed are accessible through public and institutional library systems; artist, business, and gallery websites; and YouTube, Vimeo, and general web searches.

Africa and its peoples are inherently diverse. The African creatives featured in this publication are reflective of different nationalities, races, ethnicities, and genders. They may be self-taught, hold degrees in their respective fields, or have pursued studies in other disciplines. They are of different ages and generations. Though evidence of African progenitors of Africanfuturist thought and expression exist, such as John Mbiti's ideas about time, Thomas Sankara's call for Africans to invent the future, and William Onyeabor's lyrics and experimental music, this publication emphasizes twenty-first-century production. In addition to the individuals whose works are discussed here, this book features the voices of other mainly African intellectuals, artists, and writers. Their concepts, theories, and opinions are taken from other sources, as well as interviews conducted with the author via email.

Several times throughout this publication I highlight the arguments that Senegalese economist, philosopher, author, and musician Felwine Sarr presents in his book *Afrotopia*.[26] While Sarr does not discuss Afrofuturism or Africanfuturism specifically, he calls upon Africans to work toward creating a more utopic future for the continent that is driven by the needs, interests, and desires of its own peoples rather than the West. In forging a new way forward, he emphasizes (indigenous) African viewpoints, knowledge, and concerns, which are not unlike the African American aspects that Dery identified as fundamental to Afrofuturism. Simply because Dery was focused on African American production does not mean that his comments are

wholly irrelevant to this exploration of Africanfuturism, especially as they may apply to certain tropes and themes in Afrofuturist and Africanfuturist production. Parallels exist, but certainly Dery's concepts do not constitute a universal point of reference. My study of Africanfuturism is influenced by both Dery's and Sarr's ideas about the fantastical and the possible.

In chapter 1, I touch on key moments that both illuminate Africa's place in the history of Western speculative expression and help to contextualize contemporary concerns about including African speculative production within Afrofuturism. I begin with John Rieder's study (2008) of how late nineteenth-century Western colonial projects on the African continent supported the emergence of Western science fiction writing in Europe and subsequently the United States. I then address why African Americans were motivated to incorporate African themes and characteristics in their speculative production in the second half of the twentieth century based on their diasporic concerns and political developments on the African continent. Despite their desire to make (new) connections to Africa and work against the interests of a Whitewashed future in the United States via their production, they nevertheless viewed and imagined Africa through their Western lens.

I then examine the controversies of using Western-originated and Western-defined terminology to discuss and categorize African peoples and subjects in relation to Afrofuturism. I outline the positive and negative implications that having one's work associated with Afrofuturism holds for African producers and include African creatives' reactions to the Afrofuturist label that range from mocking it to embracing it. I also discuss why Sarr and others feel it is essential for Africans to partake in defining and describing themselves and their futures. Because Africanfuturism disrupts the longer history of Western dominant influences on the continent, I connect it with the process of decolonization and demonstrate specific ways in which African creatives (re)center African concerns, topics, and strategies in their production. Though Afrofuturist and Africanfuturist production may both work toward producing a better future for their respective populations, and thus have somewhat intertwined trajectories, they are parallel bodies of expression with Afrofuturism rooted in the US and Africanfuturism in Africa. I underscore this relationship by concluding the chapter with a brief discussion of some of

the common tropes and overlap between the two, followed by a brief overview of the specifically African-oriented nature of Africanfuturist production.

Chapters 2–6 focus on Africanfuturism's common themes and demonstrate how they manifest in work from various fields. The topics and traits highlighted in this publication are prevalent but not absolute. I analyze examples of what might qualify as Africanfuturist expression primarily drawn from art, film, and speculative writing, as well as, to a lesser extent, music, architecture, and design. Following Phatsimo Sunstrum's interest in identifying an "African sensibility" that acknowledges African creatives' shared major concerns and approaches within the broader body of Africanfuturist production, I address cultural, geographic, and personal influences, as well as discuss how each work is linked to Africanfuturism.[27]

Then I consider the examples in relation to each other and, subsequently, relative to those from other chapters. This comparative approach elucidates connections across and sometimes beyond the continent, as well as contextualizes the works within broader networks of ideas and influences. I recognize if the creative producers have been included in Western discussions and publications on Afrofuturism and, whenever possible, their thoughts on the Afrofuturist label, as Westerners have largely used the term *Afrofuturism* in their investigations and projects to date. Conclusions are drawn about what the individual chapter examples impart about Africanfuturist production. Lastly, each chapter ends with suggested further materials of interest and discussion questions.

Chapter 2 examines space and time exploration. This theme is a classic hallmark of speculative production, though not an exclusively fantastical subject for some African societies as it figures into their cultural and cosmological beliefs. In Africanfuturist expression, space and time exploration may involve both forward- and backward-oriented movement, as well as simultaneous temporal existence. The chapter begins with a brief discussion of Dery's ideas about Black alienation, African endeavors in space exploration, and Sarr's focus on reinventing Africa's future.

Subsequently, I examine space and time exploration through analyses of diverse works beginning with Frances Bodomo's short film *Afronauts* about of a group of Zambians who try to outpace the United States in travel to the moon in the 1960s. Gerald Machona's

sculpture *Ndiri Afronaut (I Am an Afronaut)* is a space suit composed of decommissioned Zimbabwean dollars that speaks to his experience as a foreigner in South Africa. I examine one of Jacque Njeri's digital collages from the series *MaaSci* in which the artist repurposes images of Maasai people sourced from the internet and depicts them in outer space. Musician Keziah Jones approaches time as fluid and open-ended in his song lyrics and graphic novel featuring Captain Rugged, an African superhero. Lastly, I explore a photograph from Masiyaleti Mbewe's multimedia installation *The Afrofuturist Village*, which represents a futuristic society that is inclusive of queer and differently abled individuals.

The works in this chapter indicate that African creative producers may be drawn to the theme of space exploration due to their own experiences of failing to "fit in" and alienation. These creatives demonstrate that Africans have a place in space and time exploration by portraying subjects who are able to engage in those activities. Further, they encourage other imaginative possibilities and potential real-world outcomes by representing a diverse range of individuals undertaking these endeavors.

Chapter 3 investigates creating worlds. There are various reasons why African creative producers may be inspired to generate other worlds in response to their respective social, political, and cultural environments. Though this theme often evokes ideas of creating other planets, it can involve everything from representations of detailed alternative surroundings to the abstract inner worlds of our minds. The chapter begins with Dery's idea that restricted movement was one of the characteristics that made the African American experience comparable to a speculative horror story. I then consider author and curator Ekow Eshun's assertion that Africans' proclivity for the audacious and fantastic in their world-building exercises is a reaction to the history of control over access to and movement within the urban environment.[28] This is followed by Sarr's comments about how Africans might best imagine and shape their future cities given the continent's fast rate of urbanization.

I then explore the creation of other worlds through analyses of a series of works, including Abdourahman A. Waberi's novel *In the United States of Africa*, a satire in which people desire to escape poverty-ridden Europe and America for the prosperous United States of Africa. Director Wanuri Kahiu portrays a fictional region

of Africa that is plagued by water scarcity decades after World War III in her short film *Pumzi*. I investigate sculptor Bodys Isek Kingelez's large-scale model *Ville Fantôme* (Ghost city), in which the artist used disparate materials to create his vision of a futuristic urban built environment. Finally, multimedia artist Mary Sibande's photograph *They Don't Make Them Like They Used To* is an exploration of her alter ego, a South African domestic worker who imagines herself as epic characters.

The examples featured in this chapter elucidate the ways Africans might navigate imagined environments and existences. They also evidence how African creative producers incorporate elements from their personal experiences in crafting other worlds. Lastly, the works offer possible answers to why alternate spaces and existences in Africanfuturist production are rarely utopian.

Chapter 4 looks at technology and the concept of the digital divide. Notwithstanding existing gaps between those with and without access to digital systems and equipment, technology is a common part of many Africans' lives. The chapter starts with Dery's comments about the relationship between African Americans, technology, and Afrofuturism. I then move to the ideas of writer and self-proclaimed Afrofuturist Jonathan Dotse, who contends that his fellow Africans must "play a greater role in the technologies" they use to create a new framework for thinking about the future, since technology has become a significant part of their identities and therefore their narratives.[29] Dotse's thinking is concordant with Sarr's insistence on the necessity of African contributions and innovations in order for the continent to move beyond mimicking Western advances and systems.

I begin my exploration of different examples related to this theme with an analysis of Tendai L. Huchu's short story "Egoli" ("Johannesburg"), in which the author sheds light on technology in the rural environment by tracing developments in communication technologies over the course of a woman's lifetime. Designer and ceramicist Andile Dyalvane's *Docks Table* embodies links between the movement of ideas and people in Cape Town's growing tech sector and the computer game Tetris. Elias Sime's wall sculpture *TIGHTROPE: (4) While Observing . . .* , composed of salvaged electronic components, exemplifies the artist's interest in human contact with technological materials and finding a balance between in-person and digital communication. Lastly, I examine Eddy Kamuanga Ilunga's painting

Abandonnés (Abandoned), in which he utilizes a cyborgesque figure to address both the Mangbetu people's body arts practices and the current conflict in the Democratic Republic of the Congo over coltan—a key metal for the electronics industry.

The examples analyzed in this chapter indicate that technology in Africa is not limited to urban areas nor solely outdated equipment. The works reflect the variability of ways that African creatives feature technology in their production both through their subject matter and materials. Further, the examples demonstrate that the creative producers' use of technology is shaped by the role it plays in their own lives.

Chapter 5 focuses on *sankofa* and remix. African creatives may incorporate historical aspects in their work by utilizing the Akan principle of sankofa, which conveys the possibility of learning from the past. Dery addressed the challenges African Americans faced because of the deliberate erasure of their collective history. In Africa, Sarr extols the value of drawing from indigenous pasts and traditions in moving the continent toward a better future. Sankofa's integration of elements from the past into a present or new form makes it comparable to remix. Though most often associated with music, remix constitutes a process or communicative practice across different expressive forms.

I begin with an analysis of Ahmed Khaled Towfik's ironically titled *Utopia*, a novel set in a future Egypt that has disregarded historical examples and allowed social divisions to fester. The digital comic *Sannkofamaan*—a collaboration between American creator Akinseye Brown and Nigerian Vortex Comics—features a group of peacekeeping supernatural individuals known as Sannkofamaan. Architect (Diébédo) Francis Kéré's Gando Primary School embodies sankofa and remix through the combination of traditional materials and social practices with new design techniques. Multimedia artist Sammy Baloji remixes archival and contemporary images to comment on the local history of mining and exploitation of natural resources in a photomontage from his *Mémoire* (Memory) series. Finally, I examine how photographer Joana Choumali remixes manual and technological processes in an example from her mixed-media series *Ça va aller* (It's going to be OK) to explore ideas of presence and absence following a 2016 terrorist attack in the Ivory Coast.

The works featured in this chapter show that African creatives incorporate sankofa and remix in their works in part as a strategy to

help others avoid or overcome the same or similar challenges they faced. These examples also highlight the ways sankofa and remix are conceptually and physically evidenced in Africanfuturist production. Remixed elements or processes are often clearly discernible. Honoring and validating traditional forms and practices by incorporating them in the present is equally meaningful, though sometimes less visually obvious.

Chapter 6 explores the act of mythmaking. African societies have their own myths that address the origins of a society or event, reflect beliefs and values, and sometimes provide models for human behavior. In many African cultures, myths continue to be widely repeated and appreciated, serving as points of reference for the way individuals think about the world and their position in it. The chapter starts with Phatsimo Sunstrum's ideas about African mythology and science fiction, which although may seem unrelated—one often conceived as old and the other new—frequently employ common ideas and representations.[30] Sarr identifies myths as among the various forms of knowledge that have ensured the survival, growth, and durability of African societies, and which will continue to serve them in the future.

I examine how some Africanfuturist production involves taking existing myths and modifying them to fit imaginings of African presents and futures beginning with an analysis of how Chiagozie Fred Nwonwu combines Igbo mythology and aliens in his short tale "Masquerade Stories." Lauren Beukes uses elements of spirit possession from Shona mythology in her speculative novel *Zoo City*, set in an alternate Johannesburg. Leti Arts interprets the myth of the Akan folk character Kweku Ananse in the pilot issue of its digital comic book series *Ananse*. In Athi-Patra Ruga's tapestry, *Invitation . . . Presentation . . . Induction*, the artist plays with the myth of a racially harmonious postapartheid South Africa. Finally, I discuss an image from photographer Fabrice Monteiro's series *The Prophecy*, in which he utilizes aspects of Greek and West African mythologies to call attention to Senegal's environmental issues.

These works demonstrate that in Africanfuturist expression, creatives frequently incorporate elements from African myths they were exposed to in their childhood in their own mythmaking activities. They use forms and modes that will resonate with African audiences, creating African-originated storylines and representations rather than

African copies of Western tales. Lastly, these examples suggest that Africanfuturist production need not always be uplifting, as Africans may engage in mythmaking to convey cautionary tales.

The book concludes with an epilogue that briefly elucidates similarities and differences between how various creatives engage with a common theme of Africanfuturism. This chapter underscores Africanfuturism's flexibility, as many of the examples included in the book could be discussed under more than one strain and, thus, across multiple chapters. Finally, I speculate on how Africans might continue to engage with Africanfuturism based on the trends and tendencies to date.

CHAPTER ONE
———

From Africa in Western Speculative Expression to Africanfuturist Imaginings

BLACK PANTHER (2018) introduced Afrofuturism to a generation of viewers in the United States for whom George Clinton's music, Rammellzee's graffiti art, and Milestone Media's comics were unfamiliar. The movie was exciting because of the possibilities it suggested beyond the walls of the theater. Set in the fictional African country of Wakanda, the film portrayed a cast of empowered Black characters in an aesthetically engaging environment that included advanced technology at their disposal. In essence, *Black Panther* was a door to imagining possibilities that had been flung wide open. Not only was the film a hit with diverse populations, grossing over one billion dollars at the global box office, but it also garnered a good deal of scholarly discussion related to Afrofuturism.[1]

While numerous African creatives and intellectuals acknowledge the movie's international impact, they also point out that what is arguably the most widely known example of Afrofuturist production from recent years is a tale about Africa viewed through a Western lens. Based on the Marvel Comics character, *Black Panther* is a product of the American imagination. Ainehi Edoro, an author and African literary magazine editor, commented: "I think that the world needed 'Black Panther.' But how well does 'Black Panther' represent a kind of African imagination of the future? I don't know that it does that

very well."[2] Writer and African science fiction journal editor Chiagozi Fred Nwonwu argued that the story wasn't equally as stirring for creative producers who live on the continent, because it was told from an American perspective: "The West looked to Wakanda when they woke up to the need to include Africa in their cinematic universe party. Still, most African writers I've met aren't keen on the tale of an invented people being the go-to narrative for Africa."[3] Speculative fiction writer Nnedi Okorafor stressed how Wakanda's expansion in the movie was revealing of the story's Western-oriented approach to (a fictional) Africa by comparing it to what an African-centered Africanfuturist slant would look like: "Afrofuturism: Wakanda builds its first outpost in Oakland, CA, USA. Africanfuturism: Wakanda builds its first outpost in a neighboring African country."[4]

Beyond this individual film, such comments are indicative of how differently some African creatives regard what many Westerners consider to be inspiring Afrofuturist representations of Africa. Additionally, their remarks suggest that Africans need something other than US Afrofuturism when it comes to speculative future-oriented imaginings that have the potential to positively affect and guide the continent forward. This is both because the very emergence of Western science fiction was informed by European colonial projects of domination in Africa and the fact that African societies have always had their own traditions of speculative expression. In contrast to Afrofuturism, Africanfuturist production disrupts the longer history of Western authoritative influences on the continent and brings Africans closer to realizing a future that serves their own interests. Africanfuturism is a corrective lens, one that requires those within and beyond the continent to imagine what lies ahead from an African-oriented outlook.

AFRICA IN WESTERN SCIENCE FICTION, BLACK LIBERATION, AND (RE)CONNECTING

Africa's relationship to Western speculative expression, including twentieth- and twenty-first-century Afrofuturism, is historically linked to colonial projects on the continent. Literary scholar John Rieder has studied how Western colonization of Africa in the late nineteenth century set the stage for the emergence of science fiction literature—a form of writing characterized foremost by its divergence from realist conventions. When Europeans first made contact

with Africa along the coast in the fifteenth century, the continent represented space unknown. As Westerners penetrated deeper and deeper into the interior over the course of the late nineteenth and early twentieth centuries in their quest for social and economic domination, this was no longer the case. Having "no place on Earth left for the radical exoticism of unexplored territory," European writers resorted to inventing "other places" in their stories.[5] Besides navigating foreign spaces, colonization involved a form of backward-oriented time travel for Westerners, since they believed that "savage" Africans were perpetually stuck in an earlier stage of human development.[6] The concepts of imagined elsewheres and traversing different temporal periods would become two classic features of science fiction. This type of writing first became identifiable in England and France—two countries heavily involved in colonial projects on the African continent—and subsequently spread to other Western nations, including the United States.

In the 1930s, science fiction became solidified as a field through a series of literary conventions. However, since then, intellectuals have continued to debate what constitutes this genre to the point that, more recently, the discourse has swayed toward determining what *doesn't* qualify as science fiction.[7] For the purposes of this book, I follow Rieder and others who understand science fiction as a body of production that is recognizable through a wide range of shared characteristics more than a fixed category.[8] I employ the same approach to identifying and discussing examples of Africanfuturism. When Dery coined the term *Afrofuturism*, he was attempting to define a subgenre of science fiction writing in the United States. Subsequently, numerous individuals have offered their own understandings of the word and concept. Afrofuturism's lack of a singular definition and resultant fluidity mirrors the wider flexibility of discourse on science fiction in general.

Going forward into the mid-twentieth century, developments related to Africa's role in Western speculative expression included an increased sense of optimism about and interest in Africa among African Americans that was fostered by the era of independence on the continent. The 1960s saw the end of colonization for many African nations, though the detrimental effects of decades of foreign control were not quickly or easily undone. In the United States, African Americans fought for greater equality through the Black Power and Civil Rights movements and were eager to align themselves with

Black liberation activities elsewhere in the world. As Black Americans witnessed the nation show greater concern over "conquering" outer space and landing a man on the moon than their own well-being, African independence symbolized new possibilities.[9]

In the following decades, African Americans demonstrated an increased interest in Pan-Africanism, which emphasized ties between African descendants in the United States and the African continent. However, White Western society was comparatively less intrigued by that area of the "developing world," which, by all indications, would forever trail the Global North. When African nations experienced political, social, and economic issues in the post-independence years, their struggles only seemed to confirm what most Westerners already believed to be true. In his article "Further Considerations on Afrofuturism," British-Ghanaian writer and theorist Kodwo Eshun notes how Westerners provided abundant gloomy prognoses for Africa related to everything from its weather to economic and life-expectancy projections.[10] It seemed certain that the continent and its peoples would continue to prove themselves irredeemable and therefore remain marginal to the West's futurist concerns. By controlling the speculative narrative of the future, the West could maintain its dominant position in the world order and leave Africa in the past, where it belonged.

In embracing African themes and elements in what scholars now consider the "first wave" of Afrofuturist production in the United States, which lasted from the 1960s through the 1980s, African American creatives asserted their affiliation with the continent and attempted to counter the predominantly negative views. For Black Americans, the widespread pessimistic attitudes toward Africa, in addition to acts of discrimination and repression against people of color in the United States, fueled fears of a Whitewashed future. Through their Afrofuturist production, creatives in the United States could interrupt the dominant cynicism and avow that Blacks in Africa and across the diaspora would be present, if not a majority, in the yet to come.

Nonetheless, when African Americans portrayed African subjects and characteristics in their speculative expression, they did so from their diasporic position and perspective. Foreigners had arrived in Africa, ripped indigenous peoples from their homelands, and transported them to other parts of the world during the Atlantic Slave Trade, causing a physical and geographic break with the continent.

African Americans, whom Dery likened to the descendants of those "alien abductees," were and are necessarily prohibited from being intimately and directly connected to a particular location or people in Africa.[11] Some American creatives have combined references to the Middle Passage with contemporary experiences in their Afrofuturist expression, highlighting parallels. Though, in their excavation of a collective Black history, they can go no further back than that period in time, and no place more specific than the sea, leading them to "concentrate on the fantasy spaces in-between and nowhere at all."[12] Because their long history has almost always been deliberately erased, their immediate history is rooted in the West. Consequently, African American creatives have tended to draw from certain African cultures that challenge the realist horizons of US culture and thereby lend themselves to Afrofuturist production such as "Egyptian deities, the Dogon myths, water myths, and Yoruba orishas."[13] In so doing, they create their own new connections to Africa in a demonstration of agency and resistance against racial oppression in the United States.

Working against the generic expectations and tendencies of (White) Western science fiction literature, African American creatives have also frequently imbued their fantastical portrayals of real and imagined African places and peoples with technology. Dery identified Black subjects and technological elements as two fundamental characteristics of Afrofuturism. African American Afrofuturist producers use technology as a marker of a futuristic environment. They also incorporate it to counter the sometimes generalized and erroneous conclusions they draw about its role, or lack thereof, in Africa based on the digital divide in the United States.

To return to science fiction's inherent disruption of realist conventions, one's centered culture is what defines the scope of human possibilities and, likewise, one's realist conventions. For many Africans, nonhuman beings and forces, different realms of existence, and knowledge of outer space are parts of their cultural and cosmological beliefs, making these concepts and themes within the existing range of possibilities. Further, so is the incorporation of technology in their daily lives. Thus, when Nwonwu (chapter 6) connects an otherworldly presence with an Igbo masquerade and a holographic projection in his tale "Masquerade Stories," he creates a speculative narrative grounded in elements from the Nigerian present. Similarly, Frances Bodomo (chapter 2) uses the historical efforts of the Zambia

Space Academy to reach the moon before the United States in the 1960s as inspiration for her speculative film, *Afronauts* (2014). Moreover, when she relocates scientific elements from the more common lab setting of Western science fiction to an improvised outdoor location, she underscores Africans' powers of technological invention rather than a lack of sophisticated equipment.

If spaceships, aliens, and fantastical subjects are not necessarily limited to the future for Africans, then what makes Africanfuturism futuristic? It is the foregrounding of *African* perspectives, experiences, and concepts that are telling of and applicable to an *African*-oriented yet to come that makes it so. This centering aligns with Okorafor's premise of the inseparability of Africa and futurism as the motivation behind the unifying term *Africanfuturism*.[14] Speculative expression that can be considered Africanfuturism engages with a future that is not predicated on a rewriting of the past in the vein of a fictional Wakanda that had never been colonized by Europeans. In contrast to US Afrofuturism's concern with speculating on "what would have been" if Africans had not been enslaved and torn from the continent, Africanfuturism engages with imagining how Africans might move beyond what *has* happened on the continent.

There is a sense among African intellectuals and creatives that because Africanfuturism has a greater potential to result in real-world outcomes given its African-oriented origin and perspective, there is more at stake than just creative expression for the purposes of entertainment. When it comes to speculative portrayals of Africa and Africans, one might argue that Africanfuturist expression leans more toward the hypothetical, whereas Afrofuturist expression has a greater fantastical bent. Author Mohale Mashigo is among those African creatives who don't feel an affiliation with the term *Afrofuturism* precisely because of its perceived peripheral relevance to the continent. Referring to her own work in the preface to the publication of her short stories, she states: "There are stories that take place in the future but cannot strictly be called Afrofuturism because (I am of the opinion) Afrofuturism is not for Africans living in Africa. . . . I believe Africans, living in Africa, need something entirely different from Afrofuturism. . . . Our needs, when it comes to imagining futures, or even reimagining a fantasy present, are different from elsewhere on the globe; we actually live on this continent, as opposed to using it as a costume or a stage to play out our ideas."[15] Further, while

Afrofuturism may fantasize about what lies ahead in the absence of a traceable historical connection to Africa, Africanfuturism continues to deal with the past in the process of looking toward the future. Curator and writer Bonaventure Soh Bejeng Ndikung astutely captures why creatives on the continent are reluctant to forgo equal consideration of Africa's history in their future-oriented speculative expression: "It goes without saying that any deliberation on the 'future' necessitates an in-depth reflection on the past and the present for that matter. Otherwise, discourses around futures and futurisms are bound to be escapist, intriguing from a far, but indeed far from intriguing at closer look."[16]

THE AFROFUTURIST LABEL AND THE SIGNIFICANCE OF NAMING

Many African creatives have clearly expressed that they do not object to Afrofuturism in the US context but to Western characterizations of African production as such. This tendency among the Western scholarly community to include African speculative expression under the umbrella of Afrofuturism has also been demonstrated in a recent proliferation of websites and articles on Afrofuturism aimed at general audiences. Afrofuturism has emerged as a catchall, attention-grabbing label based on appearance on these platforms. Twenty-five years after his seminal essay, Dery expressed concern about this contemporary inclination, as approaching Afrofuturism foremost as "an aesthetic" elides its deeper significance.[17] Nevertheless, Westerners have often applied the Afrofuturist label to African expression based on a cursory identification of shared or similar characteristics to US production. In their desire to include examples from places outside the United States in their discussions and often limited familiarity with African peoples, places, cultures, religions, histories, and environments, even Western academics have frequently assessed at a surface level rather than probed deeply. In 2015, Bristow stated that when she was in the early stages of her artistic and curatorial research, "Afrofuturism was the hot word for anything associated with technology and art in Africa. . . . [South African] artists like Spoek Mathambo and Dineo Seshee Bopape were suddenly given this title. This was distressing for them, they weren't happy about it at all."[18] More recently, photographer Fabrice Monteiro (chapter 6) indicated that he rejects the association of his work with Afrofuturism based foremost on aesthetics and what he sees as a lack of understanding of

his production. He says, "It seems to me that if, as an African artist, my work even vaguely suggests a Western idea of science fiction, it automatically becomes Afrofuturist."[19]

While some creatives rebuff the perfunctory classification of their work under the Western-originated and Western-centered category of Afrofuturism, they also take issue with fellow African creatives who adopt an Afrofuturist aesthetic simply for the international attention and economic benefits. The Nest Collective, an interdisciplinary group founded in 2012 in Nairobi that focuses its projects on contemporary African urban experiences and a Kenyan audience, was unhappy that its films *Stories of our Lives* (2014) and *To Catch a Dream* (2015) were characterized as Afrofuturism.[20] In a mockumentary from their series *We Need Prayers*, the collective lampooned both the West's infatuation with Afrofuturism and some African creative producers' opportunism. In *We Need Prayers: This One Went to Market* (2017), Kui Ngirachu, a fictional young artist played by Kenyan actress and singer Patricia Kihoro, embraces Afrofuturism in order to achieve the same commercial success as other artists who have. A photographer who is getting ready to take pictures of Ngirachu at a shoot asks the artist, whose face and chest is covered in white and black paint in graphic patterns and who is placing a bunch of extension cords on her head, what she's doing. She answers, "I want to try this thing. Have you heard of 'Afrofuturism'? It's this thing. It's really big right now. And White people really like it for some reason." As she then nonchalantly stacks a light fixture on top of the cords, the photographer asks her what she'll say when art people ask her about Afrofuturism. The artist replies, "Use words like identity, reflection . . . big words . . . detachment. . . . You can never run out of things to say." Later, a glammed-up Ngirachu gives a gallery audience a profoundly heartfelt explanation of the meaning of her picture, using some of the oft-repeated terms she quoted earlier to the photographer, describing her image as a commentary on the current state of disconnect among Kenyans and the pessimistic view of African futures. The film ends with shots of numerous fictitious feature articles on Ngirachu, who has been dubbed an Afrofuturist queen and rising art star.

We Need Prayers: This One Went to Market is humorous and thought-provoking. It prompts Africans to ponder the benefits and costs of being linked with Afrofuturism and asks Westerners to consider what might motivate some African creatives to hop on the

Afrofuturist bandwagon. Journalist Amirah Mercer says that the silencing of the African artist's creative voice is an important theme of the film in which "Afrofuturism is just one more reductive label used to flatten the complexity of black artists. . . . Kihoro is in on the joke. She sails into art-world success by pandering to white people's clichés about Africa—isolation, conflict, and strife—and lands *BuzzFeed* worthy headlines. . . . But what has she lost in the process of selling her culture to [the] market?"[21] Media and communications scholar Paula Callus points out the irony in how the fictional Ngirachu "references the Western fascination with this term [Afrofuturism] while ridiculing it as she deploys the expert's language. This same language is used to validate her work, which in the film leads her to eventual success."[22]

The film raises important questions about the economics of Afrofuturism—an aspect that African creatives have acknowledged. In 2018, Okorafor told the magazine *Le Point* that due to the success of *Black Panther*, Afrofuturism had become a marketing term.[23] Ceramicist and designer Andile Dyalvane (chapter 4) indicates he is unsure if Afrofuturism has the ability to generate actual meaningful change or only commercial advancement. He says he is "uncertain of whether the concept propagates regenerative solution / narrative or community or if the focus inclines toward pop-culture [and] mass 'individualistic' consumerism under the auspices of activism of some sort."[24] Though not often a topic of Western academic writing on Afrofuturism, the Afrofuturist label unquestionably involves economic implications.

Even a brief look at a small number of African creatives provides us with a snapshot of how Westerners have associated some individuals with Afrofuturism and how the cultural producers align themselves with the category or not. Artist Cyrus Kabiru entered the international art scene in the early 2010s with his oversized sculptural eyewear made from discarded materials, which he calls C-Stunners. Since the Studio Museum of Harlem included Kabriru's work in *The Shadows Took Shape* exhibition, Westerners have overwhelmingly linked his production with Afrofuturism and the artist has been characterized as a key individual of Afrofuturist expression in Africa. Kabiru has only rarely even commented on the topic of Afrofuturism and though he has never been quoted as rejecting the Afrofuturist label outright, neither is he an artist who has portrayed himself as a producer of Afrofuturism.

Graphic designer and digital artist Jacque Njeri (chapter 2) and commercial photographer and digital artist Oscar Macharia are two African creatives who view the concept and label of Afrofuturism favorably. In a 2017 interview Njeri was asked what she thought about the frequent categorization of African artists as Afrofuturists. She enthusiastically replied, "I love it! It sets an African future apart from other futures. It alludes to a future for us and by us. It shows ownership of a voice in matters pertaining [to] Africa. I have been an Afrofuturism enthusiast even way before I started contributing to that genre."[25] Westerners have often linked Macharia's work with Afrofuturism, especially his *Ilgelunot* series, which Marvel commissioned to coincide with the movie release of *Black Panther* in London. The artist embraces the label, which he says is "all about an alternative perspective of the continent through a positive narrative that is different from the stereotype of what Africa is know[n] for, which is poverty, war, famine and disease," and that Afrofuturism "is a language of rebellion."[26] Like Njeri, Macharia feels that Afrofuturist expression is empowering and allows African creatives to participate in how their continent is represented.

The Nest Collective, Kabiru, Njeri, and Macharia, all of whom are from Nairobi, are a microcosm of African creatives' relationships with Afrofuturism. As diverse as the African continent is, it would be surprising if all artistic producers held the same opinion. Afrofuturism is but one example of the situations that creatives face in relating themselves and their expression to the trends and desires of national and international markets, between having control over how one's production is defined and deferring to the categories in which others place your work when the two are not aligned. Here, the main question to ask is, Who benefits from the Afrofuturist label?

Beyond consideration of African creatives' thoughts on Afrofuturism regarding their own production, we can also look at when and where Africans joined the discourse on Afrofuturism. Although it is challenging to identify an exact year that Africans began to contribute to the conversation through a permanent record, it appears it happened around the early 2010s. Wanuri Kahiu (chapter 3), who obtained her doctorate in the United States and whose speculative fiction film *Pumzi* was released in 2009, gave a 2012 TEDx talk in Nairobi on Afrofuturism in which she addressed her desire to explore the concept as it related to African peoples and examples. In

2013, Phatsimo Sunstrum, who had also studied in the United States, addressed Afrofuturism in *Paradoxa*'s special issue on African science fiction. That same year, and while still a graduate student, Tshepo Mahasha wrote an article about Afrofuturism on the Pan-African digital media platform "This Is Africa." In "From Afro-Futurism to Post African Futures" (2014), Bristow discussed her research on African cultures of technology and mentioned that she and her then colleague at University of the Witswatersrand, Phatsimo Sunstrum, had been discussing the topic of Afrofuturism since at least 2011.[27] Regardless of whether these and other individuals were interested in exploring how US Afrofuturism might relate to African work or distinguishing African production from it, they joined a discussion in which the West had already designed the terminology. Thus, African creatives and intellectuals immediately assumed the position of articulating how speculative expression from the continent might or might not fit into the Western-originated and Western-centered category of Afrofuturism.

At the same time, African intellectuals and creatives who were researching and creating work on topics that overlapped with Western Afrofuturist themes and interests showcased their production in festivals held in Africa. Bristow was a key player of the inaugural Fak'ugesi Digital Africa Festival (2014), which highlighted the intersection of art, culture, and technology in Africa and globally and was hosted by University of the Witswatersrand in Johannesburg. The following year, the Goethe-Institut South Africa organized concurrent interdisciplinary festivals that took place in Nairobi, Lagos, and Johannesburg under the title African Futures. In Accra, the Chale Wote Street Art Festival featured the themes African Electronics (2015) and Spirit Robot (2016). These and other temporary events fostered the growing scholarly and popular interest in discussing and producing work related to African technologies, futurist projections, and speculative expression across the continent and especially in Anglophone Africa. Parallel to Western Afrofuturist publications and exhibitions, these and other African-generated and African-organized endeavors focused on some of the same subjects and modes of expression without being framed around Afrofuturism.

The approximate point at which a number of African intellectuals and creatives were concertedly contributing to the discourse on Afrofuturism also roughly coincided with the publication of the first

Pan-African anthology of science fiction by African authors—*Afro SF: Science Fiction by African Writers* (2012), edited by Ivor W. Hartmann. In the years immediately prior to and following its release, other African publications began to showcase production under the label of science fiction, or the broader heading of speculative fiction, such as *Lagos 2060: Exciting Sci-Fi Stories from Nigeria* (2013), the journal *Omenana* (2014), and *Terra Incognita: New Short Speculative Stories from Africa* (2015). African literature scholar Peter Maurits dates a consistent and continent-wide emergence of African science fiction to approximately 2007. He cites a greater range of publishing platforms facilitated by increased access to mobile phone technology as among the factors that fostered the genre's growth on the continent at that time.[28] Certainly, there were individual narratives published earlier than this that could also be considered in the science fiction category.

Despite some Westerners' suggestions of a "rise" in this type of expression on the continent in the past couple of decades, which parallels a wave of optimism about Africa's economic future, other Africanists and Africans have countered that it is only the association of African production with the categories of science and speculative fiction that is novel.[29] In their writing on African science fiction, Matthew Omelsky points out that what Westerners consider science fiction tropes, including extraterrestrial travel and nonhuman existence, are long-standing characteristics of African storytelling modes and myths, while Mark Bould asserts that African science fiction has existed for at least a century.[30] Speculative fiction writer Dilman Dila has also stressed that science fiction stories have always been present on the continent in the form of folktales and that it is a matter of people getting used to the idea that this type of work in Africa is not only imitative of Western forms.[31] Speculative fiction author and journal editor Chinelo Onwualu similarly argues that it is a question of labeling, as popular understandings of science and technology are "often narrowly defined in ways that favour Western philosophies while dismissing non-Western notions of the same thing as 'magic realism.'"[32]

Kodwo Eshun has also challenged the presupposition that science fiction is new on the continent, a misconception that he claims even some younger generations of Africans mistakenly promote. He indicates that in their haste to identify an African equivalent for Afrofuturism, African youth posit that "there have been no African Futurisms, no speculative, and no invention to speak of until now," thereby overlooking the

cultural practices of previous generations that can be understood as inventions of the future.[33] Whether the notion that Africa and science fiction is anachronistic is coming from outside or within the continent, or both, a greater number of African creatives have embraced the science/speculative fiction label. This is perhaps due, at least in part, to the fact that Afrofuturism's problematic racial and etymological factors do not arise with this Western-originated term.

Discourse that categorizes and labels speculative African production with terminology other than Afrofuturism is still developing. While some Africans and Africanists indicate that they are focusing on an "African Afrofuturism," a greater and still growing number of individuals now utilize either or both *African Futurism* and *Africanfuturism*.[34] Apart from single essays or articles, a couple of recent collective works that demonstrate this approach include *Africanfuturism: An Anthology* (2020), which was published by the online African literary magazine *Brittle Paper*, and the anthology *Jalada 02: Afrofuture(s)*, published by a writers' collective based in Nairobi, and which also featured works from diasporic writers including Ytasha Womack. There will always be some African creative producers who are not interested in Afrofuturism or any prescribed label for that matter, including Fatimah Tuggar, whose digital photomontages appeared in the issue of *Social Text* (2002) on Afrofuturism.[35] And while author Tendai Huchu (chapter 4) thinks that Africanfuturism versus Afrofuturism is a bit of splitting hairs, the former is nevertheless "a positive direction, conceptually."[36]

There are also those Africans and Africanists who have changed their position as discourse on Afrofuturism has progressed. Okorafor had associated her writing with Afrofuturism before switching to Africanfuturism, while Kahiu first rejected and then later embraced the association of her film *Pumzi* with Afrofuturism.[37] In my own research and informal discussions on the topic, I approached the term *Afrofuturism* as inclusive of African production until I encountered the work of Phatsimo Sunstrum and Okorafor, among other individuals, who raised concerns. Importantly, Africans' views on the issues caused by extending the Afrofuturist label to African work are less frequently found in the pages of print books and journal articles and more often on websites, blogs, and in online magazine articles and interviews. Also, lack of a permanent record does not mean that many more conversations between and among Africans aren't continuing to take place.

Artist Masiyaleti Mbewe's (chapter 2) published comments provide a rare example of an African creative's process of working through several possible terms in an attempt to identify what they believe is the best. In interviews and on her YouTube show, Mbewe listed reasons the term *Afrofuturism* was problematic and why she stopped referring to herself as an Afrofuturist. She cited Afrofuturism's incapacity to reflect the full variety of African experiences, and Dery's coining of the term as within the longer history of White supremacism and naming.[38] Subsequently, she used the term *Pan-African Futurism* to place greater emphasis on African contexts. Following that, Mbewe employed *post-futurism* in response to what she perceived as others' fleeting participation and interest in Afrofuturism. In a 2021 communication with the author, she clarified that her YouTube video from the previous year "was not so much a means to encourage a complete deviation from the word Afrofuturism but to rather discuss the aspects of the term that were worth thinking about and assessing."[39] She added that she had settled on "queerfuturism because the fluidity of the term allows [her] to limitlessly engage these different aspects of [her] identity."[40]

Mbewe's search for an appropriate term affirms the power of language and the significance of naming. For many Africans, their objection to the Afrofuturist label is more than a quibble over nomenclature. What most African creatives desire is to be able to accept or reject labels as they see fit, particularly when the categories have originated and been applied in the West. In this publication, I frame my study on Africanfuturism and my own understanding of it. However, as *Afrofuturism* remains the dominant term in Western-originated scholarly discourse of which I am a part, I also include a range of African creatives' thoughts on the topic.

DECOLONIZATION

Dedicated exploration and analysis of Africanfuturism illuminates how this type of expression works in tandem with the broader process of decolonization through which the enduring harmful effects of colonialism on the continent are revealed and dismantled.[41] In his scholarship, Rieder traces how European colonial projects in Africa factored into the emergence of Western science fiction writing. The same ideas about Africans existing in an earlier state of human development that supported foreign occupation of the continent and the birth of sci-fi literary narratives also continued to shape Western

perceptions of Africa and its peoples in the postcolonial era. Many African societies have long possessed concepts and modes that overlap with those found in Western science fiction. Nonetheless, as Maurits rightly argues, it is unlikely that these formerly colonized peoples on the continent would engage to the same degree with some of the classic Western sci-fi themes, such as exploration, until reaching a greater temporal distance from colonialism.[42] The resultant misperception that Africans don't "do" science fiction, however, has also worked against publishing support for Africans active in this genre based on an assumed lack of a reading audience. In these ways, colonialism's links to science fiction have remained intact well after African countries gained their independence. This connection does not apply solely to writing and film, the forms of expression that are traditionally associated with science fiction, but extends to a range of mediums such as photography, sculpture, video, graphic novels, and comic books, all of which may be considered under the wider umbrella of speculative expression.

Because of this lasting hold, one can relate Africanfuturist expression that is grounded in (indigenous) African beliefs, concerns, and possibilities, and which does not follow Westerncentric models and perspectives, to a decolonial act. Africanist Toyin Falola explains: "African Futurism is an advanced state of African decolonization. Its discourse is centered on the severance of ties with (debilitating) Euro-American legacies, historical contexts, enlightenment reasoning with its totalizing control, its ontology (which destroys otherness by homogenizing it), and its logocentrism (white mythology)."[43] Phatsimo Sunstrum (2013) had earlier remarked upon African creatives' tendency to engage with postcolonialism and neocolonialisms in her discussion of African Futurism, and more recently, Mashigo rejected US Afrofuturism because she asserted that Africans needed "a project that predicts . . . Africa's future 'postcolonialism.'"[44] Therefore, although framing a discussion of African speculative work around the bookends of colonization seems arbitrary in the wider picture of African history, consideration of how strongly this period of foreign occupation continues to impact the continent in the twenty-first century is necessary.[45] Indeed, it is African-oriented real-world possibilities that frequently galvanize African creatives to generate their speculative work and which, consequently, may positively influence African audiences as they move farther and farther away from the colonial

era. While downplaying the potential impact of his own production, Huchu recognizes the effect other African creatives' speculative expression may have on the continent: "Imagining stuff is pretty easy.... I admire people that then go out and do things which I would never do.... Hopefully their imaginings will spark sort of really practical things going on, on the ground."[46] Africanfuturism's greater emphasis on the possible over the fantastical aligns it with the real-world objectives and process of decolonization.

Adopting the African-originated and African-oriented terminology of *Africanfuturism* (or *African Futurism*) and utilizing it as a tool to analyze African speculative production is a decolonial approach. To date, Western discourse on Afrofuturist expression that juxtaposes African and African American examples tends to accentuate a shared interest in Black liberation. However, because Afrofuturism is rooted in the diasporic experience, neither the production nor the scholarly discourse concerns itself much, if at all, with decolonization, which is a key preoccupation for Africans on the continent. The West remains the dominant voice in depicting and discussing Africa, using Western terms, and addressing Western concerns. The Nest Collective asserts that greater African participation in articulating Africa's place in the world postcolonialism is needed for this to change: "As Africans embrace the discomfort of a re-emerging self-esteem, new generations of Africans are taking back the ability to name, prioritize and create African spaces beyond developmental lack and industrial inspiration. These generations must assume the power to describe and analyse their worlds relative to their own diverse points of view."[47] This turn will require a psychological shift not only in how Africans see and approach the continent but in how Westerners do as well. Using terminology that African creatives and intellectuals put forth to identify African speculative expression, and which inherently distinguishes it from the US-originated and US-centered Afrofuturism, will help move individuals across and beyond the continent closer to adopting a common decolonial mindset.

Africans' thoughts on the significance of futurist production related to the continent, including why they believe that speculative work *about* Africa should be *from* Africa, underscores Africanfuturism's relationship to the process of decolonization. In the first Pan-African anthology of science fiction by African authors, the volume's editor expressed why it was crucial for African creatives to generate

speculative interpretations in light of the continent's position in the world order: "SciFi is the only genre that enables African writers to envision a future from *our* perspective. . . . The value of this envisioning for any third-world country, or in our case continent, cannot be overstated nor negated. If you can't see and relay an understandable vision of the future, your future will be co-opted by someone else's vision, one that will not necessarily have your best interests at heart."[48] During the colonial era, Africans experienced an extended state of dispossession to varying degrees, of their lands, languages, social systems, religions, mythologies, cultural practices, and so on. Though US Afrofuturist production that includes African subjects and references may come from a place of personal affiliation or solidarity against oppressive forces, it nevertheless continues patterns of imagining and describing Africa through a Western lens that extend even further back than colonization. Certainly, some African creatives are not focused on this history or believe that Afrofuturism is, nevertheless, mutually beneficial. Those who understand Afrofuturistic representations of Africa as primarily self-serving for Westerners, however, have responded with more critical responses such as mocking and claims of appropriation.

Africanfuturism is an intervention, not limited to its disruption of realist conventions. Sarr argues that a cultural revolution on the continent is necessary to begin "changing the way Africa sees itself, by restoring its own self-image when it gazes into the mirror, respecting itself, reevaluating itself in a new light."[49] Africanfuturism encourages Africans to see themselves in new ways, literally and figuratively, as they think about what lies ahead for Africa. It also prompts others around the world to re-evaluate African possibilities of the present and future.

In their Africanfuturist expression, African creatives counteract the injurious effects of colonialism by foregrounding subjects, concerns, and strategies that are indigenous in nature and relevant to what possibly lies ahead for the continent and its peoples. For example, Westerners have a linear concept of time that correlates with progress. Africanfuturist expression subverts this thinking, allowing for forward and backward movement and simultaneous coexistence of multiple periods. When Baloji (chapter 5) remixes archival photographs of Congolese laborers into contemporary images of Lubumbashi, he elicits the indigenous belief that "the dead are not dead

at all" but share the present.[50] Kahiu (chapter 3) makes the three-woman council in her film symbolize the past, present, and future to correspond with her cultural beliefs about cyclical time and rebirth.[51] And when Waberi (chapter 3) inverts the current world order in his story and writes that in Paris, one has the sensation that "the present goes on forever," he is poking fun at the Western notion that Africa is timeless.[52] Still other examples of Africanfuturist production communicate African perspectives on technology, mythology, and strategies. Leti Arts (chapter 6) centers the Akan myth of Ananse in its digital comic book series, building on traditional stories of supernatural beings in a form that meets the desires of younger tech-savvy African audiences. Similarly, Kahiu (chapter 3) takes influence from Kikuyu mythology in her cinematic narrative. By featuring a Black female protagonist in a tech-heavy dystopian society who problem solves environmental degradation, she demonstrates how African women devise techniques in the best interests of their communities. Although these and other examples shift the default from the West to Africa, they do so in ways that are not always obvious for all audiences.

Creatives' use of the literary technique of metonymic gap, in contrast, is a more easily identifiable form of African centering for Western audiences. Though the authors write in English—the language of the former colonizer—they purposefully use terms, phrases, and concepts that will be unknown to the Western reader. They create a type of "gap" with the effect of rendering the individual only partially literate.[53] Huchu's (chapter 4) and Lauren Beukes's (chapter 6) incorporation of Shona words and indigenous South African healing practices prevent foreigners from being fully "in the know," thereby emphasizing that Western languages and cultures are not universal. Similar to decolonization, Africanfuturism involves a complex process of revealing the subtle and not so subtle ways that foreign influences have taken hold on the continent and how African creatives might offset them.

AFRICANFUTURISM AND AFROFUTURISM: PARALLEL ROOTS, INTERTWINED TRAJECTORIES

Rather than view arguments in favor of distinguishing Africanfuturist production from US Afrofuturist work as divisive or somehow detracting from larger discussions of Afrofuturism, we might consider

what is gained from doing so. For one, it helps us to understand how creatives engage with futurist projections that relate to the conditions of their respective presents. For African Americans, these concerns have been linked, at least in part, to their experiences as a minority population in the United States and the suggestion of a Whitewashed future. For Africans, the concerns have been connected, at least in part, to (re)centering indigenous beliefs, practices, and strategies that are applicable to African futures. Afrofuturism and Africanfuturism exist parallel to each other, rooted in their individual contexts.

However, as Africanfuturist and Afrofuturist production share several common themes and tropes and are frequently unified by speculative imaginings leading toward better futures, they are on intertwined trajectories. This relatedness is found in works that deal with exploring outer or foreign spaces and the afronaut, a neologism that, depending on the context, refers to an African or African-descendant astronaut. Another common aspect across African American and African speculative expression is the nonhuman alien, cyborg, or android. In this case, Nelson's (2000) discussion of the cyborg in Tuggar's photomontages from the 1990s of digitally manipulated rural African women's bodies might be relevant to an analysis of the cyborg-looking figure in a painting by Eddy Kamuanga Ilunga (chapter 4) that speaks to the exploitation of Congolese labor from the colonial era to the present.

At the same time, because creative expression is most often a reaction to one's environment, one's regional, cultural, or ethnic affiliations can be especially relevant to exploring how individuals incorporate historical references in their work in the spirit of the Akan principle of sankofa, which conveys the possibility of learning from the past. The examples I analyze in chapter 5 demonstrate that African creatives tend to utilize elements and influences from a specific local history or cultural past with which they have a direct relationship. However, the *Sannkofamaan* digital comic book—a collaboration between American comic book creator Akinseye Brown and Nigerian company Vortex Comics—also discussed in chapter 5, shows a mutual interest in featuring African concepts in products for international populations.

Lastly, while African American and African creatives may draw from a common African creative pool of subject matter, the latter's work is almost always informed by a high level of familiarity

and personal identification with the topic. African cultural producers imbue their expression with their intimate knowledge of African peoples and subjects through use of culturally or geographically specific symbolism, in addition to customs and practices including graphic languages, masquerades, ceremonies, and the like. An African "sensibility" may be motivated by concerns that are relevant at the local or national level and by the desire to shape behaviors that have real-world results. These interests might include regional issues such as water insecurity and other environmental concerns, promoting locally sourced materials to encourage economic sustainability, or introducing global consumers to African realities and entrepreneurship through African-created products. Finally, across mediums, African creatives often have fellow Africans in mind as their primary audience. These producers understand the importance of inclusivity in speculative representations of African futures and take religious, cultural, and mythological beliefs into account when considering how to best reach other Africans.

Imagining is a political act. Though Afrofuturism and Africanfuturism may be similar in their desire to elicit a better future, these futures are not necessarily one and the same. Likewise, the bodies of production are distinguishable even as their paths come into contact. Exploring Africanfuturism illuminates the rich contributions of African intellectuals and creatives as they reveal imaginings of an African-oriented yet to come from an African point of view.

CONCLUSION

Africa's place in Western speculative expression can be traced to the nineteenth century, when colonial projects on the continent set the stage for the emergence of science fiction writing. Afrofuturism, which originated in the United States, is part of the longer history of Western fantastical portrayals of African themes and subjects. While African American creatives have steadily incorporated African influences and references in their Afrofuturist production in opposition to White Western concerns and to create new connections with the continent, their work is informed by their Western perspective and position, making the West the default.

The inequitable relationship between the West and Africa continues to manifest itself in the dominant Western approach toward naming and categorizing African peoples and things, including applying

the Afrofuturist label to African production. As African intellectuals and creatives have become active in the international discourse on Afrofuturism, they have expressed a range of views on the subject. Some have called for greater African participation in defining and classifying when it comes to the African continent, which forms part of the wider process of decolonization and supports adoption of the term *Africanfuturism*. Though both Afrofuturism and Africanfuturism have points of overlap, Africanfuturism is nevertheless a forward-thinking autonomous means of describing and determining African presents and futures.

CHAPTER TWO

Exploring Space and Time

FROM A Western perspective, space and time exploration appear to squarely belong to the realms of science fiction novels and films, comic books, superheroes, and superpowers. After all, these are not things that mere humans are able to do in real life, at least not without the aid of sophisticated technology. This is one of the reasons why US Afrofuturist work dealing with space or time exploration that uses predominantly fantastical elements has attracted a lot of attention. For some African societies, including the Dogon, knowledge of outer space is part of their historical cultural beliefs. For others, such as the Kongo (also referred to as the BuKongo), time has different realms, and may be malleable or cyclical. Thus, Africanfuturist expression involving space and time exploration can be rooted in existing possibilities at the same time that it is applicable to what lies ahead. Similar to Afrofuturist work, the Africanfuturist production still involves the act of imagining, where anything and everything is conceivable. Nonetheless, the African endeavors may be more heavily rooted in real-life experiences and their objectives more focused on real-world desired outcomes.

Space travel is a common theme in US Afrofuturist expression and discourse, stemming from Afrofuturism's original link with speculative fiction and the African American point of view. Dery underscored how the Black experience in the United States was analogous to the genre of science fiction by suggesting that African Americans were, in a very real sense, "the descendants of alien abductees."[1] His characterization

compares Europeans, who tore Africans from their homes on the continent and took them to other unfamiliar places as part of the Atlantic Slave Trade, with aliens. In the new locations, Whites treated those and subsequent generations of Blacks as if they were an "other" or "foreign" species. Throughout the era of slavery in the West and the colonial period on the African continent, White societies exploited Blacks in various ways for their own benefit. The negative effects that these power imbalances had on Black populations have lasted well after abolition and independence, evidenced by systematic racism and other mechanisms that put Black populations at a disadvantage.

Because survival is not a given on a planet where individuals of color have routinely faced repression and hardship, the idea of exploring outer space is a strategy for finding an alternative place to live. It is no wonder then that space travel and exploration became a reoccurring theme in US Afrofuturist work. In Africanfuturist expression, creative producers have seized the opportunity to represent Africans participating in an endeavor that has historically been the privilege of White Western men. Further, their portrayals involve both real and imagined African engagement with space exploration.

In the United States, most people associate the beginning of space travel with the mid-twentieth-century Cold War era, which was marked by political tension with the USSR. Because of this friction, the competition in achievements in space exploration is most frequently framed as a battle between the United States and Russia. However, unbeknownst to many, there was another hopeful contender—the African nation of Zambia. In 1960, Edward Makuka Nkoloso (1919–89), a former schoolteacher and activist, founded the Zambia National Academy of Science, Space Research and Philosophy. He planned to send an envoy to the moon, followed by an envoy to Mars.[2] Nkoloso named his rocket DKalu-1, after the first president of independent Zambia, Kenneth David Kaunda, and intended to hold the launch on October 24, 1964, which was Zambia's Independence Day.

Without any significant financial backing, the operation was rudimentary and seemingly untenable from the start. Nkoloso set up a makeshift facility on an abandoned farm outside Lusaka where trainees underwent exercises such as being rolled down a hill in an empty oil drum to prepare them for takeoff and reentry. After nearly a decade, the program's end was hastened by the United States' successful launch of the Apollo mission in 1969. Nkoloso blamed the demise of

the Zambian program on a lack of funds, issues with morale, and one of his astronaut's departure from the program.

Recent coverage of Nkoloso's project has shed light on this little-known initiative. Few people are aware of it due, at least in part, to limited and dismissive press coverage from the time. Author Namwalli Serpell's essay "The Zambian 'Afronaut' Who Wanted to Join the Space Race," which appeared in the *New Yorker* in 2017, prompted contemporary interest in the project. Regardless of how seriously or satirically one views Nkoloso and the Zambia Academy, the program is evidence that African participation in space exploration is not solely limited to the realm of the fantastical. At least one nation had plans to take its place among the leaders of space travel in the twentieth century.

Africanfuturist production that deals with time exploration may also bring together real-world references and fantastical elements. As Kenyan philosopher John Mbiti discusses in his book *African Religions and Philosophy* (1969), Africans have their own views on time that do not necessarily align with Western understanding of it as exclusively linear.[3] African beliefs likewise may influence African creatives' approaches toward representing time exploration, including the premise that multiple time periods can occur at once and the possibility of forward- and backward-oriented movement. Given the ways that Western colonization of the African continent negatively affected African peoples, one might expect African creative producers to be concerned with speculating on the "what would have been" if this had never happened, and thus present an alternate present or mixture of temporal elements concerned with a rewriting of the past. Instead, the works featured in this chapter reflect a greater focus on the present and future, especially when adverse contemporary conditions might be avoided or corrected in the yet to come.

Sarr encourages Africans to shift their focus from trying to compete with Western nations to constructing a future that best serves their own interests. As opposed to long-standing predominantly pessimistic Western views of Africa, Sarr hopes to harness the recent more optimistic attitudes about the continent and its inhabitants.[4] He encourages Africa's population to turn inward to consider the power of indigenous African concepts. Such action might involve rethinking beliefs about time, as some Africans have adopted the Western view.

According to Sarr, Africans will not be able to move closer to a more utopic future by taking a passive approach or without facing

challenges. They cannot rely on hope to succeed but instead must exercise their agency as they undertake a trial-and-error process to discern what works best for them. There are no limitations on inventiveness and Sarr dares Africans to use their imaginations to forge a new way forward and reinvent the continent's future.

EXPLORING SPACE

Nuotama Frances Bodomo is a Ghanaian-born filmmaker, writer, and director whose short film *Afronauts* (2014) is a fictional portrayal of the Zambia Space Academy. After spending her formative years between Africa, Asia, and Europe, Bodomo moved to New York. She received her BA in English and film studies (2010) from Columbia University and her MFA in film direction (2016) from New York University's Tisch School of the Arts.

In the fourteen-minute film *Afronauts*, Bodomo weaves together the stories of the United States' and Zambia's efforts to be the first to reach the moon. The film amalgamates archival audio and visuals from the Apollo 11 launch on July 16, 1969, and the famous July 20 spacewalk on the moon, with fictional scenes of the Zambia Space Academy's training camp that were shot on the Hurricane Sandy–decimated beach of Sea Bright, New Jersey. Because most viewers are unfamiliar with Nkoloso's space program, within the first few moments the film states that the story is inspired by true events. Audience members will likely recognize the names of American astronauts Aldrin, Armstrong, and Collins when they are announced but are probably surprised to learn that the Zambian program is represented by seventeen-year-old Matha Mwamba. The academy's makeshift structures, improvised instruments, space suit, and rocket are rudimentary and appear woefully inadequate. Thus the audience is required to buy into the idea that this could be a successful mission despite its apparent unlikelihood.

Afronauts largely features the film's protagonist, Matha, played by African American model Diandra Forrest. The main scenes consist of Matha undergoing physical training exercises to prepare for travel to the moon, Nkoloso and his men celebrating before the rocket launch, and the rocket returning sans Matha. These events are interspersed with vignettes of Matha by herself or interacting with Nkoloso or Auntie Sunday, who is a program assistant.

In this unexpected story about space exploration, Bodomo centralizes the equally uncommon theme of Black female agency. In the

Zambian mission, the sole astronaut is a teenager on whom the hopes of the space academy, and perhaps even the whole nation, are pinned. The only other female character—Auntie Sunday—is a voice of reason in contrast to Nkoloso and his male assistants' almost blinding optimism. Because it is obvious this experiment will likely be fatal, Auntie Sunday presents Matha the opportunity to withdraw from the trip. However, when Matha affirms that she wants to proceed, the older woman acquiesces. For Bodomo, the interaction between the two women is significant: "[Auntie Sunday] has to step back... which is a painful thing to do, but that's the thing that you do when you respect somebody's agency.... She is the only person here that treats Matha like a person with agency, worthy of deciding what she wants for herself."[5] Bodomo emphasizes the inner strength required for a woman to step outside the more "traditional" roles of wife and mother with the physical demands of the program.

In her interpretation of this extraordinary young female astronaut in training, Bodomo presents a character who is largely unremarkable. Matha does not possess any superhuman powers, and several times appears fatigued, as most seventeen-year-olds would be after being put through the same exercises. She's not a fictional female superhero bent on saving others. She demonstrates strength, independence, and her self-worth through the decisions she makes about her own life. Bodomo based her character's age and gender on the real Matha. This history provides an interesting comparison with the "more advanced" United States, which sent an African American woman, Mae Carol Jemison, into space for the first time in 1992.

Bodomo's *Afronauts* is in keeping with Africanfuturism's focus on African narratives, space exploration, and elements of fantasy and technology. In this example, the storyline is specifically African and inspired by historical events. In contrast to most portrayals of space exploration that are replete with sophisticated technological tools, this film highlights makeshift instruments, at least some of which work. Moreover, Bodomo's film relocates science from the more common lab setting in Western speculative expression to an improvised outdoor location, which underscores Africans' powers of invention both historically and today. Undeterred by limited resources and materials, Nkoloso and his assistants show their ingenuity and determination to carry out their plan.

One of the aspects of *Afronauts* that relays its grounding in African concerns is its reference to colonial history. Nkoloso instructs Matha not to impose Christianity or the nation-state on the beings she encounters. It is a clear directive not to force one's cultural and political systems onto other peoples, as the Europeans did in Africa during the colonial era. The real Nkoloso indicated that although he would send a missionary with Matha to Mars, the missionary should not force the Martians to convert. It is uncertain if he was being sincere or facetious, taking a jab at the role that missionaries played in compelling Africans to follow Western religions.

In *Afronauts*, Bodomo prioritizes highlighting the optimism that Nkoloso's program represented over an accurate portrayal of its anticlimactic end. Because this history was unknown to most audiences, the director perhaps had greater leeway to deviate from the facts without confusing or frustrating viewers. Bodomo's story shows that desire, creativity, and optimism are not dependent upon feasibility. While Nkoloso might have wanted to put his newly independent home country on the world map by participating in the space race, Bodomo does not determine worth through the results of competition with other nations. The African imagination cannot be measured.

Gerald Machona is a multimedia artist who also uses the trope of the afronaut in his work that deals with space exploration. Born and raised in Kwekwe, Zimbabwe, Machona was interested in pursuing a degree in art after finishing high school, but his country had few university programs in that field. As a result, in 2006 he relocated to South Africa, where he received a BA in fine art (2009) from the University of Cape Town and an MFA in sculpture (2013) from Rhodes University.

Following the end of apartheid in the early 1990s and the opening of South Africa's borders, the country experienced an influx of immigrants. In neighboring Zimbabwe, the economy had been deteriorating to the point that hyperinflation of the Zimbabwean dollar reached its peak at the start of the twenty-first century. The financial crisis prompted much of the country's population to make daily border crossings to South Africa or permanently relocate there. Subsequently, migrants were blamed for a variety of issues in South Africa, including increased unemployment, crime, drugs, and HIV rates. In May 2008, South Africans in different parts of the country committed a series of xenophobic acts against individuals whom the perpetrators

assumed were "foreigners." The assaults caused injuries and deaths. Foreign nationals in South Africa, including Machona, risked being attacked if they stood out in terms of clothing, gesture, or language. Any exterior display of foreign nationality could be extremely dangerous. Moreover, the fear of being singled out was psychologically taxing.

Machona's *Ndiri Afronaut (I Am an Afronaut)* developed out of his artistic experimentation with the themes of displacement and nationality that he had begun in 2010 (fig. 2.1). The prefix *ndiri* means "I am" in the Shona language, which is spoken primarily in Zimbabwe. Machona's work is a freestanding, life-sized piece, which was also worn in a series of filmed performances, including *Vabvakure (People from Far Away)*. The creation appears to be both an actual space suit and a fashion statement. The helmet, roomy suit, gloves, footwear, and oxygen pack are standard equipment for a spacewalk. Machona even includes an opening for a tether that would connect an astronaut to the spacecraft. However, in the place of the usual largely monochromatic material, the artist has crafted a patterned suit made from decommissioned colored Zimbabwean dollars. The gloves are made of a gold-toned fabric, which is also visible beneath the currency. The material has a luxurious sheen that resembles velvet. Shiny black-and-gold high-top sneakers and goldleaf-covered plastic tubing complete the ensemble. Instead of the traditional astronaut's helmet, Machona's headpiece is a dark glass bell jar that completely conceals the wearer's identity, similar to tinted car windows.

In *Ndiri Afronaut (I Am an Afronaut)*, Machona uses currency as a visual element and a signifier. He creates patterning and a mark of affiliation with this material. The Zimbabwean currency as a visually recognizable symbol of nationality corresponds with the way the 2008 offenders used outward physical appearance to identify their "foreign" victims. The money has significance while it is also devoid of value due to hyperinflation. Perhaps Machona is suggesting that nationality is a meaningless concept. According to fellow Zimbabwean artist Vulindela P. E. Nyoni, Machona's chosen material can be understood as a "commentary on how set adrift [Machona] felt when the currency that was supposed to have assured him of security began to lose value and eventually became redundant."[6] Over time, the artist's safety net—the economic stability of his home country and family's privileged status—disappeared.

FIGURE 2.1. Gerald Machona, *Ndiri Afronaut* (I Am an Afronaut), 2012, decommissioned Zimbabwean dollar, foam padding, fabric, wood, Perspex, rubber, plastic tubing, nylon thread, gold leaf. *Courtesy of the artist and the Goodman Gallery.*

Machona's experimentation with alienation and space exploration is directly related to the artist's experiences in South Africa. He was also inspired by the Chewa ethnic group in Malawi, whose masquerade society and masked dances are known as *Nyau*. The Chewa migrated to Zimbabwe in both the pre- and postcolonial periods and utilized their masquerades as a form of ethnic resistance to everyday discrimination and formal policies aimed at "foreigners." Machona translated the essence of the masquerade into a tangible object with his sculpture. He says the "afrofuturistic element came" into play when he used the form of the space suit to address the climate of African xenophobic violence, "where one has to create some sort of mechanism or vehicle in order to survive a hostile foreign terrain."[7] While evoking the protective gear necessary for a journey into outer space, Machona's work deals with safely navigating unwelcoming spaces here on Earth.

Different from Bodomo's and Machona's works, the pieces by Kenyan artist Jacque Njeri represent Africans in outer space. Born and raised in Kiambu, she earned a BA in design and applied arts (2013) from the University of Nairobi. After finishing her degree, Njeri went to work as a graphic designer for an ad company, where she regularly used Photoshop. In 2017 she created the *MaaSci* series composed of fifteen digital collage images. The title is a portmanteau of the words *Maasai* and *Sci-Fi*. After initially publishing her work on a friend's blog, Njeri's images caught the attention of CNN and the BBC.

In her series, Njeri features the Maasai people of her native Kenya and neighboring Tanzania. The Maasai are a Nilotic, seminomadic people who are primarily cattle herders. The pastoralists often cross the border between the two countries and are settled near several of the game parks of the African Great Lakes region. The area is popular with international tourists who come for safaris and to experience the Maasai people's customs related to their pastoral lifestyle, music, dance, clothing, and jewelry. The group's distinct appearance and preservation of cultural practices makes them synonymous with the idea of "tradition" in Kenya.

This example demonstrates Njeri's juxtaposition of realistic and fantastical elements that gives the *MaaSci* series its aesthetic (fig. 2.2). In this image, a young woman looks directly at the viewer. She is dressed in white armor, reminiscent of the stormtroopers' outfits from the *Star Wars* films. The young woman wears a color beaded choker, necklaces, and earrings. Her face appears human; however,

Exploring Space and Time 49

FIGURE 2.2. Jacque Njeri, *MaaSci*, 2017, digital collage, dimensions variable. *Courtesy of the artist.*

breaks at the shoulders and elbows reveal an underlying network of wires and plastic joints similar to the robot C-3PO, also from the *Star Wars* movies. The viewer understands then that this is not fully a human being but rather a cyborg composed of a young woman with some mechanical parts. The hindquarters of another hybrid creature, perhaps a cross between a robot and a dog, are partially visible on the left. The setting looks inhospitable with its rocky terrain, outcroppings, and shadows. Stars light up the otherwise dark sky.

Those who are familiar with the Maasai might recognize some of the typical aspects of their culture and lifestyle in this and other images from the series. For example, the Maasai use dogs to help herd their cattle and protect their livestock from wild animals. Several of Njeri's images show people dressed in the *shuka*, the traditional predominantly red robe. Individuals of different ages and genders

typically wear beaded jewelry. As in many African societies, Maasai jewelry is not solely worn for beauty. Rather, it indicates the person's age and social status. Njeri transforms this nonverbal method of communicating information about oneself into a digital mode of transmission in her image. The figure's most pertinent details are projected to its right: ethnicity, age, and gender. Here Njeri plays with words, ideas, and cultural values. Rather than give the Maasai subject's age in years, the artist treats the information like a version of electronic software: 12.2. The figure's gender designation is still "loading," failing to conform to a definitive category. Njeri places these facts in a rectangle next to a circle of light that encompasses the subject's upper half, contrasting round and hard lines. A typical Maasai village is built in a circular formation. The group keeps its most valuable asset, which is its cattle herd, in the center for protection.

Njeri combines elements representative of the familiar and foreign, "traditional" and modern, to create visual and symbolic tension in her work. The artist is not Maasai, but ethnically Kikuyu. However, the Maasai's traditions and style of dress are visually captivating and effective as recognizable markers of Kenya. She combines that national reference with the grungy look of the fictional desert planet Tatooine from the *Star Wars* films, whose scenes were filmed in the North African country of Tunisia. In this way, Njeri creates her own African setting that draws from real and fictional places. The artist sources copyright-free images from the internet that will work in the rough draft she designs, and then uses Photoshop to polish the image and do all the placements. It can take her up to a day to produce each of her pieces.[8]

Njeri presents diverse and empowering representations of Africans engaged in space travel in her series. Alongside Maasai men in outer space, she includes Maasai women in her digital photomontages. In 2017, when Njeri produced *MaaSci*, discussions about women assuming more diverse roles were taking place around Kenya, as three women were elected to gubernatorial positions. Njeri says, "When I was creating the [*MaaSci*] series, it was during the election period in the country. My goal was to address the role of women in leadership and politics."[9] Her images suggest that there are no limits for African women, not even earthly boundaries. Njeri further shattered the glass ceiling of representation by portraying Maasai children in outer space. She has considered what effect her images might have

on Africa's youth: "I hope this [*MaaSci*] project inspires kids from African backgrounds showing that we can advance or progress intellectually and scientifically without having to feel like they have to lose their African-ness."[10] In countries where only Western styles, products, and depictions are used to represent all things contemporary, images in which African children see individuals who look like themselves can be especially impactful.

EXPLORING TIME

Keziah Jones is a Nigerian-born artist and musician whose work exemplifies the idea of time as fluid. Because there are no hard distinctions between periods, concurrent existence is possible. Born Olufemi Sanyaolu in Lagos, Jones spent most of his formative years in Europe, where he was educated and lived until recently. The artist created an African superhero named Captain Rugged, whose eponymous character was the subject and title of Jones's sixth studio album (2013). Jones has appeared as his musical alter ego Captain Rugged in some concerts and videos, in addition to having traced the character's endeavors in the *Captain Rugged* graphic novel (2014), set in Lagos.

Jones's musical style and subjects are strongly influenced by his international experiences. At the age of eight, his family sent him to study in London, where he was required to speak English exclusively rather than in combination with Yoruba. Far from his relatives and friends, he took comfort in music. Jones wrote songs and taught himself to play the piano and the guitar. His sound was a combination of blues, funk, and Yoruba rhythms. By his second album, *African Space Craft* (1995), he was addressing themes of racial conflict, colonialism, African pessimism, and escapism in his lyrics. He was particularly drawn to those topics as a Nigerian expatriate who largely came of age in Europe.

In Captain Rugged, Jones found a character and representation of Africa with which he could identify. He created Captain Rugged as a counterpoint to Marvel's Black Panther and other crusaders with whom he felt no connection. Rather than a superhero who rights wrongs, defeats the bad guys, and flies away, Jones realized that in Nigeria, a superhero would "have to deal with the police, armed robbers, politicians, and navigate a much more complicated political and moral terrain."[11] The musician's unique style and refusal to conform to social norms is mimicked by the fictional Captain Rugged. Jones sings on the track "Afronewave":

> Only the freaks can do this strange afrobeat
> We're rugged, we're deep
> We know it, put it on repeat[12]

In the graphic novel, Captain Rugged wears jeans, high-top sneakers, wristbands, a cape, and face paint, and occasionally holds a lit cigarette. When Jones performs in the guise of Captain Rugged, he wears jeans, high tops, sunglasses, and a flowing red cape with the word *Rugged* across the lower back. In the book, Rugged, a military officer who abandoned his post patrolling the oil-rich Niger Delta, becomes the target of a corrupt military leader when he learns of plans to evict the community of Makoko for control over its desirable land. Along the way, Captain Rugged must contend with crooked police, poverty, social inequity, and power-hungry politicians.

Jones was concerned with representing his home city in the graphic novel in a way that was accurate and relatable to a variety of audiences. People outside Nigeria would need to understand that Lagos was as visually arresting as any large Western city and yet also physically characterized by areas of financial disparity. He found collaborative partners in Kelechi Amadi-Obi, a Lagos-based painter and photographer, for the album graphics, and Native Maqari, a Paris-based multimedia artist who grew up in the United States, for the book graphics. Like Jones, Maqari had lived outside Nigeria for most of his life and had also read a lot of comic books in his youth.

Lagos's mixture of architectural styles made it an apt setting for a story without a defined time period. The sprawling city, which spans part of the mainland and several islands, comprises different neighborhoods, each with its own characteristics. As Jones and Maqari describe it, the incongruent combination of structures makes the city as captivating a backdrop as any fictional location:

> [It's] the juxtaposition of different architectures imposed by its inhabitants from different eras—from the Portuguese houses constructed by the returned slaves from Brazil, to the colonial buildings left by the British or the ultramodern and almost brutalist creations of the architects of the 70's where the capital city of our newly oil rich nation was the playground of several avant garde European architects. . . . After the oil boom years of the 70's, visually, Lagos

resembled what can only be described as an unfinished African utopia; grand projects lay abandoned and subsequently taken over by the homeless, grand motorways that span the lagoons surrounding the islands of Lagos overrun by hastily constructed shanty towns on stilts. The city became both futuristic and of the past at the same time.[13]

As readers and viewers accompany Captain Rugged on his escapades in the graphic novel and video for *Afronewave*, they go on a virtual tour of the city that takes them around Lagos Island and the mainland, and to the city's bustling marketplaces and Obalende bus station.

The way Jones approaches time in the *Captain Rugged* novel is in keeping with the idea of time as flexible and also makes a statement about the (ir)relevance of defined time periods in Nigeria. The artist grants his African protagonist the superhuman ability to stop time for the pragmatic task of safely crossing heavy traffic on foot. Otherwise, the notion of fluid time is supported by Lagos's built environment that simultaneously connects the city and its inhabitants to the past and the future. Apart from the physical setting, Jones's tale includes only vague clues to an approximate time period, such as the presence of computers or when a reporter asks if Rugged is "the new Saro Wiwa," referring to the Nigerian writer and environmental activist Ken Saro-Wiwa, whom the military dictatorship executed in 1995. Through his narrative, Jones emphasizes that the exploitation of Nigeria's national resources, be it oil or land, is never-ending, thereby suggesting that past, present, and future are indistinguishable.

The deeply ensconced corruption, as well as formal and informal abuses of power that Captain Rugged fights, reveal Jones's focus on typically Nigerian issues. The storyline involving greedy individuals who want to displace the people of Makoko—a community of houses built on stilts—to develop more profitable waterfront real estate echoes the 2012 government eviction and subsequent destruction of Makoko. Rugged also helps the young pickpocket Jetlag elude the corrupt policemen who plan to kill him and keep his spoils. The superhero ultimately recruits the child thief to join the Lagos Recovering Criminals Association. Likewise, Jones criticizes international systems that keep Nigerians and other Africans in marginalized positions, including immigration restrictions, in the lyrics to the track "Rugged":

> Only the freaks can do this strange afrobeat
> Dance right through immigration
> I'm never gonna queue for abuse
> In a superhero situation
> I got mad juice[14]

The issues that Jones raises in the book and in his songs are not exclusive to the inhabitants of a particular nation; however, they are challenges that Nigerians and other Africans often face both in their daily lives on the continent and in their attempts to settle elsewhere.

Masiyaleti Mbewe is a Zambian-born artist and writer who muses on the future and a fictional society in her multidisciplinary installation *The Afrofuturist Village* (2018). Mbewe grew up in Botswana and moved to Namibia in her late teens. She received her BA in media studies and English (2016) and her MA in English (2020) from the University of Namibia Windhoek. For most of her life, Mbewe experienced discrimination because of her immigrant status. As an individual who identifies as queer and femme, she often also felt repressed by cis-heteronormative gender categories.[15] When the Goethe-Institut Namibia put out a call for artists to participate in the Namibian component of the *Future African Visions in Time* traveling exhibition, Mbewe saw an opportunity to represent the kind of inclusionary existence she desired for herself and for others who, in various ways, don't fit into mainstream social norms.

In her installation, the artist combines various components and ideas. The work consists of a cluster of large color photographs and a six-minute film, *Venture into the Afrofuturist Village*, all of which took Mbewe three months to complete. She used social media to scout queer and differently abled people to be her villagers and ultimately selected individuals who identified as having vitiligo, albinism, vision and hearing differences, mental illness, were noncisgender or any combination thereof. Mbewe sought input from the visually impaired, as well as hard of hearing and deaf individuals, and included braille in her text and sign language in the video, alongside a mixture of Silozi, Setswana, Nyanja, and English, all of which are spoken in Namibia.[16] The artist stressed Black diversity, the need to avoid treating individuals with disabilities as an afterthought, love for all Black womxn, the role of Black innovation and traditional African rituals in healing and treatment of Black mental illness, and celebration of all gender identities in her image labels.

Tove the Guardian is one of the members of the fictional society that Mbewe included in the Namibian version of *The Afrofuturist Village* (fig. 2.3). In this image, the skyline and land meet approximately halfway with a fat black pipe separating the two. Tove wears a pink-feather headpiece and a flowing pink dress with elongated sleeves that extend beyond his hands. The image captures the garment and individual midmotion. He flares the fabric away from his body with his right hand, while the fabric from the elongated left sleeve curves back toward him. The water in the lower left of the image is similarly colored pink, which visually marries human and landscape. The subject has his head turned to the side and his black facial makeup has been applied in a pattern of lines that resemble jagged tears. The photograph appeared with the accompanying text label:

NON-MONOLITHIC FUTURES

> Black people living with albinism, vitiligo and other skin conditions that affect the production of pigment in Black people are not tokenized or fetishized in the afrofuture. Tove represents the shift of these perspectives that pigeonhole Blackness as a set of specific things that cannot exist beyond colonial imaginaries. Blackness is diverse.

FIGURE 2.3. Masiyaleti Mbewe, *Tove the Guardian*, 2018, C-print, dimensions variable. *Courtesy of the artist.*

In her representation of a fictional population, Mbewe highlights the landscape without tying her vision to any one location or country. With the exceptions of the photograph and footage of Diana Abankwah in the Post Street Mall in Windhoek, which would be recognizable to local audiences, Mwebe's images and video feature remote scenes of land, water, and sky. Some of the photographs capture the otherworldly appearance of Walvis Bay's pink lake that gets its color from the salt, or the moon landscape, which is an area marked by mountains that forms part of the Namib Desert near the coastal town of Swakopmund. Nevertheless, Mbewe was concerned with the terrestrial in general and "the immediate reality of what moving through spaces on earth could look like for Black people while still engaging or evoking a visual aesthetic that was futuristic."[17]

Mbewe's mixed-media installation deals with time exploration, centers African experiences and perspectives, and incorporates technology, all of which are characteristics of Africanfuturist expression. She emphasizes the yet-to-come aspect of her society by calling it an Afrofuturist village. She uses video to introduce the members. Her text labels and photographs feature African subjects, themes, and concerns without tying them to a specific location or nationality.

At the same time, Mbewe imbues her Africanfuturist representation with a strong rootedness in her own position and perspective on the world. In *Tove the Guardian*, she features a local model, actor, and then student at the University of Namibia, Tove Jeomba Kangotue, who had spoken publicly about living with albinism. She also eschews some of the imagery and aspects that many other Western and African creatives use to represent the future, such as robots and an abundance of technological elements. Her rural settings connect her subjects with traditional African social and religious practices linked to nature. From Mbewe's point of view, the idea that Africans are able to escape oppression only by leaving the planet and engaging in space exploration is depressing; instead, she "adopts a naturalistic approach to Afrofuturism in which societal advancement is projected through the presentation of serenity and power."[18]

CONNECTIONS ACROSS AND BEYOND THE CONTINENT

These various examples of creative production dealing with space and time exploration demonstrate several shared characteristics, including the theme of alienation. Encounters with foreign beings, including

aliens, are common in representations of space exploration. Apart from Njeri, the contemporary producers whose works are discussed in this chapter had the similar experience of being a foreigner at some point in their lives. Their struggle to "fit in" was challenging and sometimes even dangerous. Bodomo and Jones experienced an outsider status in their childhoods. Machona and Mbewe faced discrimination as foreign nationals in other African countries. These situations of Africans being "othered" correspond with Dery's characterization of the African diasporic experience as one predicated on alienation, which lent itself to outer space and space exploration in Afrofuturist expression, and yet are also dissimilar because they weren't exclusively based on racial difference.

These examples also show that African creatives are crafting diverse representations of space and time exploration. In Machona's and Jones's works, African men assume the roles of astronaut and superhero, respectively. Bodomo, Njeri, and Mbewe further expand the spectrum by featuring African women, children, and individuals who do not conform to normative social categories. Bodomo and Mbewe may have been inclined to feature individuals with albinism in their creative production because they know what it is like to be "othered" for being different. Moreover, some of the creative producers discussed in this chapter go so far as to insert their own bodies in their representations, modeling the inclusivity they want to see in the world. Machona has worn his suit in performances and likewise titled his work with the reflexive *ndiri* (I am), and Jones has appeared as his musical alter ego Captain Rugged in concert and in videos. Mbewe not only created *The Afrofuturist Village* but is also a member of the village, as she is the subject of the photograph *Masi and Anxiety*.

Some of these African creatives and their works form parts of broader networks of influence and awareness across and beyond the African continent. For example, in his use of decommissioned Zimbabwean dollars, Machona can be compared with Congolese artist Bodys Isek Kingelez and Ethiopian artist Elias Sime, who also elect to use "nontraditional" materials in their respective productions (figs. 2.1, 3.1, 4.2). Bodomo and Njeri have expressed their appreciation for Kenyan director Wanuri Kahiu's film *Pumzi*, discussed in chapter 3, which features an African female protagonist. Further, Njeri's use of the android dialogues with Congolese artists Eddy Kamuanga Ilunga's and Sammy Baloji's utilization of the cyborg to comment on the relationship between African bodies and robots (figs. 2.2, 4.3, 5.3).

Jones demonstrates several Africanfuturist connections with other creatives. Like South African artists Mary Sibande and Athi-Patra Ruga, Jones utilizes an alter ego to explore an alternate existence (figs. 3.2, 6.2). He showcases an African superhero as do American writer Akinseye Brown and Vortex Comics in their collaborative *Sannkofamaan* comic book, and Ghanaian/Kenyan Leti Arts with its *The True Ananse* comic (figs. 5.1, 6.1). Lastly, Jones names George Clinton and Jimi Hendrix, two African American musicians who have been associated with Afrofuturism, as among his musical influences.

Both Bodomo and Machona have been included in discussions of Afrofuturist expression that involves space exploration and the concept of the afronaut. Most scholars have compared their production to works by artists who are located in the West, including John Akomfrah, Daniel Kojo Schrade, Robert Pruitt, Christina DeMiddel, and Yinka Shonibare. While Bodomo characterizes her film as science fiction, Machona has connected his piece to Afrofuturism, acknowledging shared approaches between his and others' production. In particular, Machona has indicated that his practice is an "attempt to pick up where [Shonibare] left off," building upon the British-Nigerian artist's use of the African astronaut to comment on the historically entangled relationship between European colonizer and colonized African, by shifting the focus of conflict to xenophobia among Africans.[19] By way of his artistic experimentation with the afronaut, Machona has inserted himself into a wider international history of production and analysis centered on this figure and the theme of space exploration.

While Jones has only been tangentially linked to Afrofuturism primarily through his participation in the Johannesburg venue of the African Futures Festival (2015), Njeri's *MaaSci* series has frequently been characterized as within the realm of Afrofuturist expression for its space exploration theme. Though Njeri does not refer to herself as an Afrofuturist, she has asserted that she was an "Afrofuturism enthusiast even way before [she] started contributing to that genre."[20] In addition to creating *The Afrofuturist Village*, which connected her work to Afrofuturism through its title, Mbewe has analyzed Afrofuturism's terminology and coined her own terms. Further, Mbewe's views on Afrofuturism are informed, in part, by her familiarity with discourse from the United States, making her part of the international circle of individuals participating in discussions on the topic.

AFRICANFUTURIST REVELATIONS

We might consider what these examples suggest about space and time exploration in Africanfuturist production. Certainly, the works indicate the powerful role that imagination plays in representing these themes in ways that involve both fantastical and real-world elements. In Bodomo's *Afronauts*, for example, speculation was a critical aspect of a narrative that, although inspired by true events, was largely unfamiliar to international audiences. Njeri created imaginative photomontages of the Maasai in outer space while retaining culturally relevant aspects. Jones invented a superhero who navigated various identifiable areas of Lagos. Some of the examples discussed in this chapter also demonstrate that Africanfuturist expression might influence real-world outcomes through new narratives of Africans engaged in space travel. Similarly, Bodomo's and Njeri's works show African women taking on roles that have traditionally been dominated by White Western men.

These examples also indicate that African cultural producers create characters that resonate with themselves and other Africans. Jones's Captain Rugged takes on common Nigerian issues and Njeri's digital collages of the Maasai in space give Kenyan children a new set of positive images. Further, fashion choices may visually reverberate with African audiences. The clothing in Machona's and Njeri's representations is associated with specific African populations. Captain Rugged's street style is modeled after Jones's own eclectic look born from going back and forth between England and Nigeria. Mbewe's images demonstrate that fashion can be a way to express identity in one's community.

These Africanfuturist works dealing with space and time exploration prompt viewers to consider Africans' strengths as well as their shortcomings. In her fictional account of the Zambia Space Academy, Bodomo takes technology out of the more traditional lab setting to showcase African ingenuity. Mbewe emphasizes Africans' connections to nature. Machona uses his sculpture to encourage Africans to be more accepting of those from other countries. Mbewe's futuristic village provides a model society in which all people on the continent find acceptance.

Lastly, these examples shed light on how Africanfuturist expression figures into the wider process of decolonization. Some African creatives have already risen to the challenge that Sarr outlines in

Afrotopia about ceasing to privilege or prioritize Western notions of success and instead looking inward to indigenous concepts and traditions to fortify one's quality of life. In this way, African creatives are actively working against perceptions of inferiority promulgated by Westerners in colonial and postcolonial times. Bodomo directs her focus toward celebrating Zambian optimism and resourcefulness rather than measuring the African nation's worth by comparing its achievements to the United States. Machona turns to the indigenous African cultural practice of the masquerade to resist xenophobic oppression by others on the continent and remind viewers to find indigenous sources of fortitude during times of social unrest. Njeri demonstrates that Africans do not have to lose their cultural customs in order to acquire new knowledge and technologies.

CONCLUSION

The works featured in this chapter deal with space and time exploration, which are both key themes of Africanfuturism and Afrofuturism. Likely because of this, all the examples have been linked to Afrofuturism through publications or festivals. Certainly though, some of the individuals and works in this chapter figure more prominently in discussions of Afrofuturist production than the others. While the themes may be common, the African creatives included in this chapter have taken different approaches to representing these ventures.

Analysis suggests that these Africanfuturist representations of space and time exploration function as some sort of catharsis. The works are a way to process the experience of being "othered." They also celebrate African endeavors, even when they are not ultimately successful. Lastly, they encourage a new path forward for the continent that is characterized by acceptance and equality.

SUGGESTED ADDITIONAL RESOURCES

In addition to the materials cited in this chapter, here are suggested additional resources. Full details for each source can be found in the bibliography.

For further discussion of the afronaut, including in relation to the work of some of the African creative producers discussed in this chapter, see the following articles: Magalí Armillas-Tiseyra, "Afronauts: On Science Fiction and the Crisis of Possibility"; Elizabeth

Hamilton, "Afrofuturism and the Technologies of Survival"; Paul Wilson, "The Afronaut and Retrofuturism in Africa"; and W. Ian Bourland, "Afronauts: Race in Space." Katie Bradshaw's interview with Frances Bodomo in *Bomb Magazine* provides additional background information on the director and her film *Afronauts*, and Jacque Njeri shares details about her *MaaSci* series, *Star Wars* influences, and thoughts on Afrofuturism in an interview with Fanny Robles.

Keziah Jones addresses how his personal style influenced that of his superhero Captain Rugged in his video interview with *Globetrotter Magazine*. The video component, "Venture into the Afrofuturistic Village," of Masiyaleti Mbewe's mixed-media installation, *The Afrofuturist Village*, is available for viewing on YouTube. The film was conceptualized by Mbewe, shot and edited by filmmaker Mpingana Dax, with costume design by Synedgy by Simeon, and makeup by Jay Aeron. For further information about Mbewe's installation, see the interview "What Feminism Looks Like in an AfroFuturistic Village with Masiyaleti Mbewe" in *Monochrome Magazine* and Paul Wilson's exhibition review, "The Afrofuturist Village: Masiyaleti Mbewe."

DISCUSSION QUESTIONS

What is the significance of identity at the individual, cultural, and national levels in these Africanfuturist expressions of space and time exploration?

How have these African creatives fostered a sense of belonging in their Africanfuturist works dealing with space and time exploration when they, themselves, have struggled to feel accepted?

What regional, national, and international elements or influences have these African creatives chosen to incorporate in their representations of space and time exploration?

What roles do clothing, bodily adornments, and appearance play in communicating an outsider or insider status in these Africanfuturist works?

What do the examples analyzed in this chapter suggest about diversity in Africanfuturist portrayals of space and time exploration?

CHAPTER THREE
───────────

Creating Worlds

AFRICANFUTURISM'S SPECULATIVE nature supports the creation of other worlds. The new world is somehow different from the one in which we currently exist, yet is still recognizable. By maintaining some semblance of reality, the audience can focus on contemplating significant underlying questions related to the other world rather than getting swept up by the purely inventive. Such important questions might include, "In what ways does the environment shape us as humans, and in what ways have we as humans shaped the environment?"[1] Creatives often imagine another world as a positive or negative reaction to their own social, political, and physical environments. Therefore, consideration of what characteristics or qualities they have elected to keep or change in their other world, and why they might have been inclined to do so, can be enlightening.

Within the scope of the Africanfuturist themes discussed in this book, creating other worlds is most similar to exploring space (chapter 2). This isn't surprising given that encounters with other planets and signs of life thereon are common features of speculative representations of space exploration. We can distinguish the two by thinking about it this way: space exploration in Africanfuturist production is frequently weighted toward musing about elements tied to a foreign or otherworldly existence, whereas creating other worlds more often presents another already-formed environment. In the former, open-ended curiosity normally supersedes providing a concrete answer to, or representation of, what is found when one moves away from

Earth. In contrast, creating worlds doesn't necessarily involve portraying a different planet. That other world can be Earth—just not Earth as we know it.

World-building in US Afrofuturist expression is another tendency that ties back to Dery's comparison of the Black American experience with science fiction. He asserted that American Americans "inhabit a sci-fi nightmare in which unseen but no less impassable force fields of intolerance frustrate their movements."[2] Even after the end of enforcement of Jim Crow laws, Blacks were still subject to redlining and other types of discriminatory practices that complicated or prohibited their navigation and occupation of certain spaces. Afrofuturist imaginings of speculative environments in which African Americans did not face these explicit and implicit restrictions were one way to overcome such obstacles.

British-Ghanaian author and curator Ekow Eshun has analyzed the significance of creating worlds in speculative expression from the African continent. In his 2018 article "There Is a Desire among Black People to Make the World Over," he argues that the African production is as much about inner worlds as it is about outer space. This is because a person's worldview is directly shaped by their environment and how they perceive their place in it. The urban or rural nature of someone's reality may factor so strongly in their life that it becomes one of the ways they define themself alongside gender, race, ethnicity, and religion. As such, the meaning of our "world" more closely equates with our existence in the world rather than our planet as a whole. Therefore, creating worlds is just as, if not more, likely to involve representations of alternate spaces and environments on Earth than inventing other planets.

African creatives imagine from an Afrocentric perspective, and this frequently influences their approach to world-building in terms of space and the built environment. Ever since the colonial era, during which Westerners created cities in Africa for their own exclusive inhabitation, Africans' relationships to urban spaces often have been regulated or otherwise affected by foreigners. Eshun emphasizes that precisely because of these "boundaries of the real and the prosaic," African works reveal "a desire to make the world over, to create imagery more fantastic... buildings more audacious, than ever previously witnessed."[3] Africanfuturist producers may choose to conceal their weighty concerns in a fantastical-appearing aesthetic or

creation. Nevertheless, their objectives often run deeper than designing a make-believe Wakanda.

Sarr identifies the African urban space as a prime example of how to build a better future for the continent's inhabitants. Because Africa is becoming urbanized at such a fast pace, it's necessary to think about what is essential to constructing an African city beyond the practical matters of urban planning, energy and waste management, and the like. Sarr argues: "Our cities must resemble us and express the form of living together that we have chosen (which presupposes we have already deeply reflected on and resolved the question of who we are and who we want to be)."[4] Regardless of whether the new environment is urban or rural, a public space or the private space of one's imagination, Africanfuturism's world-building ultimately might have real-world effects.

Abdourahman A. Waberi is a Djiboutian author who presents another world in his novel *In the United States of Africa*. Waberi was born in Djibouti City in what was then the French Somali Coast. In 1985, he relocated to France to study English literature and ultimately received his PhD in French and Francophone studies (2012) from Paris Nanterre University. In France, Waberi worked as a journalist, literary critic, and professor of English at the University of Caen, while also establishing himself as a writer. *In the United States of Africa* was published in 2006 in French, and the English-language translation came out in 2009. Since 2011, he has resided in the United States, where he has continued his work as an academic and author.

In his novel, Waberi portrays an alternate world in which Africa is the economic, cultural, and political center, and Europe and the United States are on the periphery. The protagonist is Maya/Malaïka, a White female born in France, whose story takes her between Africa and the West. A Black doctor from East Africa, who was on a humanitarian mission, adopted Maya/Malaïka as a child and took her home with him. The well-to-do physician and his ailing wife, who is dying, raise Maya/Malaïka in Asmara, the federal capital of the United States of Africa. The narrative follows Maya/Malaïka's life from childhood to young adulthood, tracing her struggle to come to terms with her identity and being adopted. Following several tumultuous years at art school in Ghana, during which Maya/Malaïka establishes herself as a painter and sculptor, her adoptive mother finally succumbs to her illness. Continuing her personal journey of self-exploration,

Maya/Malaïka travels to France to find her birth mother. After having located her, she elects to return home to Asmara.

Waberi's main theme is the dystopia that is created when one geographic area is exceedingly economically and socially dominant. Addressing the notions of first world versus third world and the Global North versus the South, the author flip-flops the current relationship between the West, sometimes referred to as Euroamerica in the novel, and Africa. In his book, the African continent takes on the role of the hegemonic North and therefore the referential center in the center-periphery model. Accordingly, buildings, streets, and institutes are named for continental and diasporic African figures and locations. Africans have been at the forefront of everything from sixteenth-century colonial expansion in the West to winning the space race in the twentieth century. McDiop, Hadji-Das, Africola, and Nka are thinly veiled African versions of the international consumer brands McDonalds, Häagen-Dazs, Coca-Cola, and IKEA. Waberi uses referential proliferation in both humorous and poignant ways throughout his novel as a "technique of orientation and distortion," by inserting mostly unfamiliar African and diasporic examples in the place of Western ones to indirectly underscore the privileging of Western individuals, locations, and achievements across the globe.[5]

The author uses his book to shine light on human bias rooted in arbitrary factors, including nationality and race. In the novel, Caucasians desire to escape their poverty-ridden lives in Europe and America for a more desirable existence in the United States of Africa. The author opens the book with the character Yacouba, a male Swiss refugee and carpenter, who is just one of the masses of destitute migrants who have traveled to Africa in search of a better life. Such individuals are caught in a no-win situation between their home countries, which are full of illness, poverty, and violence, and their adopted African nations, where they are considered undesirable outsiders and somewhat insufferable. Even Maya/Malaïka's privileged upbringing in her African parents' household cannot protect her from the racism she experiences from early in life, including her classmates' taunts of "Milk-face," "Curd-face," and "Sour-milk skin."

At the same time, the author does not use his alternate world to present an anti-West statement and a wholly utopian Africa. Though Waberi's Africa has many positive features, its east coast is still dotted with historical slave ports marked with the sweat and blood of

foreigners, and the continent is currently making plans to deport immigrants, who are painted as a drain on Africa's resources. It has high technology, but newspapers and the media serve to fan the flames of fear of "the other." AIDS, which originated in Greece, is a global problem, and there is still no cure for cancer. Waberi's Africa also mimics Western capitalist models. Thus the reader is encouraged to question if it really matters which countries are on top if the oppressive systems would remain the same. With these structures intact, some populations would still benefit, and others would still be marginalized. Instead of pitting Africa against the West, the author emphasizes that all humans deserve respect and compassion.

Waberi's novel is decidedly satirical and his narrative more complex than the simple concept of a mirror world. He allows Western readers some familiar points of reference through his mention of well-known Black figures such as Aimé Césaire, Jean-Michel Basquiat, and Langston Hughes, but he does not explain how these and other African descendants would come to be part of the diaspora if the Atlantic Slave Trade had not occurred. Further, in the novel, the Holocaust still occurs in the West despite the inversion between the West and Africa. These and other aspects of the story reveal that "our" world and that of *In the United States of Africa* don't match up precisely. Waberi's choices prompt us to consider the logic of his mirror world and to ultimately conclude that some things just don't make sense, which is perhaps exactly his point.

Nevertheless, the author proposes creative expression as a way that people from different countries and races can find common ground and overcome social prejudice. In his story, the author intimates that art and literature can unify diverse peoples. Waberi pushes back against the long-standing and widespread Western misconception that great and sophisticated cultural expression is limited to Western civilizations by delving into the emotional depths of Maya/Malaïka's romantic life and creative pursuits as a tortured soul who is trying to find herself during her years at art school in Accra. Besides art, Waberi indicates that if novels from Africa, the West, and other areas were translated into different languages, literature could be a uniting force. "If narratives can bloom again, if languages, worlds, and stories can circulate again, if people can learn to identify with characters from beyond their borders, it will assuredly be a first step toward peace. A movement of identification, projection, and compassion—that's the

solution."[6] This proposal emphasizes how stories can be a tool for fostering empathy.

The other world that Waberi presents in his novel was shaped, in part, by his lived experiences with negotiating identity. The author spent the first twelve years of his life as a French colonial subject, though not a French citizen, before Djibuti gained independence in 1977. At the age of twenty, Waberi went to France to study, ultimately establishing himself as an academic and author there for the better part of the next two-plus decades. During that time, he also became a French citizen through marriage. In his book, Waberi explores the concept of double or split identity—European and African—in his protagonist Maya/Malaïka. This character navigates difficult experiences in both settings and faces challenges related to belonging. Similar to Waberi, Maya/Malaïka decides not to remain in her birth country. Nonetheless, she struggles with being an outsider in her adopted country, something the author has intimated he also faced in France.

The protagonist's travels between periphery and center also relate to the author's experiences. Waberi was raised in Africa, which qualifies as the periphery in the center-periphery model from a Western perspective. Moreover, most American and European readers have likely never even heard of his home country, Djibouti, a small nation on the Horn of Africa, on the continent's east coast. Nevertheless, Waberi wrote *In the United States of Africa* from the center, in France, where he had been based for many years. He references his own travels between the geographical ends of the spectrum by dividing Maya/Malaïka's story, and his book, in four sections: "Voyage to Asmara, the Federal Capital," "A Voyage to the Heart of the Studio," "A Voyage to Paris, France," and "Return to Asmara."

The hypothetical premise upon which *In the United States of Africa* is based places Waberi's book squarely within Africanfuturist expression. The story revolves around the idea of an alternate world in which the current relationship between the hegemonic West and Africa is largely reversed. Waberi asserts that his narrative is intended to be humorous, but that the "more serious side of the story is what we call nowadays Afrofuturism or African futurism . . . a way of playing with dystopic fiction."[7] In his book, the author suggests that even if Africa were the dominant area, things would not be better for all global citizens. Social inequality and prejudice would still exist.

Waberi's foregrounding of the African experience and perspective from an Afrocentric point of view connects *In the United States of Africa* with Africanfuturism. Through his various references the author underscores the richness and diversity of the peoples and nations of the African continent and, to a lesser extent, of the African diaspora. He also indicates that the current Global North and South structure did not come to be spontaneously, but rather is a product of historical events, namely colonial expansion. For Waberi and individuals like him, who were once colonial subjects, African colonialism is not something distant that is learned about through a book; it is part of their personal story.

Importantly, the author uses his own experiences as a basis to offer suggestions as to how to foster global unity in his novel. Reading *In the United States of Africa* would require his students at the University of Caen to think about what life would be like if everything were upside down from what they knew. Young Westerners often conceptualize the current world order as a given. Waberi's book reminds his readers of how easily things could have been different.

In the United States of Africa is a combination of fantasy and reality. In the book, Waberi asserts that individuals from around the globe have made important literary contributions, including African authors. He also contends that art and literature can serve as unifying instruments and means to foster compassion. This may be what Waberi has found to be true in his own life, having established himself as a successful author of Francophone literature. Most importantly, however, is recognizing that social biases exist. All humans must be treated with respect if there is to be any progress in this world.

Kenyan screenplay writer and director Wanuri Kahiu also set her work, the short film *Pumzi*, in an alternative world. Born and raised in Nairobi, Kahiu received her undergraduate degree in management science (2001) from the University of Warwick in Coventry, England. She then relocated to the United States and earned her MFA in film direction (2005) from the University of California at Los Angeles.

Pumzi takes place on a damaged planet where life outside the Maitu community no longer exists and water is scarce. The group is forced to live exclusively inside and is wholly dependent on self-generated power from kinetic movement that produces zero pollution. Individuals are allotted a certain amount of water, and they transform their

sweat and urine into potable liquids. The film's protagonist is Asha, the curator of the Virtual Natural History Museum.

Conflict occurs when Asha receives a soil sample and disregards her superior's instructions to report the package to security and then move on with her work. The sample, which has an abnormally high moisture content, induces Asha into a hallucinogenic state related to her earlier dream vision of a large tree. Asha mixes the soil with water and plants the museum's remaining seed from the mother tree, which subsequently begins to sprout. The three-woman Maitu Council denies Asha's request to travel to the original site of the soil sample, even though the specimen seems to indicate proof of life outside the community. Guards forcibly remove Asha from the museum, unaware that she has managed to keep the seed and map with the soil coordinates on her body. Ultimately, a bathroom attendant comes to her aid, passing her a compass and helping her to escape.

Once outside, Asha immediately finds herself surrounded by mounds of garbage. The trash has presumably been generated by the Maitu and goes against the mantra of zero waste. She makes her way through the harsh, arid environment to the origin of the soil sample, where she sees the large, flourishing tree of her earlier visions. However, upon close inspection, it is one of several dead trees. Nevertheless, Asha takes the sapling she is carrying and plants it in the sand. She uses her body, the last of her bottled water, and her sweat to nurture the planting. The film ends with an elapsed time shot in which Asha's body is replaced with the tree that continues to grow. The camera pans back to reveal a lush forest and we hear the sound of thunder.

Kahiu bases her portrayal of an alternate world on a combination of realistic and fictional elements. In the first few moments of *Pumzi*, the viewer learns that the setting is the East African Territory thirty-five years after World War III—the Water War. This information suggests that the story takes place on an alternate Earth of the hypothetical future. Although water scarcity has not resulted in widespread conflict on the international scale to date, regional clashes indicate that it is not outside the realm of possibility. Kahiu reveals the film was motivated by her frustration with having to pay for bottled water, and thinking about a future in which air, sunlight, and water are commodified and sold.[8] Being forced to purchase bottled water is a reality in many places around the globe where tap and well

water are not safe for drinking. Therefore, a scenario in which water is so scarce that it becomes a central issue is not implausible.

Pumzi is a dystopian speculative narrative that features another world and incorporates technological elements in keeping with the common themes and characteristics of Africanfuturist production. Technology, in various forms, is prominent in the film. Humans use technology to generate power via the treadmill and rowing machine, for example. The technological environment is a counterpoint to the natural world that existed prior to the Water War and with which Asha desires to reconnect. Technology is also part of what makes Kahiu's alternate world undesirable. Under the film's "techno-dictatorship," individuals are seemingly coerced to produce power for the greater Maitu community. People can only communicate with others via machines and other nonverbal means. Higher-ups who regulate the technology also exercise control over Asha's freedom to express herself.

Though Kahiu's alternate environment is speculative, it reflects direct parallels to the director's homeland. Kenya is plagued by environmental issues, including water scarcity, which is closely related to deforestation. Kenyan activist Wangari Maathai was an internationally recognized leader in the fight against environmental degradation. She was best known for her work with the Green Belt movement, which she founded in Kenya in 1977, and whose efforts spread to other African countries. Kahiu was intimately familiar with this Nobel Peace Prize–winner's work, as she created the documentary *For Our Land* (2009) on Maathai for a South African television channel immediately before *Pumzi*. The filmmaker not only addresses deforestation and water scarcity in *Pumzi* but also alludes to Maathai's reforestation projects through Asha's planting of the mother tree. There is an intimate connection between Kahiu and her subject matter.

Kahiu also incorporates Kenyan cultural influences with which she is directly familiar. In the Swahili and Kikuyu languages of the director's homeland, *pumzi* means "breath," *asha* means "life," and *maitu* is "mother."[9] *Pumzi* builds upon the Kikuyu's oral storytelling traditions, as well as their origin myth, featuring a tree. The director retains the primacy of the tree while she reduces intrapersonal communication in the film to technological means. This may be Kahiu's way of making a statement about the need for Kenyans to have a voice in shaping their futures, including regarding their physical environments.

In spite of *Pumzi*'s dystopian character, the film shines a light on Black female activism in Africanfuturist expression. Because of its emphasis on a woman's relationship to the earth, including her ability, and perhaps even responsibility, to nurture nature, *Pumzi* can be understood as an expression of ecofeminism, which seeks to expose the connection between exploitation of the environment with gender, race, and class inequity. Kahiu, herself, has recognized the fundamental role that African women have played and will play in ensuring their communities' and families' well-being in the past, present, and future.[10] In the film, Asha's use of her bodily fluid to sustain the seedling is analogous to breastfeeding an infant. When the protagonist tells Binti about her successful implantation of the seed in the soil, the supervisor instructs her to "get rid of it," reminiscent of language related to pregnancy and abortive acts. Lastly, Asha's transubstantiation of her body into a tree at the end of the film demonstrates the African woman's power to give life.

Kahiu's film exhibits diverse gender representation by featuring women in a variety of roles. Whereas the female members of the Maitu Council and Binti are impeding forces, the White female bathroom attendant enables Asha to escape and pursue proof of life outside. Her assistance was likely rendered in return for Asha's previous act of sharing her personal water with the worker. *Pumzi* suggests that women of different races and classes can support each other to achieve positive results. Moreover, this collective female agency counterbalances the makeup of most speculative fiction works in which White male characters are the leads and females are relegated to secondary roles. Asha's ability to work with others to overcome challenges is but one of the characteristics that makes Kahiu's protagonist a positive representation of an African woman.

Pumzi takes its place among other speculative representations of Africa by African cultural producers that are not always utopian. Regardless, Kahiu brings her vision of an alternate African existence to life through the medium of film. For this director, growing the number of empowering representations of Africans is what is most important. Kahiu says, "I think there are more instances of joy than remorse in Africa. If we don't see more images of ourselves as hopeful, joyful people, we won't work towards it. I truly believe seeing is believing."[11] She imparts this sense of optimism in *Pumzi* by leaving her audience with the impression that nature ultimately thrives again.

Bodys Isek Kingelez was an artist from the Democratic Republic of the Congo who explored the idea of other worlds by creating what he called "extreme maquettes" or "extreme models" of fantastic buildings and cities. Born in 1948 in what was then the Belgian Congo, Kingelez grew up in a rural village. After earning his high school diploma, he moved to the capital Kinshasa in 1970. He studied economics and industrial design, among other subjects, at the (former) University of Lovanium, while he also worked as a secondary school teacher. From 1978 to 1984, he was employed by the conservation and restoration division of the (former) Institute of the National Museums of Zaire. Following that, he dedicated himself to the creation of his work until his death in 2015.

The artist's approach to a fantastical built environment was partially shaped by national political developments that had a direct impact on Kinshasa. In 1965, five years after the country gained its independence from Belgium, General Mobutu Sese Seko seized power. As part of his campaign of Authenticité (authenticity), the leader endeavored to rid the nation of European influences, including foreign-style clothing, names, and political systems. He also initiated projects for several impressive architectural structures to be built in Kinshasa that would demonstrate his power and status. Over the course of the 1970s and 1980s, the capital was transformed by an influx of both individuals from rural areas of the country and architectural works that solidified a socioeconomic divide of the population. By the 1990s, Mobutu's rule had become a kleptocracy, and the country was in a financial decline that continued until the leader was forced into exile in 1997 and died months later.

Kingelez's work is a reaction to the architectural structures and urban environment associated with the concept of the "new" African city after independence. Upon arriving in Kinshasa from his agricultural community, he witnessed the somewhat chaotic transformation of the capital's built environment. While Mobutu was proceeding with his city plans, Kingelez was turning his own ideas of innovative urban structures into concrete forms. By the late 1970s, the artist had begun to create models of buildings from found materials and everyday items. By 1989, his work had been tapped by gallerist and curator André Magnin for the large-scale international exhibition *Magiciens de la terre* (Magicians of the earth) in Paris. Kingelez's attendance at this exhibition marked his first time venturing outside his home

country. This and subsequent travels outside Kinshasa provided access to a wider range of materials for his works, including some purchased items. In 1992, he moved beyond single buildings to create a model of an entire city.

Kingelez's 1996 *Ville Fantôme*, which translates to "Ghost city," exemplifies the artist's imagining of another world in the form of a fictional urban environment (fig. 3.1). His three-dimensional model consists of two distinct areas. The main section is the city, which he labeled *Ville Fantôme* and below it the words *Parc des fleurs; Ciel sur terre*, or "Park of flowers; Heaven on earth." His city contains groups of architectural structures that are surrounded and interspersed by decorated roads, cobblestone avenues, bridges, elevated train tracks, and flower beds. As was typical of his work, he labeled some buildings with international references, including Swiss University, Vietnam Train Station, Seoul, Canada, and, in the left foreground, USA. He also included everyday urban structures and features such as a post office, hospital, artificial lake, and parking lot. The second area is connected to the main city by the *Pont de la mort*, or "Bridge of death." This part contains an airport, complete with a landing strip.

FIGURE 3.1. Bodys Isek Kingelez, *Ville Fantôme*, 1996, paper, cardboard, plastic, and other found materials, 120 × 570 × 240 cm. © B.I. Kingelez. *Courtesy of the Jean Pigozzi Collection of African Art. Photo credit Maurice Aeschimann.*

In total, what was ultimately Kingelez's most ambitious creation includes nearly fifty structures and is approximately eighteen feet long, eight feet wide, and almost four feet tall.

Although fantastical, *Ville Fantôme* is infused with a good deal of realistic, if not practical, ideas and features. Its international character reflects the Western art deco style architecture that the artist saw in Kinshasa, as well as the idea of the city as a confluence of international influences, which Kingelez also experienced in the capital. *Ville Fantôme*'s size, level of detail, and inclusion of public infrastructure and services, suggests its feasibility as a scaled-down model for an actual planned city. Close inspection of the structures reveals the disparate elements Kingelez used in their construction. The artist incorporated words from product packaging such as *batteries* and *Lipton* in the upper right, in his design, simulating the presence of signage and other markings in the built environment. In Kingelez's hands, paper, plastic, pushpins, bottle caps, and a plethora of other items are accumulated and transformed, giving an overall appearance of solidity, opulence, and functionality. Indeed, as several scholars have noted, these types of items that seem ordinary and inconsequential were difficult to come by, and the artist selected and handled all his materials with great care.[12]

This representation of a fantastical city fits within the Africanfuturist activity of creating worlds. *Ville Fantôme* is both a utopian and dystopian alternate urban environment. The imagined city is free of police, prisons, and conflict, in stark contrast to the turmoil and violence that characterized Mobutu's reign. Additionally, Kingelez's prolific inclusion of the star motif in this and other works "seems to be a wicked play with or surreptitious disavowal of the national imaginaries promoted by a regime to which visual and cultural symbolism meant everything," since the star was a common feature of "colonial and postcolonial Congolese flags, before and after Mobutu."[13] The artist put his own mark on his works by including his name or initials on structures. In this example, his name appears at least once on a building on the right side. Kingelez described *Ville Fantôme* as a "peaceful city where everybody is free. It's a city that breathes nothing but joy, the beauty of life. It's a melting pot of all the races in the world. Here you live in a paradise, just like heaven."[14] It is a fictional utopia, however, with scant evidence of inhabitants. As its title suggests, the city seems a place for ghosts

rather than people. The artist leaves us to wonder why this place was either once populated and now abandoned, or only ever designed for phantoms to inhabit. Perhaps the artist realized that even in an alternate world, complete social harmony was neither possible nor wholly desirable.

Kingelez's city model encourages a rethinking of what creating worlds means in Africanfuturist and Afrofuturist production. Because we live in the digital age, in addition to both Afrofuturism's and Africanfuturism's association with technology, building other worlds is often understood to mean creating virtual worlds. The fantastical character of Kingelez's buildings and cities lend themselves to that computer-generated form of expression. In fact, when the Museum of Modern Art in New York City held the exhibition *Bodys Isek Kingelez: City Dreams* (2018–19), visitors were able to see *Ville Fantôme* in person and take a virtual reality tour of the work. Nevertheless, Kingelez manually brought his abstract visions to life in concrete forms. Though the artist used his imagination as a fundamental part of the process, he constructed fictional cities with his own hands, thereby physically, rather than solely conceptually, creating other worlds.

Ville Fantôme is telling of how Kingelez envisioned African cities would look and function in the future from his Afrocentric perspective. After the artist left his village, Kinshasa was the first and only city he knew for approximately a decade. It was not until after he began to travel internationally that he had other points of comparison. He made a reimagined, alternate version of his agricultural birth village, Kimbembele-Ihunga, as his first city model, which he filled with restaurants, a train station, soccer stadium, and high-rise buildings. When Kingelez arrived in Kinshasa in his early twenties, he saw his first skyscraper, albeit only ever partially completed. He understood this architectural feature to be such an inherent part of the urban built environment that he later declared, a "city without high-rise buildings is a dead city, a nonexistent city."[15] In his mind, Africa's future was not to be found in the rural village with its mud and thatch structures like those found in his agricultural community, but instead in urban spaces.

Kingelez's Afrocentric perspective is also revealed through his views on African art, including his own. He complained that "most often art critics and western or even African curators neither see nor understand Africa from Africa's perspective. . . . I draw my ideas from

Africa."[16] He also argued that art from the continent was superior to Western art: "Art is the mother of the sciences and has a universal value. Art is the product of great reflection, movement, and imagination. Art is a high form of knowledge, a vehicle for individual renewal that contributes to a better collective future. . . . What's left of art in the West is nothing more than trophies. In Africa, the real origins of African art and contemporary art remain forces yet to be explored."[17] Though Kingelez was well known for his lack of modesty, his claim wasn't completely baseless. By the time that he made these comments in 2000, he had become an internationally recognized artist who had traveled to the West. His statements about the power of art and what he saw as African art's unrecognized potential were based on his own experiences and observations.

This creative producer was active throughout decades of frenzied transformation, national unrest, and political turmoil in his home country. The urban environment in which he lived was designed to foster division; he had the opposite objective in mind for his creations. The artist created other worlds through his models to encourage international harmony. Regardless of whether his structures and cities were ever intended to be built or not, a purely fantastical reading of Kingelez's work belies the creator's underlying concern with the real world around him.

Mary Sibande is a South African multimedia artist who explores alternate identities and existences through an alter ego. Sibande was born in Barberton in Mpumalanga province. She earned her diploma in fine arts (2004) at the Witswatersrand Technikon in Johannesburg and went on to earn an honors degree in fine arts (2007) from the University of Johannesburg. Sibande began to make works featuring her alter ego Sophie in 2008. Sophie appears in the form of life-size fiberglass sculptures modeled after the artist's likeness, and photographs of the artist in character. In the representations, Sophie, a domestic servant, acts out a variety of roles that range from an orchestra conductor to an equestrian queen.

Sibande's family history inspired her to experiment with an alternative existence as a maid. Her great-grandmother, grandmother, and mother all worked as domestics. This was one of the very few options Black women had for employment in South Africa. The name Sophie is also related to their experiences. Whites gave Black South Africans Christian names as a part of their wider program of social

control. When Sibande's great-grandmother, Fanedi, was hired, "she was given the name of Elsie, which was formally documented into her identity book. There [was] a general group of traditional English middle names that were picked for domestic workers; in light of this practice Sophie was a random choice."[18]

They Don't Make Them Like They Used To is a visual record of Sibande acting out an alternate existence as Sophie (fig. 3.2). In this digital image, we see a sculpture of a Black woman dressed in a voluminous blue uniform that pools on the ground around her. The clothing includes white lace accents on the collar, cuffs, apron, and hem. The apron is knotted in an oversized bow that sticks out from behind the woman's elbow. Her hair is covered with a white scarf. The woman's

FIGURE 3.2. Mary Sibande, *They Don't Make Them Like They Used To*, 2008, archival digital print, 104.5 × 69.5 cm. *Courtesy of the artist and SMAC Gallery.*

head is tilted downward, and her eyes are closed. She is knitting a sweater that is suspended upside down in front of her lower half. There is a large yellow-and-red Superman emblem on it. A thread runs from the knitting needle to a spool on the floor.

Consideration of the image's details makes apparent its multiple layers of meaning. The female figure is the sole focus of our attention. The uniform is largely typical of female domestic servants in South Africa, though both the size of the skirt and the lace accents appear at odds with the physical demands and messiness of housework. Moreover, these characteristics are reminiscent of the type of dress upper-class White women wore during the Victorian era. Sibande has employed a limited palette, matching the white knitting needles and blue sweater, save for the emblem, to the woman's clothing. During apartheid, maids traditionally wore blue-and-white uniforms. Nevertheless, the various temporal references to the Victorian age, Superman, and the era of apartheid challenge the viewer to discern a specific period; this lack of clarity also has the effect of suggesting that the visual of a Black woman in a maid's uniform is a timeless image across the decades.

Sibande's use of clothing or costume is deliberate and yet also open to interpretation. The artist strategically selects the color and style of dress to associate her female subject with servitude. At the same time, she positions the Superman emblem to face the woman, as if in her reflection. It's unclear what the viewer is meant to deduce from the juxtaposition of the two uniforms—the maid's and the superhero's. The work's title is equally indeterminate. Does *them* refer to the servant, the superhero, or both? If nothing else, the image encourages its audience to consider how clothing can be linked to one's role in society or social position. In this case, Sibande points to different ends of the spectrum through a superhero, who performs superhuman, attention-grabbing feats, and a maid, whose mundane tasks garner little if any recognition, much less admiration.

The foregrounding of the African narrative and incorporation of the fantastic are common characteristics of Africanfuturist expression and, in this particular work, help to introduce Black female representation into the national artistic narrative. Because of the history of apartheid, Black women have not featured prominently in South African art. Black artists were kept out of formal art circles; and when White artists did feature Black subjects, they tended to be derogatory

portrayals. Sibande's photographs and sculptures widen the scope of how Black South African female subjects and creatives figure into national art history, including speculative representations. The artist marries make-believe with her family history in her production to make a very personal work. She says: "The character of Sophie is my alter ego, and she plays out the fantasies of the maternal women in my family. I tasked myself with creating this mythical figure that I imagined from stories that my forebearers used to share with me.... Sophie comes as a culmination of their collective escapism."[19] Therefore, her production is both representative of her female relatives' fantasies and of the artist's imaginative vision.

This work gives us another way to think about creating other worlds in Africanfuturist expression. In the photographs and sculptures, Sophie always has her eyes closed. Her imagined alternate existences are exclusively hers. We, the viewer, are not privy to those hypothetical private visions. We only see what the artist shares with us. Sibande says this deviation from the racial and gender hierarchies imposed on the Black female body in South Africa is a "tapping into Afrofuturism and to a land that is not colonized."[20] Sophie turns inward. She shuts out the reality around her and gives herself over to the imagination of her mind where she can be anything she chooses. Aspirations abound.

Sibande's alternate existence blurs the line between fact and fiction. The artist creates an alter ego but roots the personality in her family history. One can address the Black female domestic as a "type," a category of anonymous women in South Africa past and present. However, Sibande draws from her own ancestry to emphasize that each of these women was an individual, perhaps with her own family, and with her own indigenous Bantu name. Simultaneously, the artist challenges the conventional appearance and concept of a superhero. Sibande's father was conscripted into the South African army when she was a child, and her mother left to find work in Johannesburg when the artist was ten years old. Sibande was mainly raised by her grandmother and mother. Despite the significant social challenges these women faced, they persevered. Speaking of the previous three generations of women in her family, Sibande says, "I regard these women as superheroes."[21] Unlike her mother, her grandmother, and her great-grandmother before her, though, she has had quite a different experience. Sibande is an internationally acclaimed artist in a postapartheid South Africa. She experiments with an alternate

existence and reimagines her family history as a way to shine light on the arbitrary link between race and social status in her home country.

CONNECTIONS ACROSS AND BEYOND THE CONTINENT

The creatives behind these Africanfuturist interpretations of alternate spaces and existences have made their African-oriented representations dystopian to some extent. In Waberi's novel, deep social, racial, and economic divisions still exist in the world. Additionally, *In the United States of Africa* demonstrates that Black Africans are just as likely to make assumptions based on race and geographical origin as White Westerners. In *Pumzi*, council leaders rule the community and use misleading directives to regulate social behavior. Individuals do not have the right to exercise agency and challenge the status quo. Kingelez's fictional city is highly developed, though apparently not for human habitation. Sibande's Sophie can dream but can't escape the burden of her disproportionate maid's uniform.

Both Waberi and Kingelez hoped that sharing their representations of other worlds with different audiences could foster connections between disparate groups of people. This was not solely an abstract idea, but something that each of them witnessed firsthand. Waberi advocated for worldwide respect and compassion between countries and global citizens through his work. Kingelez frequently included international references in his models and declared, "Relations between countries and cultures must be handled with respect and consideration. We must listen to each other."[22] Whether it was in the pages of Waberi's narrative of the fictional United States of Africa or viewing Kingelez's fantastical sculptures, each artist hoped that readers and viewers might recognize something of themselves.

Looking at these examples alongside other Africanfuturist works reveals additional shared techniques and objectives across countries and mediums. Kahiu and photographer Fabrice Monteiro take a speculative approach to shining a light on environmental concerns that plague their respective nations (fig. 6.3). Sibande, painter Eddy Kamuanga Ilunga, and multimedia artist Sammy Baloji demonstrate a common concern with engaging the history of labor in their production (figs. 3.2, 4.3, 5.3). Though they focus on their respective homelands, they all underline the theme of Black labor for the benefit of White society. Kingelez and Burkinabe architect Francis Kéré incorporate domestic and Western influences in their architectural projects, sourcing locally

available materials and highlighting African constructions in the real and imagined built environments (figs. 3.1, 5.2).

Sibande and fellow South African artist Athi-Patra Ruga employ some of the same devices and techniques in their production (figs. 3.2, 6.2). For example, they use alter egos or avatars in their work. Though this technique is not unique to these individuals, both use it as a fictional entry point to explore the history of racial and social division in their home country. Also, both artists use color to imbue their production with an additional layer of meaning—Sibande to reference South African domestics' uniforms and Ruga to allude to South Africa by its postapartheid moniker the "Rainbow Nation." Perhaps most significantly, however, these artists utilize space in a way that defies its role as a mechanism of control during the era of apartheid, when White South Africans regulated where Blacks could live and controlled their access to different areas. In response, these artists take up space in a demonstration of agency—Sibande through the voluminous skirt and Ruga through the bulbous balloon outfit. Further, Sibande reclaims the space of Sophie's imagination and Ruga places his avatar in a battle for control over the land.

A comparative look beyond the African continent illuminates how the works analyzed in this chapter form parts of even broader connections. Kahiu has indicated that African American musician Sun Ra is an important reference for her production. Interested in identifying how Afrofuturism relates to Africa, Kahiu was able to draw parallels between the composer's claim that he was sent to Earth from another planet to spread a message of unity and love and the fantastical aspects of Kikuyu myths from her native Kenya, Nigerian novelist Ben Okri's writing, and the legends and stories told to her by her mother.[23] Kahiu's speculative style of expression, in turn, has inspired other African female creatives, including fellow filmmaker Frances Bodomo (chapter 3) and digital artist Jacque Njeri (chapter 3), who views Kahiu as a mentor.[24] Meanwhile, Sibande has indicated that her pointed use of fabric and costume was inspired by British-Nigerian artist Yinka Shonibare, who employs textiles and Victorian-era dress in his sculptures and installations to explore the relationship between colonizer and colonized, European and African.[25]

The four individuals discussed here have all been connected to Afrofuturism, principally through articles for scholarly and general audiences, though to different degrees. Kahiu has been the most vocal

about associating her own work with Afrofuturism, locating *Pumzi* within the development of Afrofuturist discourse and expression in her 2012 TEDx Nairobi talk. For Kingelez, the 2018–19 MoMA exhibition was the first time the American press characterized his visionary production as Afrofuturism.

AFRICANFUTURIST REVELATIONS

Through their portrayals of other worlds, the cultural producers discussed in this chapter challenge Western-originated misconceptions and stereotypes of Africa and Africans, linking their production with decolonization. Waberi's African-dominant world shows how easily the current global order could have been different had the direction of colonial expansion been reversed. Kahiu features a Black African female protagonist whose intelligence and tenacity propel her to problem-solve environmental degradation. Kingelez's model of an international, modern cityscape complete with high-rise buildings defies Western associations of Africans with exclusively rural communities and provincial structures. Sibande's work shows that imagination and aspiration are not restricted by class.

We can reach several tentative conclusions about Africanfuturist works that deal with creating worlds based on the examples featured here. Foremost, they defy any assumption that African creative producers will naturally gravitate toward utopian representations of African alternate spaces and existences. In Kingelez's *Ville Fantôme*, the city where people can live in peace has no inhabitants. Waberi's African-dominated world is undesirable, as are Kahiu's East African Territory and Sibande's portrayal of domestic service.

However, it is precisely through some of these problematic alternate spaces and existences that the creative producers showcase Africans' abilities to overcome challenges. The creators may also use their dystopian representations as cautionary tales to shape real-world behaviors in Africa and elsewhere. For example, Kahiu believes that her film will teach Africans about caring for nature and how their "own behaviors will affect generations to come,"[26] while Waberi wrote his novel to encourage his French students to have compassion for foreigners like him.

Sarr might consider these less-desirable environments and existences a necessary part of bringing the continent closer to an African utopia. It is not a passive process but an active one. It is a daunting

prospect that involves much work, including trial and error. The acts of creating worlds and their corresponding spaces and environments discussed in this chapter reveal, at least to some degree, who Africans *don't* want to be going forward.

These works also show how African creatives draw from and thereby center their real-life experiences to shape their alternate worlds. For Waberi, his own relocation from the geographical periphery to the center influenced his thinking about his relationship to both Africa and the West, as well as how difficult it was for his French students to imagine a life in which their part of the world wasn't at the head. For Kingelez, moving from his rural agricultural village to the international city of Kinshasa was a major influence on his production. It exposed him to a world of new possibilities, including those presented by the urban environment. Kahiu looked to her Kikuyu heritage and cultural traditions such as storytelling in her conceptualization of a fantastic future existence in which technology and nature are at odds. Sibande turned back to focus on earlier generations of her female relatives and how she might interpret their realities and fantasies.

Creating worlds can mean different things in Africanfuturist expression. It may mean envisioning other planets in an outward projection. However, it can also involve looking within oneself to the inner workings of one's mind. Ekow Eshun asserts that African creatives have a predilection for the audacious. We see that in these examples through exaggerated situations, conditions, details, and forms. In his novel, Waberi tells of an African-invented dream-making device that brings sleepers whatever dreams they want. These Africanfuturist works are a type of precursor to that machine.

CONCLUSION

The works discussed here demonstrate the common Africanfuturist endeavor of creating worlds. Though none of the representations are wholly utopian, they are, nonetheless, empowering. They demonstrate the ability to explore alternate geopolitical orders, challenge authority, construct sprawling cityscapes from an array of materials, and speculate on the fantasies and ambitions of one's ancestors. Creating worlds begins with turning inward to the imagination. Only afterward can one bring that alternate space or existence to life through the words on a page, a film, a sculpture, or a photograph.

SUGGESTED ADDITIONAL RESOURCES

In addition to the materials cited in this chapter, here are suggested additional resources. Full details for each source can be found in the bibliography.

Jacqueline Dutton provides an interesting analysis of Waberi's book in "Flipping the Script on Africa's Future: *In the United States of Africa* by Abdourahman A. Waberi." Waberi himself addresses the idea behind his novel in the recorded lecture "Abdourahman Waberi," for the Library of Congress's Conversations with African Poets and Writers series. For additional analyses of Wanuri Kahiu's film *Pumzi*, see James Wachira's "Wangari Maathai's Environmental Afrofuturist Imaginary in Wanuri Kahiu's *Pumzi*," Kirk Bryan Sides's "Seed Bags and Storytelling: Modes of Living and Writing after the End in Wanuri Kahiu's *Pumzi*," and Susan Arndt's "Human*Tree and the Un/Making of FutureS: A Posthumanist Reading of Wanuri Kahiu's *Pumzi*."

Johan Lagae and Kim De Raedt discuss changes in the built environment under Mobutu Sese Seko in their article "Building for 'l'Authenticité': Eugène Palumbo and the Architecture of Mobutu's Congo." For a deeper discussion of how Mary Sibande uses dress as a historical signifier, see Alexandra Dodd's chapter "Dressed to Thrill: The Victorian Postmodern and Counter-Archived Imaginings in the Work of Mary Sibande" and Tracey Walters's chapter "The Art of Dressing Up in Mary Sibande's *Long Live the Dead Queen*."

DISCUSSION QUESTIONS

How have these creative producers used names, titles, symbols, emblems, and color to give meaning in their Africanfuturist work?

How do these examples of Africanfuturist expression collapse the dichotomy between "self" and "other"?

What do these Africanfuturist works reveal about how peoples of different races and nationalities coexist?

What is the role of community in these Africanfuturist representations of alternate spaces and existences?

What do these Africanfuturist works tell us about the role of the sciences and the arts in creating other worlds?

CHAPTER FOUR

Technology and the Digital Divide

TECHNOLOGY IS a prevalent aspect of speculative future-oriented expression. In US Afrofuturism, African American creatives turned the tables on White society through their command of technological features. Because Whites had historically used technology, including "branding, forced sterilization, [and] the Tuskegee experiment," as a tool for repression, African Americans' incorporation of it in their Afrofuturist expression was particularly powerful.[1] Nowadays, it seems impossible to envision life without technology. This is because many people around the world have become increasingly dependent upon it. Nevertheless, demand does not guarantee availability. The digital divide refers to the division between those who have and those who do not have access to digital technologies and equipment. The gap is often a part of larger socioeconomic issues and is not limited to any geographical area of the world.

The idea that Africans are largely cut off from technological systems and devices is simply outdated. So is the notion that Westerners willingly embrace advances in technology while Africans eschew them in favor of adhering to "tradition." Technology is a common aspect of many Africans' lives, especially those of younger generations. Use of the internet, computers, and especially mobile phones is more widespread in Africa than many Westerners likely realize. At the same time, access to some technologies does not necessarily mean easy or unlimited availability in all forms. For example, one might have a cellphone but not stable electricity.

Most discussions of technology's role in Africa fall into either the pessimistic doomsday or optimistic headway categories. There have been numerous articles about Agbogbloshie in Ghana, and other places like it—infamous dumping grounds for e-waste mainly from industrialized nations. In these narratives, Africa is largely portrayed as being on the "receiving end," both literally and figuratively, of obsolete technology from the West. On the other hand, there are so-called success stories of African nations that have adopted technology such as M-Pesa, a mobile money system in Kenya. In these discussions, Africans' acceptance of technology is generally interpreted as hope for the future and a step toward narrowing the digital gap between the West and Africa. Africa's relationship with technology is more diverse and complex than these extremes suggest.

Jonathan Dotse is a Ghanaian science fiction author, digital artist, and self-proclaimed Afrofuturist who has addressed the role of technology on the continent. In his essay "We Know We Will" (2016), he discusses how a person's relationship to technology affects how that individual perceives possibilities of the future. This is because technology has become such an integral feature of many people's lives across Africa that it is now a part of their identities. And when we think about possible futures, we ponder both the real and fictional possibilities of our own narratives.

True to Dotse's assertion, how African creatives approach incorporating technological subjects and processes in their speculative work is often influenced by their own relationship to technology. They utilize technology to comment on the world as they see it, and as they would like to see it. How does it serve them? What are its drawbacks? Various examples of what might be considered Africanfuturist expression demonstrate that Africans use technology in creative ways. However, utilization and suitability are different things. If Africans continue to incorporate technology in the futures they envision, then it is vital that they also "play a greater role in the technologies and systems [they] use" in determining their futures.[2]

This direct involvement is the type of action that Sarr champions for Africans in shaping what lies ahead for the continent. African contributions will be essential to breaking the mimetic cycle in which Africa always trails the West. Instead, Africans must use the "digital revolution—the information society—founded upon knowledge and innovation whose diffusion has been accelerated by information and

communication technologies," together with traditional models and systems, to their advantage in areas such as education.[3] In an African-oriented future, technology does not have to be an either-or situation.

Tendai Huchu is a Zimbabwean author who shines light on various forms of technology in a rural woman's life in his short story "Egoli" (2020). He takes his title from the name for Johannesburg in the Zulu language, which is mainly spoken in South Africa. Born in the town of Bindura, outside Harare, Huchu relocated to Scotland in 2002. He has dedicated himself to his writing since 2010, establishing himself as an author of novels and short stories. His works are frequently included in Western and African discourse on African speculative writing. "Egoli" appeared in *Africanfuturism: An Anthology*, published by the online literary magazine for readers of African literature, *Brittle Paper*.

In Huchu's short story, an elderly Shona grandmother born in what was then Southern Rhodesia, now Zimbabwe, contemplates the changes that have taken place in her village since she was a young girl. Awakened during the night by the need to go to the bathroom, she wanders around outside her compound as she reflects on her life from childhood up to the present day. Throughout the decades in her village, she has remained connected to the outside world via technology. Even at this advanced age, when most of her immediate family members are either deceased or live elsewhere, she stays in touch with her remaining loved ones via her mobile phone.

Huchu emphasizes change over time by sprinkling bits of the history of communication into the narrator's reminiscences. Oral expression is joined by written and then visual forms of communication. Not necessarily in chronological order, Huchu mentions oral storytelling, wireless radio, telegrams, letters, newspapers, online comic books, multimedia images, video calls, and interactive holograms. Over the years, the narrator learned about everything from Shona mythology to her extended family's lives and to international events through these various systems.

The author makes an indirect comparison between developments in the transference of information and the movement of people across increasingly greater distances. During the colonial era, when the grandmother got married, she relocated fifteen miles from one side of the village to the other to live with her husband's family. Her grandfather-in-law, who was a rural agricultural extension worker under the colonists, traversed the region on his motorcycle. Going

forward, more than one generation of males from the family, including the narrator's own sons, followed the railroad tracks south to cross into what is now the neighboring country of South Africa. The men went to mine diamonds in Kimberley, and gold in Johannesburg, the latter referenced in the story's title. The narrator's grandson, Makemba, travels even farther into outer space.

Huchu combines fantastical and technological elements in his narrative, both of which are characteristics of Africanfuturist expression. He joins the past and the presumably near future, in which the story is set, through fact and fiction. When the narrator was a child, her grandmother told her about the Rozvi, a Shona people who tried to build a tower to the sky so that they might bring the moon back as an offering to their leader. Now she is a grandmother, and her grandson is capable of space travel beyond the moon. Neither of these scenarios are so highly unlikely that they defy the realm of possibility. It is not unfathomable that the Rozvi, an empire that was founded in the seventeenth century, believed that they could reach the moon from Earth. Similarly, given humankind's advances in space exploration, it does not seem incomprehensible that people might be able to land beyond the moon in the not-too-distant future.

Huchu's story demonstrates that technology is not something relatively "new" to Africa. Technology has factored into the rural woman's life for decades, beginning with the radio, by which villagers kept abreast of global events. In "Egoli," the author does not suggest that technology causes the abandonment of "traditional" practices or the marginalization of rural societies. Although the narrator appreciates the latest advances that allow her to maintain contact with her family members, make her agricultural work easier, and give her access to free online comic books, she doesn't seem to value the technology that enables her grandson to travel into outer space. It is, perhaps, a generational view dependent upon the narrator's own interests. Life in the village is sufficient and the older woman finds everything she needs in her local environment.

A storyteller and author who communicates through the written word, Huchu draws parallels between his craft and technology. "Egoli" is written in English and peppered with Shona words and phrases. Huchu has described his own language communication in terms reminiscent of digital technology: "Shona is my base code.... Shona is the default-factory operating system my mind is programmed

in, English [is] an optional secondary software retrofitted a little later in life, so it is running off a Shona foundation."[4] Over time, technological forms and systems become outdated and obsolete, ultimately replaced with newer versions. In a similar vein, Huchu recognizes the challenges that the Shona language presents in being able to capture his current and future reality:

> I am bilingual, fluent in Shona and English. I also do translations between the two languages and can tell you that working concepts from English into Shona, e.g. when translating SFF stories, is a nightmare. Shona hasn't developed signs and signifiers for dealing with advanced technology. Thus, you cannot teach physics, mathematics, chemistry, architecture, engineering in the language.... So I am very much cognisant of having one language with a limited utility in comprehending and navigating the world I live in, and another through which the doors of discovery are open, maybe even limitless.[5]

Huchu's issue cannot be rectified simply by buying the latest software or device. It's a situation individuals face when the language of technology continues to be dictated by Western societies.

Though "Egoli" is fictional, the author has selectively incorporated elements from Shona history that resonate on the personal and wider Shona community levels. He includes the tradition of burying the umbilical cord, or *rukuvhute*, in addition to referencing the Shona patrilineal system, Rozvi empire, and architecture made from mud, cow dung, and thatch. During the colonial era, only male children were sent to school, where they were educated in English. Hence, in the story, the narrator's grandfather-in-law must translate the BBC Radio transmissions into Shona for her, and she learns to read only later in life. Huchu was also educated in English in Zimbabwe, a result of the British colonization of Southern Africa. Lastly, he ends his story with the expression *Ndiko kupindana kwemazuva*, which means "How time passes." This phrase is also the title of a well-known novel by Charles Mungoshi (1947–2019), a Zimbabwean author who wrote in English and Shona. Huchu addresses the significance of Mungoshi's (1975) publication for Zimbabwean literature and in relation to his own narrative: "The stream-of-conscious, fragmentary approach he used

in this novel was highly innovative in comparison to the classical realism favoured in our canon. 'Ndiko Kupindana Kwemazuva' ... was apt for 'Egoli,' which is a story about the passage of time, the new replacing the old."[6]

In his use of Shona cultural references and terms, Huchu also creates a metonymic gap that is revealing of how many Africans navigate the world across two languages.[7] English, as the language of the former colonizer, allows Huchu's Western readers to understand his narrative. At the same time, his use of Shona references a culture with its own values, systems, and practices that we cannot know. Through language, he provides us a window into life in the village only to the extent that we can appreciate its fullness. He utilizes indigenous expression in a contemporary narrative that captures the essence of his own point of view. It also replicates how the Shona, like other African peoples, have always adapted in an ever-changing world, using more than one language to understand and describe their existence.

Andile Dyalvane is a South African ceramicist and designer who has also addressed how technology has changed over time and factored into the local environment. In his work *Docks Table*, he explored the physical and digital movement of information and goods as they relate to the landscape of Cape Town. Dyalvane was born in Ngobozana, Eastern Cape, and received his degree in art and design (1999) from Sivuyile Technical College in Gugulethu, Cape Town. He earned his degree in ceramic design (2003) from Nelson Mandela Metropolitan University in Port Elizabeth. In 2007, Dyalvane cofounded Imiso Ceramics, an outlet shop for handcrafted collectible one-off pieces located in Cape Town's Woodstock neighborhood. *Imiso* is derived from "for our tomorrows" in the Xhosa language, suggesting that future generations will benefit and learn from positive changes made today. In 2013, Dyalvane began to produce different versions of his *Docks Table*. Embodied in these one-of-a-kind works are the contrasting ideas of rural and urban, traditional and contemporary, and digital and physical movement.

Beneath the custom cut-glass top of *Docks Table* is a collection of different-colored ceramic blocks in various modular shapes, which Dyalvane made from clay pressed in plywood molds (fig. 4.1).[8] Clay is a material that the artist first experimented with as a child, collecting it from the riverbanks when he was not herding his family's

FIGURE 4.1. Andile Dyalvane, *Docks Table*, 2013, ceramic, steel, and glass, 110 × 80 × 50 cm. *Courtesy of the artist and Southern Guild.*

cattle. He created the table base and legs from raw steel, which he coated with beeswax and red enamel. In keeping with the designer's usual approach, he sketched the template for the various parts to fit together like a puzzle prior to physically constructing the piece.

The main themes of Dyalvane's functional table are movement and change in Woodstock, which are represented by the assemblage of interlocking ceramic forms. In the seven years since Imiso Ceramics opened, the area had transitioned from a somewhat rundown neighborhood to a trendy, multiuse district with bars, restaurants, and shops popular with tourists. The multiracial population who lived and worked locally found it difficult to keep up with the rising costs, as developers snatched up properties that largely catered to White patrons. Gentrification became a common topic among community members and in the local press.

Woodstock's primarily industrial character, evidenced by the daily flow of goods in and out of the dockyards in shipping containers, changed with the arrival of Bandwidth Barn, Google, and other tech-oriented businesses that enable the movement of information and products around the world in seconds via the internet. Dyalvane noted the transformation as he moved through the streets and looked out from the large windows of his Albert Road studio:

> Woodstock was undergoing major realtor changes, we'd work late nights, attuned to the unseen shifts in both the Dock Yards (being on the fifth floor I could see foreshore activities throughout the day) and cranes in motion, of recently demolished buildings. . . . Walking and driving through the area daily, allowed for recollection of what was and what was becoming—we felt a sense solidarity for community losses and, as a business, that our systems would be better streamlined online; . . . virtually we could fast track showcas[ing] what Imiso Ceramics was up to.[9]

Imiso's owners commiserated with the local population while assessing the potential benefits this development could have for their business.

Dyalvane's *Docks Table* also relates to Woodstock's technological turn through its affinity with the computer game *Tetris*. The artist frequently played in the evenings in his studio and made a visual connection between the game and movement taking place in the dockyards nearby. He says, "[The] stacking, off-loading and restacking of container towers reminded me of Tetris during my design processes."[10] Discussions of *Docks Table* in design publications reiterated the artist's correlation of his piece and the computer game, crafting descriptions of Woodstock that were both picturesque and critical. For example: "Just as in the computer game *Tetris*, moving ceramic parts form a colourful mosaic that mimics the close-knit rows of houses in the neighbourhood, alongside the ships and containers in Woodstock harbour."[11] "Through its Tetris-like layout," Dyalvane's *Docks Table* "shows the irony of developed cities that have achieved so much in terms of modernized fabrication that there is no space left for natural environment. City dwellers may have every other latest technology with them but they are lagging behind when it comes to open indigenous landscapes."[12] For some, Dyalvane's piece was as innocuous and visually engaging as the video game. Others, however, seized the opportunity to emphasize the work's approximation to *Tetris* as symptomatic of what they viewed as Woodstock's encroaching technological sector.

Dyalvane's allusion to the movement of goods and ideas via technological processes connects *Docks Table* with Africanfuturist expression. He approaches Cape Town's dockyards and growing tech presence via a conceptual lens in the work. The clay blocks, which

symbolize shipping containers and pieces of information, become the mobile elements of *Tetris*. It is easy to imagine the static modules beneath the glass top in motion.

Though Dyalvane created his table in response to the change taking place in Cape Town, the movement of people and information was also a part of his family history. His father came to Cape Town to work as a welder in the dockyards at about the same age that Dylavane was when he made the first version of *Docks Table*. Like many other migrant laborers from the countryside, the artist's father lived in a hostel—a long trainlike structure that resembled some of Dyalvane's block forms. When he was able to return home to the Eastern Cape at the holidays, his father brought discarded pieces of metal and other bits of materials that he would use to fortify the family homestead. Dyalvane's father contributed to the family home through his expertise as a welder, bringing goods, ideas, and labor from the city. Dyalvane brought his knowledge of clay to the city, where he was able to use the goods, manufacturing, and business technology available in Woodstock to create his table and other works. *Docks Table* then speaks to transitions within family and area histories, as well as from manual labor to creative production.

Docks Table is a utilitarian artwork that embodies the ideas of movement involving people, information, and goods related to technology, in addition to change over time. On the surface, "tradition" and technology may seem incongruous; similarly, clay might not appear to be an obvious choice of material to artistically address growth of the technological sector in Woodstock. Something sleeker and shinier might come to mind. However, just as Dyalvane creatively associates his piece with *Tetris* and Cape Town's various movements, so does he assert that clay is the right medium for him to "bridge the gap between the past, the now, and the future."[13] From his point of view, a material indigenous to the continent is the most fitting to conceptually and symbolically represent a changing African environment.

Elias Sime is an Ethiopian multimedia artist who carefully chooses his materials to call attention to the growing role of technology in people's lives. Sime was born in Addis Ababa and received his degree in graphic art (1990) from the Addis Ababa University School of Fine Art and Design. Because his professors encouraged social realist work in keeping with the Communist state of the

then People's Democratic Republic of Ethiopia (1987–91), Sime was barred from creating mixed-media pieces from discarded objects until after graduation.[14] He worked with items such as yarn, buttons, and bottlecaps and eventually turned to experimenting with elements from electronic equipment in 2009.

TIGHTROPE: (4) While Observing..., is typical of the type of art Sime creates with technological materials (fig. 4.2). The large-scale wall sculpture is made of reclaimed electrical wires and components attached to a supporting panel. Red half-moons composed of intricately braided wire visually anchor the top and bottom of the sculpture. They are separated by fragmented bits of electronic pieces in a variety of shapes and sizes. The expanding midsection is

FIGURE 4.2. Elias Sime, *TIGHTROPE: (4) While Observing . . .* , 2018, reclaimed electrical wire and components on panel, 160 × 139 cm. *Courtesy of the artist and James Cohan, New York.*

predominantly shades of green and brown owing to its various parts, with intermittent pieces of bright blue plastic. From a distance, the work resembles an aerial view of a landscape or topographical model. Only upon closer inspection does the viewer recognize that the work is a highly detailed and textured sculpture.

Sime uses composition and form to create visual tension in his piece. The curving lines of the red forms contrast with the sharp edges of the sculpture's underlying grid structure. Visual resistance is suggested by the two half-moons that expand toward each other only to be pushed back by the middle section. The pops of blue and plethora of individual pieces draw the viewer's eye around the sculpture, fostering a sense of movement within the static work.

This optical push and pull exemplifies Sime's sentiments about the precarious relationship between people and technology. Over the years, the artist went from thinking about the balance a city has to strike "in the face of rapid urban development," to pondering the need for balance between embracing technology for its communicative abilities and acknowledging the ways it also impacts human relationships.[15] He has captured his evolving ideas about finding an equilibrium through the idea of a tightrope, which he utilizes in the title of this and other works. Technological devices such as computers and cellphones facilitate one's ability to communicate with people in faraway places and stay connected. However, Sime stresses that it's important for people to also converse in person, to be able to look into each other's eyes and recognize the different emotive impact of expressing "I love you," for example, face-to-face versus via text.[16] The artist's desire to remind people to dig deep within themselves to connect emotionally parallels his choice to utilize the inner workings of computers and other technological devices, now broken down, dismantled, and exposed.

Sime's thematic and material focus on technology in *TIGHTROPE: (4) While Observing...*, connects this work to Africanfuturism. Rather than allude to this topic in an abstract way, he features technology in the concrete form by placing electronic components in front of the viewer. This choice demonstrates the range of ways technology fits into Africanfuturist production and emphasizes the role of physical contact between human and technological instrument. Sime uses the example of a computer to illustrate his interest in the tactile aspect: "The materials I select, by the time they get into my hands, they've been touched

by so many people, and now they're in my hands. Even though it may not be visible, when you're working on your personal computer, you leave a part of you on that. Then, when it breaks, there is somebody else who goes inside it and touches it; there's that fingerprint."[17] When the artist utilizes disparate parts of equipment, he adds himself to the record of contact with the pieces, creating another link in the chain of connection, and compiling the layered histories of each individual component into a single work of art. The number of people represented in a single one of his sculptures transcends the already-staggering number of individual pieces he incorporates in each work.

Beneath the technological surfaces of Sime's creations, however, are manual processes. The artist solders metal bits, intricately braids wires, and arranges pieces into complex compositions. There is also the process of having to attach everything to the underlying support. Technology allows for the rapid transmission of ideas and information, yet it sometimes takes Sime years to create one of his larger sculptures as he must find enough of the same type or color of material. Somewhat ironically, the artist's creative process is frequently at odds with the speed of technology suggested by the work's physical components.

Sime's choice of materials and creative production are influenced by his local environment. Not to be found in any art supply store, the artist sources his materials from Addis Ababa's Mercato, the largest open-air market in Africa. Merchants in the mercato and the shops that surround it sell new and rebuilt electronics, among other products, that are vital to Sime's supply of parts.[18] Over time, the artist has established relationships with sellers and entrepreneurs who help him amass the quantity of components necessary to create such a high volume of sculptures. Even prior to his work with technological elements, Sime has always found his materials locally, both at the market and in and around his neighborhood.

Sime's works speak to his views on Africa's relationship with technology as part of the increasingly globalized world. The continent has not been isolated from the process, which often involves technology. Nonetheless, the artist is not interested in focusing on one geographical region or another in his sculptures. The work is not just about Ethiopia or the African continent. Rather, it's the wider story of globalization. People worldwide, not just in the West, must decide technology's place in narrating the future.

Eddy Kamuanga Ilunga is a painter from the Democratic Republic of the Congo who also addresses the topic of digital technology in his representations of Congolese cultural and labor histories. The artist graduated from the Institute of Fine Art in Kinshasa in 2009 and pursued further study at the Academy of Fine Arts, also in Kinshasa. Kamuanga Ilunga has conducted primary research to educate himself about his homeland and expose his audiences to various aspects of the national past and present through his work. In 2015 he began to feature the Mangbetu people in his paintings to comment on the current socioeconomic conditions in his country and insert himself in a long tradition of creating images of this population.

Throughout the colonial period, foreigners were intrigued by the Mangbetu people in the northeastern Upper Uélé province of what is now the Democratic Republic of the Congo. They took note of the Mangbetu's funnel-shaped basket hairstyle, body painting and scarification, and practice of *lipombo*, or head elongation, in their written accounts and visual records. Subsequently, their drawings and photographs were circulated in the West and used in the service of European projects of political control. The Belgians employed images of the Mangbetu to stress cultural and physical differences between Westerners and Africans in their campaign to justify their domination over the African "other." Photographs of Mangbetu subjects created in the first quarter of the twentieth century remain some of the most frequently reproduced images from the colonial era.

The painting *Abandonnés*, which translates to "abandoned," is typical of Kamuanga Ilunga's contemporary depictions of the Mangbetu figure (fig. 4.3). In this life-sized work, a female is seated with her eyes closed. She has tucked one of her legs behind a stool and cast one of her flip-flops to the side. Her red shoes match the color of her painted lips, nails, earring, and head wrap. She wears a colored print cloth around her lower body. The woman has an elongated forehead and funnel-shaped hairstyle that is adorned with long, narrow hair pins. She rests her head and hand against an undiscernible object that is covered in different textiles in saturated colors. Her Black skin is marked with white and gray forms that resemble circuit boards and microchips. Partial horizontal lines of abstract script in yellow traverse the canvas, juxtaposed against the flat gray background.

Kamuanga Ilunga's painting is a combination of historical elements and artistic prerogative. He takes aspects from some of the

well-known colonial-era renderings of the Mangbetu and from the photographic records he made during a research trip to the Mangbetu homeland in 2015. The basket hairstyle and long ivory hairpins, both of which were indicators of status and wealth from approximately the mid-nineteenth through the mid-twentieth century, are ubiquitous characteristics of colonial representations of Mangbetu women. In his painting, the artist reimagines the traditionally dark string used to bind the head as a bright red band. The printed textiles featured in the work have different names and meanings derived from their association with proverbs, concepts, or customs. The guinea fowl–pattern cloth Kamuanga Ilunga's female subject wears may relate to the Mangbetu's practice of decorating their elaborately woven hats with guinea fowl feathers in the late nineteenth and early twentieth centuries.[19] The artist includes older fabric designs in his

FIGURE 4.3. Eddy Kamuanga Ilunga, *Abandonnés*, 2015, acrylic on canvas, 200 × 200 cm. Private Collection. *Courtesy of the artist and October Gallery.*

paintings as a sign of "tradition," as opposed to the global-influenced fashions more popular with today's younger generations. His decoration of the skin can be understood as a reference to Mangbetu body painting and scarification practices, which foreigners noted in their colonial-era records. One could also interpret the treatment of the skin, however, as an allusion to contemporary coltan mining.

Kamuanga Ilunga's home country has one of the largest reserves of coltan—an ore that contains tantalum, a key metal for the electronics industry—in the world. This black ore is most often used in mobile phones and computer chips. Since the late 1990s, coltan has been in high demand due to the rapid growing production of technological devices. In the Democratic Republic of the Congo, preexisting structures may stand on coltan deposits not visible from the earth's surface. According to the artist, when a vein is discovered, everything in that area is sacrificed: "They raze the forest. As mines bring in more income than agriculture, the fields are abandoned and children no longer go to school."[20] Desperate Congolese with few opportunities to earn a living engage in artisanal mining, bringing in whatever unsteady income they can get for their labor. Various groups hailing from within the country and from neighboring nations vie for control over coltan-rich areas. The violence caused by the struggle for economic power over this natural resource is known as "blood coltan." Many people around the world are unaware of this conflict related to the technological devices that they use in their daily lives.

The somewhat otherworldly appearance of the Congolese bodies in Kamuanga Ilunga's *Mangbetu* series is in keeping with the aesthetic of Africanfuturist expression. The artist integrates his figures with circuit boards and microchips, marking African bodies with symbols of labor and technology. Because Kamuanga Ilunga's Mangbetu subjects appear largely human, other than their skin, they could be considered cyborgs. Some US Afrofuturist producers have utilized the part human, part artificial cyborg to critique the flawed relationship between technology and the Black body: "In the fraught relationship between blackness and technology... black bodies are used as technology, but technology is also wielded against black bodies . . . In this capacity, it is not foreign to then imagine those same bodies being projected into the future as androids and cyborgs."[21] Kamuanga Ilunga may be using a cyborgesque figure for the same effect. His circuited and chipped skins signal an inextricable link between the

Congolese population and the technology that coltan supports in the present and future digital worlds.

What can we make of Kamuanga Ilunga's mixture of references to the past and present in *Abandonnés?* The extraction of coltan in the Democratic Republic of the Congo involves human labor that is directly or indirectly coerced. The process and the resultant technology are repressive. The artist alludes to this oppression through resigned facial expressions and sometimes belabored or vulnerable poses. However, Kamuanga Ilunga embellishes those same bodies with elaborate hairstyles and adornments that were once markers of status and wealth. Viewers are left to draw their own conclusions about the meaning of the painting. Its title might apply to the various Mangbetu arts of enhancing the head and skin that have fallen out of fashion. Or perhaps it is the Congolese people who have been abandoned by their government and left to fend for themselves in the war over coltan.

While Kamuanga Ilunga's painting is open to interpretation, his concerns are clearly national subjects and issues. The Société Cotonnière de Bomokandi (Bomokandi Cotton Company), which concentrated its activities in the Upper Uélé region of the Bomokandi River Valley, engaged the Mangbetu in involuntary labor through compulsory crop cultivation during the colonial period. As early as 1936, the Usines Textiles du Leopoldville (Textile Mills of Leopoldville) dedicated much of its production to fabrics known in the Democratic Republic of the Congo as *pagnes* and throughout West Africa as wax prints. The artist is aware of how this ubiquitous textile figures into the history of colonial exploitation: "The Belgians brought in cotton, made plantations and used forced labor to grow local supplies for their new factories. . . . [They] realized they could control the entire chain of production, at negligible cost, within their own African colony. It was pure economics!"[22] Kamuanga Ilunga drapes his figure in this type of cotton printed cloth that is still worn in the Democratic Republic of the Congo.

Similarly, the painter foregrounds another element related to the cycle of social disruption and economic inequality through his allusion to coltan. During the colonial era, communities were torn apart due to forced labor and relocation policies. Large-scale mining driven by the Democratic Republic of the Congo's deposits of diamonds, copper, gold, iron, and other minerals also began during the period of foreign occupation. Kamuanga Ilunga's homeland is a nation rich

with a variety of natural resources from which few Congolese benefit. From cotton to coltan, the artist traces a pattern of exploitation that contrasts his nation's wealth and the population's continued economic marginalization.

In the twenty-first century, the Congolese people are integral to the international chain of technological equipment production. Yet many do not reap the benefits of their involvement. Some people in the Democratic Republic of the Congo do not have access to the devices that incorporate coltan. Whereas Sime's work was inspired by the question of how much technology people should allow in their lives, Kamuanga Ilunga's painting is a visual statement about the narrowing gap between human and machine.

CONNECTIONS ACROSS AND BEYOND THE CONTINENT

These examples demonstrate how technology can be a subject or characteristic of Africanfuturist production. Huchu utilizes technology to show how even Shona who live in rural villages without indoor plumbing remain connected to the rest of the world with their mobile devices. Dyalvane uses the computer game *Tetris* both as an artistic inspiration for his modular forms and a conceptual model for the movement of containers in the dockyard. Sime works with the disparate electronic components of technological equipment as his material of choice. Kamuanga Ilunga decorates his Mangbetu subjects with technological elements, including chips, circuits, and motherboards, in a contemporary play on traditional body arts.

These African creatives pair technology with a sense of movement in their works. In Huchu's "Egoli," technology allows the narrator to remain connected to family members across increasingly greater distances, an ability that is underscored through the contrast with her stationary existence in the village. The undulating units of *Docks Table*, which correspond with information and goods related to technology, foster a suggestion of motion that a solid form table could not. Sime arranges his technological components in compositions that look mobile. Kamuanga Ilunga makes his figure's circuited and chipped skin appear activated, as if someone has pressed the "on" button.

Both Huchu and Kamuanga Ilunga call attention to Africa's natural resources and how other parties benefit from African labor. In "Egoli," the narrator's grandson is preparing the way for other

individuals to mine gold and other precious minerals in outer space. Because those men will bring the materials back to Earth for profit, the grandson refers to the rocks as the "new Egoli." Thus Huchu alludes to the history of mining in Johannesburg and suggests that African labor will continue to factor into the extraction of minerals beyond Earth. Kamuanga Ilunga uses the *pagne* for its connection to textile production reliant on African agricultural and manufacturing labor during the colonial period under the Belgians. Additionally, he links the Congolese with coltan mining through his figure's skin, transforming human into cyborg. By layering the cloth and technological components onto the wearied body, the artist emphasizes the key role that African laborers played and continue to play in processes that only bolster the economic positions of other nations or groups.

Further comparison of these Africanfuturist works with those from the other chapters of this book reveals additional connections and influences. Huchu's and Kamuanga Ilunga's allusion to mining on the African continent thematically links their production to multimedia artist Sammy Baloji's photomontages that also deal with the history of this industry in the Democratic Republic of the Congo (figs. 4.3, 5.3). Also, Huchu and South African author Lauren Beukes, whose *Zoo City* is discussed in chapter 6, highlight Shona culture and mythology in their writing, and Huchu has expressed appreciation for Beukes's speculative novel.[23]

The works from this chapter also dialogue with other Africanfuturist expression in terms of process and material. Both Kamuanga Ilunga and Ivorian photographer Joana Choumali combine manual and electronic processes in their pieces (figs. 4.3, 5.4). Kamuanga Ilunga decorates his figure's skin with microchips and electronic circuits to reference digital capabilities enabled by the use of coltan in certain devices. However, the artist does this manually, drawing in the integrated circuits by hand.[24] Choumali uses her iPhone to take photographs, then prints the pictures on cotton and hand sews details onto the images. Both Dyalvane and Burkinabe architect Francis Kéré choose to utilize clay in their contemporary designs (figs. 4.1, 5.2). Lastly, Sime and Bodys Isek Kingelez construct their works from discarded items and objects (figs. 4.2, 3.1). Though nontraditional and lowbrow artistic selections from a Western point of view, Kingelez's paper, cardboard, and other items, as well as Sime's electrical components, were somewhat rare and thereby valuable.

Because the works discussed in this chapter deal with technology, it is unsurprising that three of the creative producers have been included in discourse and projects related to Afrofuturism and Africanfuturism. Huchu's "Egoli" appeared in *Africanfuturism: An Anthology* (2020) together with several African writers whose work has been labeled science fiction. While Huchu sees the potential of categorizing bodies of production under one future-oriented term or another as a theoretical approach, he says, "As a practicing writer, it's not too useful when it comes to informing the stories I craft," and has elsewhere expressed his ambivalence toward the term *Afrofuturism*.[25] The Metropolitan Museum of Art was the first to link Dyalvane's work with Afrofuturism when it included one of his ceramic pieces in their show *Before We Could Fly: An Afrofuturist Period Room*, which opened in November 2021. The exhibition presented Dyalvane's work alongside that by other contemporary African and diasporic artists under the umbrella of Afrofuturism. Some individuals have described Kamuanga Ilunga's works as Afrofuturist based on their seemingly futuristic appearance, though the artist, himself, has not characterized his production as such.

AFRICANFUTURIST REVELATIONS

There are conceptual parallels to be drawn between the ideas of penetration that appear in these Africanfuturist works and how deeply rooted technology is across the continent. Huchu's narrator mentions the toiling beneath the earth's surface—the digging for diamonds and gold in South Africa—actions that will be repeated in the mining endeavors that will take place in outer space. Dyalvane's glass top is transparent, allowing a clear view of the interlocking modules beneath it. Sime crafts interior components, the rarely seen inner workings of electronic equipment, revealing them to the viewer. Kamuanga Ilunga makes it appear as if the markings are situated underneath the surface of his figure's skin. Similarly, technology is multilayered and entrenched in contemporary African life.

Can we also think of these various modes of peeling back the layers and dissecting as actions in support of decolonization? Perhaps. The first step in the process of decolonization is to expose the "hidden" aspects of institutional and cultural forces that continue to suppress African nations and peoples postindependence. The African creatives behind these works appear to have an objective view of technology.

They don't condemn it in their comments or speculative expression. Neither do they try to sell their audience on it through romanticized, escapist representations. However, these works largely present Africans as the consumers of technology or as those who are consumed by it in the case of Kamuanga Ilunga's cyborg. They are not at the front, driving it. In their own way, most of these speculative works advocate for Africans having a more prominent place in the production of technology, not only in the production of its materials and other industries that ultimately benefit other nations.

These works center African experiences and demonstrate that creatives incorporate technology as a theme or material in their production based on their own relationship to it. Huchu takes influence from how individuals in his birth country use technology: "Most rural folks in Zimbabwe have mobile phones. Charging can be done through solar power banks or batteries. These phones are how people make and receive money transfers, keep in touch with loved ones, and access information via the internet.... Tech offers the tools essential for how we live today."[26] Dyalvane saw how the arrival of the tech sector in Woodstock spurred change that was positive for some in the community and negatively affected others. Sime utilizes computer components that are for sale in and around the mercato as his materials. Kamuanga Ilunga focuses on the conflict over coltan in the Democratic Republic of the Congo and its use in technological equipment.

The works of speculative expression analyzed here support Dotse's idea that technology will undoubtedly be a characteristic of the African continent's future, as it is already a fixed aspect of its present. Further, the different ways that the creative producers have elected to engage technology underscores how and why Africans may use certain technologies or not. We control technology; it does not control us, though we often approach it that way. Huchu underscores that point and why it is essential that Africans be more involved in the creation of the technologies they utilize: "Technology feels like an inevitable part of our reality. These tools are designed in Europe and America, and made in Asia, so Africa finds itself in this dastardly spot of having to adapt and refit tech that was never designed with it in mind. But it's a very hard leap to make from merely consuming technology to actually innovating. . . . Whoever designs and makes the technology creates the future in their own image."[27]

CONCLUSION

These examples demonstrate different approaches African creatives take to address technology in their speculative expression. It may figure into their work as a subject or a material. The examples discussed here suggest that African cultural producers understand technology to be a guaranteed aspect of the future based on the way it factors into present African realities. Kamuanga Ilunga's painting attests to the digital inequalities that exist on the African continent as elsewhere in the world. However, Huchu's short story confirms that technology is accessible and part of daily life even in some "unexpected" places.

SUGGESTED ADDITIONAL RESOURCES

In addition to the materials cited in this chapter, here are suggested additional resources. Full details for each source can be found in the bibliography.

Tendai Huchu shares more thoughts on his writing and Afrofuturism in the recorded panel discussion moderated by Eilidh Akilade, "Scottish BAME Writers Network: Afrofuturism—Present Realities, Possible Futures," from the 2021 Edinburgh International Book Festival. Andile Dyalvane speaks about his process and work in the interview "5 Minutes with Andile Dyalvane," and in the video feature "AFPR—Meet the Artists: Andile Dyalvane" related to the Metropolitan Museum of Art's exhibition *Before Yesterday We Could Fly: An Afrofuturist Period Room.* Elias Sime discusses his ideas and approach in conversation with Ugochukwu-Smooth C. Nzewi in *Second Careers: Two Tributaries in African Art*, and in the Wellin Museum of Art's video "Elias Sime: Tightrope." It was produced for Sime's exhibition at the institution and also includes excellent visual details of his creations.

For an overview of the history of mining, including coltan, in the Democratic Republic of the Congo from the colonial era through the present, see Sarah Van Beurden's article "A New Congo Crisis?" and Jeffrey W. Mantz's article "From Digital Divides to Creative Destruction: Epistemological Encounters in the Regulation of the 'Blood Mineral' Trade in the Congo." For further information about cotton cultivation, textiles, and labor history during the colonial period, see Osumaka Likaka's *Rural Society and Cotton in Colonial Zaire* and Frans Buelens and Danny Cassimon's chapter "The Industrialization of the Belgian Congo." Additional useful images

and discussion of Eddy Kamuanga Ilunga's work are found in Billie A. McTernan's article in *Art Africa* and in Gabriela Salgado's essay in the exhibition catalog *Eddy Kamuanga Ilunga*, published by October Gallery.

DISCUSSION QUESTIONS

What stories do these creative producers tell about technology through their Africanfuturist work?

What is the significance of shape and form in these Africanfuturist examples?

How do these Africanfuturist works support or contradict the idea of narrowing the gap between human and machine?

Based on these Africanfuturist pieces, what are the positive and negative aspects of technology?

What natural and synthetic materials have these African creatives chosen to utilize or mention in their Africanfuturist production dealing with technology?

CHAPTER FIVE

Sankofa and Remix

SOMETIMES SCHOLARLY and popular interest in emphasizing speculative future possibilities overshadows exploring creative producers' use of information and elements from the past. The Ghanaian principle of sankofa is a way that African creatives may draw from history while focusing on what lies ahead. *Sankofa* is a word in the Twi language that means "go back and pick or choose."[1] It relates to the Akan proverb *Se wo were fi na wosankofa a yenkyi*, which means "It is not wrong [taboo] to go back to fetch that which you have forgotten." Sankofa suggests the possibility of learning from the past to craft a better future. It can also stress the importance of knowing one's past to better orient oneself toward the future. Sankofa is expressed visually through the *adinkra* symbol of a bird with its feet facing forward (suggesting future-oriented movement) and its head turned backward.

Though sankofa originated with the Akan people, the majority of whom live in Ghana, groups from multiple locations across the diaspora as well as from the African continent have utilized the concept and symbol, thereby expanding its application greatly. African Americans, as a "community whose past has been deliberately rubbed out, and whose energies have been consumed by the search for legible traces of history," may use sankofa to reference their historical and indissoluble ties to the African continent.[2] Because the Atlantic Slave Trade involved ripping Africans from their communities and thereby breaking direct and intimate connections, diasporic creatives have selectively

chosen which African histories, peoples, and traditions they want to draw from for their Afrofuturist expression. African creatives, in contrast, almost always look to their immediate environment.

Sankofa is widely relevant across and beyond the African continent, but not without distinction. Just as Africanist creatives often address a nation-bound future in their work, they also may be concerned with a geographically or culturally specific history. When they turn to the past, African creatives often reference colonialism because of its lasting effects on much of the continent. Because Europeans did not take a universal approach to their colonial projects, peoples in and among the various African nations had different experiences. Those historical distinctions reverberate in contemporary uses of sankofa in Africanfuturist expression.

Sarr emphasizes the practicality of drawing from African pasts and traditions in the process of moving the continent toward a better future. Over time, Africans have cultivated beliefs and information based in their traditions that have enabled them to withstand a variety of shocks, fortifying their physical and mental resilience. He argues that by providing a place for "traditional and customary forms that have already been tested and which have demonstrated their value," Africans will be better prepared to meet the demands of the moment, as well as those of the future.[3]

The idea of bringing elements or knowledge from the past forward into the present and future encapsulated by sankofa is not unlike remix. Many individuals only know remix as a musical practice in which an artist samples another (old) song in their (new) song; in fact, it applies to a variety of expressive forms. In terms of the visual arts, there are correlations between remix and the postmodern techniques of bricolage, assemblage, and appropriation. Most of these types of artistic remix involve utilization of discarded items, everyday objects, and other "nontraditional" art materials. They also often employ technology, including Photoshop and other types of digital manipulation software. These tools enable creatives to take elements of pre-existing images from one or more sources and bring them together to create something new. Because the development of artistic processes has temporal associations, remix can also apply in this sense. Manual processes preceded digital processes. So when an individual utilizes a manual technique on top of or following a technological one, we can also think of this as remix.

In a broad sense, remix can be understood as a communicative practice. Combinatorial processes, which consist of bringing together different elements, relay meaning within communities. Each musician or artist, for example, creates meaning through the discrete units of their respective "vocabulary." Someone from outside that community, or who is unfamiliar with a particular history in the sense of sankofa, can only understand each individual word at face value. In contrast, within a given community, members do not give and receive meaning by adding up each separate "dictionary-like" component but rather imbue networks of meaning that "function as a cultural encyclopedia" across different forms and mediums.[4] In this vein, both sankofa and remix can be conceptual and present themselves in ways that are not always obvious at first glance.

In his novel *Utopia*, Egyptian author Ahmed Khaled Towfik illustrates the wisdom of sankofa by showing what happens when a country turns a blind eye to history and allows social divisions to fester. Towfik was born in Tanta and earned a medical degree from Tanta University, where he would go on to hold a position as professor of tropical diseases until his death in 2018. Towfik was also a pioneer of Arabic speculative fiction and horror writing. He began publishing his work in the early 1990s and became a prolific author of novels and short stories. *Utopia* was released in 2009 in Arabic and the English-language translation came out in 2011.

In Towfik's story, Egyptian society in 2023 is divided into two groups—the upper and lower classes. The elites live in a gated community on the Mediterranean coast called Utopia and the poor live in the "Territory of the Others." The narrative alternates between chapters grouped under the subtitle "Predator," a reference to a spoiled and selfish elite male youth who is only identified in the book by the alias Alaa, and those grouped under the subtitle "Prey," a reference to a young adult male "Other" by the name of Gaber. In the story, Alaa and his female friend Germinal venture outside their community to harvest a souvenir—a body part from an "Other," as the elite youth do for entertainment. When they ultimately fail, it is Gaber who protects the couple from being discovered and facing the wrath of his fellow "Others" until he can get them safely back to Utopia.

Towfik's main theme is the dystopia that results when society is cleaved into haves and have-nots, which he underscores by portraying both groups as equally undesirable. The conditions of each respective

population affect every facet of one's life such as housing, sanitation, transportation, nutrition, access to medical services and recreational drugs, and relationships with individuals of other nationalities, including Israelis and former United States Marines. Nothing is considered sacred or shocking for the youth of either group, and their interests and pastimes are devoid of any social value.

Through *Utopia*, the author illustrates why sankofa is a sound social principle. If society had learned from the past, this dystopia would have been avoidable. Previously, there was an Egyptian middle class that served as a buffer between the two extremes. Gaber blames society for not acting when there were signs of the impending division: "But there had been some terrifying indicators, and everyone should have taken notice of them. When you smell smoke and you don't warn the people around you, then in some way you've participated in lighting the fire. When I look over the newspapers of the first decade of the century, I smell a whole lot of smoke. . . . So why didn't anyone do anything?"[5] *Utopia* is set in 2023 and was published in 2009. Through the character Gaber, Towfik indicates that Egyptian society should have acted upon the increasingly apparent warning signs apparent in the first decade of the twenty-first century—that is, the years immediately preceding the release of his book. His criticism was timely given the antipoverty and prodemocracy uprisings that occurred in several North African and Middle Eastern countries beginning in 2010 that are known collectively as the Arab Spring. In Egypt, President Hosni Mubarak (1981–2011) was forced to resign following the 2011 protests and was later tried and found guilty of being responsible for the deaths of peaceful demonstrators.

Lest the reader dismiss *Utopia*'s social polarization as simply a national matter, Towfik creates links between the divisiveness in Egypt and historical discord in other countries. Several times he cites the 1789 storming of the Bastille, when French revolutionaries took over the Paris prison they viewed as a symbol of the monarchy's abuse of power. Germinal is the seventh month in the French Republican calendar and the main female character among the elite youth of Utopia. The author goes further back in time to reference tyrannical Roman rulers, including Nero, Caligula, and Julius Caesar. Alaa and Germinal's codependent relationship parallels that of Caesar and Cleopatra, whom Towfik also cites. Julius Caesar needed financial resources from Cleopatra and she, in turn, required his support to rule Egypt.

Towfik's *Utopia* may be read as Africanfuturist expression for its speculative representation of a future Egypt and inclusion of technology. The author emphasizes the near future over the far-off future by setting his tale in 2023. In so doing, he stresses that the dissolution of the middle class is happening in real time, something he confirmed in a 2012 interview: "The vision of a near future Egypt that [*Utopia*] paints is something that has been very real recently. The rich are becoming richer, the poor are becoming poorer, and the rich are sequestrating themselves in colonies on the north coast. One of them is even called Utopia."[6] In this context, speculative aspects of the narrative overlap with real life, narrowing the gap between fiction and reality.

Moreover, Towfik provides insight into Egypt's disenfranchised younger generation's ability to save the country from the outcome depicted in *Utopia*. Even without collective social agency, one has personal agency. Alaa's friend Rasim attributes Safiya's resistance to her attack as a demonstration of her will, her freedom of choice. Gaber refrains from harming Germinal and killing the elite pair, thereby showing that people can exercise self-control and prevent themselves from giving in to evil. Egypt's future will come down to a question of agency, will, and abstention from retaliation for being treated as less than human.

Technology is present in *Utopia* in the form of synthetic "biroil." The United States has freed itself from its dependency on oil from the Middle East and gained Egypt's antiquities in exchange for the substance. One of the elite's advantages is their access to the oil substitute. Should they want to leave the country, they no longer need to depart Utopia and navigate the masses, as now their private planes and vehicles all run on biroil. Ultimately, however, it is their dependency on it that leaves the community stranded.

In his Africanfuturist tale, Towfik demonstrates a concern with regional issues and audiences. Rape is a tactic of humiliation and control in *Utopia*. While it is a global problem, Western readers might find Towfik's repeated offhand references to rape unnerving. In the interests of narrative flow, the English translation left out elements of the original Arabic text, including a nearly two-page-long "list of statistics on the assault, rape, and murder of women," which appeared in the "form of quotations from actual newspapers."[7] It is unclear if the numbers were taken from papers or crafted by Towfik. Regardless, the author included rape in his narrative as a real-world social issue rather than something to use purely for shock value.

Towfik likely shaped other aspects of his narrative based on local audiences. For example, oil has a prominent place in the narrative and is a relevant topic for Egyptian readers. Though the country is part of North Africa and an oil-producing nation, it is frequently lumped into the history of oil production in the Middle East and its related international relationships, including with Israel. Similarly, Towfik may have tailored his narrative to appeal to older generations of Arab readers who are not as drawn to stories that predominantly "lean on science or technology" and to younger audiences who "appreciate the connections between art, the imagination and technology."[8] He strikes a balance between factual aspects and histories that underscore the implications of his story, while including teenage protagonists and enough fantastical elements to make the story appealing to the youth who will eventually lead the country. Towfik's dystopian *Utopia* is an entertaining lesson about the consequences of failing to follow the principle of sankofa.

Vortex Comics' (now VX Comics) *Sannkofamaan* digital comic book series is a more literal approach to promoting the value of sankofa. Nigerian entrepreneur Somto Ajuluchukwu received his degree in economics (2012) from Crawford University in Igbesa and founded Vortex in 2015. Headquartered in Lagos, the company specializes in digital products, including comic books, that showcase African superheroes. In the past few years, Vortex has greatly expanded its offerings of its own original titles; however, in its early endeavors to establish a global brand, the company acquired the rights to publish colored, digital versions of American creator Akinseye Brown's black-and-white *Sannkofamaan* comic books. Brown is an author, illustrator, and graphic designer who received his BFA in drawing and painting (1991) from the Cooper Union in New York. The *Sannkofamaan* series features Dr. Derek Daren, an African American physicist who acquired superhuman speed and strength, as well as the ability to multiply himself, via a lab accident with a foreign substance.[9] He is part of a group of supernatural individuals known as Sannkofamaan, whose mission it is to promote and protect justice and peace for Africans.

In the 2016 pilot issue, Dr. Daren arrives in Nigeria to look for his friend and fellow Sannkofamaan, Kwesi, who disappeared following a Bell Oil company explosion. Individuals from Orin in the country's oil-rich Niger Delta region have assembled to peacefully protest Bell

Oil's exploitation of the country's natural resource and repeated oil spills. In response, the company's security personnel have begun to attack the demonstrators as they chase them off the grounds. Daren, as Sannkofamaan, appears on the scene to fight the guards and allow the protestors to escape. Subsequently, while searching for Kwesi in Orin, he becomes interested in the problems the local population has with Bell Oil. Osaze, one of the community members, rebuffs Sannkofamaan's presence, asserting that the American foreigner is unable to help in their fight against the oil militias that are responsible for everything from polluting Orin's land and water to sexually abusing the women. At a town meeting, the locals are divided between lobbying White Westerners to diplomatically intervene in the situation or, as Osaze encourages, taking up arms and going to war with the oil companies. The comic ends when Sannkofamaan, who has left the meeting, finds himself being attacked by an otherworldly creature that emerges from a blob of black oil.

This page from the first issue in the series, titled *Sannkofamaan: Pet the Beast I*, shows Sannkofamaan as he ponders Orin's situation with Bell Oil (fig. 5.1). In the left panel, we learn that the townspeople asked Sannkofamaan to leave the meeting so they could reach an independent decision about their plans. In the top right panel, Sannkofamaan struggles with the idea of potentially going to war, while also reminding himself that he has yet to find his friend Kwesi. He holds his mask in his hand and wears a sleek white-and-black unitard, which emphasizes his highly muscular body. The suit has the Akan adinkra symbol for sankofa emblazoned in gold on the chest. In the bottom right, he has almost completely pulled his mask back over his head when he is startled by the dark liquid that oozes toward him.

The *Sannkofamaan* pilot issue devotes more attention to real-world issues than the fantastical escapades of its eponymous superhero. Ajuluchukwu says it was the story's accurate and relatable concern with the "struggle of present-day Niger Delta at the mercy of foreign corporations destroying an entire ecosystem while mining oil, with zero compensation to the locals of the affected towns" that resonated with Vortex.[10] Shell-BP first discovered oil in the Niger Delta region in 1956, and Nigeria is currently the highest producing nation in Africa. Oil excavation in the Niger Delta has resulted in not only environmental degradation but also conflict between and within the

FIGURE 5.1. Vortex Comics, *Sannkofamaan: Pet the Beast #1*, 2016, digital comic. *Courtesy of Vortex Inc.*

government, oil companies, and local communities, in addition to community counterviolence. Of the comic book's fifteen pages, five show Saankofamaan fighting the bad guys, which in this case are the Western guards who work for Bell Oil. The other two-thirds of the comic are largely dedicated to the saga of the people from Orin, including three pages depicting a community meeting.

Sannkofamaan falls within the body of Africanfuturist production due to its technological and fantastical elements, as well as narrative that foregrounds African concerns. Like most Marvel and DC comic books, the technological aspect of the storyline is linked to a lab setting and accident with a foreign substance. The superpowers that Sannkofamaan gains via the mishap are comparable to those of many Western superheroes, as is his form-fitting suit. In other ways, though, Brown's character and storyline are quite distinct from other Western-originated comics. For example, Saankofamaan's costume is adorned with an adinkra symbol. Additionally, the narrative is set in Nigeria, where inhabitants of the Niger Delta have been facing problems with oil companies for decades, and the term *sankofa*, which forms the root of *Saankofamaan*, is African in origin. Lastly, while Sannkofamaan may use his superpowers to physically protect the Orin people, the townspeople make it clear that they will determine how they should fight the oil companies. It's not often that a comic book features everyday Africans potentially taking up arms to battle a Western entity. Brown explains why he included these relatable people making important decisions in his story: "Africans have the right (and story obligation) to go to war with evil. To ensure that the climax and conclusion to these stories are worth the reader's time and investment—Africans must be Africa's heroes."[11] Audiences worldwide deserve to see Africans in the role of savior and not always victim.

Saankofamaan demonstrates what perhaps can be described as a Pan-African "sensibility" by highlighting cross cultural indigenous characters and communication systems. The concept of sankofa and the symbol on Saankofamaan's suit relate to the Ghanaian Akan proverb and verbal-visual system of adinkra. However, the locale is Nigeria and the comic book portrays the conflict over oil in the Niger Delta region. Additionally, the author is American. In the story, Osaze tells Saankofamaan he can't save the day just because he is from the United States, to which the superhero replies, "Don't call me American." The

dialogue indicates that although African American Saankofamaan feels a strong bond with Africa, the Nigerians see him primarily as a Westerner. When asked about this contentious exchange, Brown indicated that he included it in the comic "in an attempt to be true to types of interactions between people. There is embracing and rejection and every shade of grey in between."[12] The tense scenario is somewhat analogous to the way some Africans resent African Americans portraying African futures in their Afrofuturist production.

Vortex's early collaboration with Brown and simultaneous development of its own characters and series are consistent with sankofa. The Sannkofamaan character and storyline fit Ajuluchukwu and his team's objective to not simply offer comics that feature "superheroes of African heritage but tell stories that impact society."[13] In the past few years, Vortex has grown its offerings of what it calls Spirit Fiction, which are original stories driven by African mythologies, cultures, and traditional philosophies. Through its digital platform, the company enables readers worldwide to learn about Africa's rich histories, indigenous concepts, and customs in a format that appeals to contemporary global audiences. In the spirit of sankofa, Vortex's comics show how Africans might turn to traditional beliefs and practices when facing difficult real and imagined future situations.

(Diébédo) Francis Kéré is an architect from Burkina Faso whose Gando Primary School exemplifies how African creatives apply the concept of sankofa to the built environment (fig. 5.2). Kéré apprenticed as a carpenter at the age of thirteen, and subsequently won a German Academic Exchange Service scholarship to study carpentry in Berlin. In Germany, he worked as a carpenter on projects during the day and attended classes in the evening to finish high school. He received his undergraduate degree in architecture (2004) from the Technical University in Berlin, the same city where he currently resides and has his firm, Kéré Architecture. The primary school was the first of several school buildings in Gando that Kéré designed.

Kéré's approach to the primary school project emanated from his familiarity with Gando, including its lack of educational opportunities. He was born in Gando, and when he was seven years old his father sent him to live with relatives in another town so he could go to school. Because the community's primary means of subsistence is agriculture, this meant one fewer family member to work the land. In addition, the school that Kéré was able to attend had poor

FIGURE 5.2. Kéré Architecture, Primary School, Gando, Burkina Faso, 2001. *Courtesy of Francis Kéré. Photo credit Siméon Duchoud.*

ventilation and lighting, which was not conducive to learning. Because of these unfavorable conditions, he started planning to build a school in his hometown while he was still pursuing his degree in Germany.

Kéré's Gando Primary School, which was completed in 2001, is a 5,661-square-foot structure composed of three independent, rectangular classrooms with spaces in between that are used for outside instruction or break time. The building's fifteen-inch-thick walls are composed of clay mixed with 6 percent cement. "Above each load-bearing wall is a concrete bond beam; metal rods spanning the space of each classroom are anchored to the bond beam and suspend a ceiling made of compressed earth block."[14] Above that primary ceiling is a wider tin roof.

Kéré utilized well-suited design techniques and materials to produce the best structure possible. The addition of cement to the clay fortified the walls' ability to withstand humidity during the rainy season, as well as termite damage. Clay bricks that were created with a hand press promoted structural stability and sustainability through use of locally available materials. When the metal roof heats up from the sun, it draws hot air in the classrooms up and out through the gap between the clay ceiling and the layer of tin. The metal overhang creates shaded porches and courtyards. The school's east–west orientation also limits the sun's heating effects on the side walls. Together,

these features create a natural cooling system that keeps the temperature within the classrooms agreeable and makes the building maintenance-free.

The Gando Primary School can be understood as Africanfuturist expression through its embodiment of the concept of sankofa. In rural communities such as Gando, individuals assist each other with housing among various other tasks. Members of an entire village work cooperatively to build and repair homes. Regardless of financial resources, community members labor on each other's houses as a type of reciprocal exchange: I will work on another's housing because the invested time and labor will come back to me when it is time to repair my compound.

Kéré needed to heed the local approach toward housing for the primary school project to function as a compatible part of the Gando built environment. In addition to soliciting input from community members, the architect and his team developed low-tech, sustainable methods so that everyone in Gando could participate in the building process.[15] Children carried stones for the structure's foundation to the site. Women transported water that was used in creating bricks, and later created the stamped clay floors—a labor-intensive process that requires numerous hours of compressing the clay. Men were taught to use a hand-press machine, and those who were skilled in welding participated in creating the roof.

The architect faced some resistance, however, when it came to his materials. In rural Burkinabe villages, traditional structures such as housing and granaries are made of clay walls and thatched roofs. Cement walls and imported corrugated iron roofs are more expensive and make the interior of the structures very hot. Nevertheless, because clay is both cheap and readily available in Gando, the villagers consider it "the material of the poor."[16] Kéré had to convince the community, who expected the internationally trained architect to use more expensive, imported materials, of the soundness of his choices.

The architect's approach to the primary school project demonstrates a depth of knowledge about the history and customs of Gando's population. As a result of the colonial process in which Westerners overwhelmingly disparaged and dismissed indigenous practices, many Africans have been indoctrinated to believe that all things foreign are superior. Kéré's choice to use clay was not only validation of the material but also, in a sense, the community's indigenous techniques and

practices. By using locally available supplies he produced a structure that was sustainable and not dependent on Western imports, which will better serve Gando going forward.

By involving the villagers in the actual construction of the school, Kéré was investing in and thereby strengthening the community in multiple ways. Having a functional space dedicated to education promotes local opportunities for the acquisition of knowledge alongside other traditional forms of learning. Additionally, locals acquired valuable construction skills they subsequently used to gain employment as laborers on projects outside Gando. Facilitating education in Gando through the school project was as much a part of the process as it was the end goal.

In numerous ways, the Gando Primary School enabled the community to be better prepared to move forward by learning from the past. Kéré gleaned aspects of local traditional approaches, imbuing the principle of sankofa in the school's foundation upon which a new form was built. He says the school "spurred self-empowerment, confidence and solidarity as the community confronts the responsibility of building its own future, together."[17] This primary school demonstrates that the future does not always require a clean break with the past, nor must futuristic forms be solely fantastic. Africanfuturism also allows for the practical application of the past to create a better future.

Sammy Baloji is a multimedia artist from the Democratic Republic of the Congo whose series *Mémoire*, or "memory," reflects the concept of sankofa and involves the technique of remix. Baloji was born and raised in Lubumbashi, the country's second largest city and the capital of the Katanga province. He earned a BA in computer science and communication (2003) from the University of Lubumbashi, after which he began to experiment with photography. Subsequently, he earned a degree in video and photography (2005) from Haute Ecole des Arts du Rhin in Strasbourg, France, and a PhD in artistic research (2022) from Sint Lucas Antwerpen in Belgium.

Mémoire addresses the past and present of mining in Lubumbashi. In 2004 the director of the city's French Cultural Center hired Baloji to document the old and dilapidated equipment and former spaces of the Mining Union of Upper Katanga (Union Minière du Haut Katanga). The same individual also digitized photographs from the mining company's archives, as the former UMHK, now Gécamines, was

set to be liquidated. *Mémoire* is a series of twenty-nine photomontages produced over the course of 2004–6, in which Baloji combines his pictures of contemporary Lubumbashi and cropped sections of archival photographs, the majority of which relate to UMHK's activities from the 1910s to the 1930s. The artist extracts elements from the black-and-white images and then superimposes them on his own digital color pictures using Photoshop, merging past and present.

Untitled #17 from *Mémoire* exemplifies how Baloji creates a visual narrative of the regional history of mining (fig. 5.3). The viewer is faced with a man who looks at us head-on with a stern expression. He stands erect, bare-chested, with his arms by his sides. His pants are ripped and held up with a belt. The background is chaotic. Large, elevated metal framing cuts across the sky on the left and right. Behind it are other dilapidated structures and chimneys. The right foreground is littered with remnants of mine tracks, carts, and wheels on dirt. At center left, the base of a steep slag heap and a dark entryway at ground level are visible. Both halves of the image are dotted with individuals in contemporary clothing. Some are standing still, while others are captured mid-movement. Several of them are submerged in holes to various degrees, and one male in the center-left foreground holds a shovel.

Baloji's visually impactful photomontages incorporate historical elements into the twenty-first century. The artist makes the man, whose photo is archival, the single black-and-white aspect in an otherwise color image. Digitally enhanced to larger-than-life size, the figure dwarfs everything around him. It appears as if he could throw the metal debris with little effort and crush the other humans like ants. He is an imposing figure not only for his size but also for the way he engages the viewer directly with his somber expression, while the other

FIGURE 5.3. Sammy Baloji, *Untitled #17* from *Mémoire*, 2006, archival digital photograph on satin matte paper, 60 × 157 cm. *Courtesy of the artist.*

individuals either survey the scene or are busily engaged in work. Baloji has manipulated the image in such a way that the elevated framing resembles wings sprouting from the man's back. We are in the presence of an oversized cyborg that is only part mortal. We might interpret this deliberate visual effect as an allusion to the way Black Africans were valued for their labor and treated more like machines than humans.

On the surface, Baloji's image resembles a fantastical postapocalyptic war zone. The photomontage might resonate differently with a viewer who is familiar with the history of mining in Lubumbashi, however. King Leopold II of Belgium gained control of present-day Democratic Republic of the Congo during the Berlin Conference (1884–85) and created UMHK in 1906. In 1910, two years after he relinquished rule to the Belgian government, the company constructed a foundry for extracting copper. That same year, the Belgians also built the neighboring city of Elisabethville, which is present-day Lubumbashi. In subsequent decades, UMHK acquired additional machinery and trained African operators to reduce production costs. The company provided housing, running water, primary and secondary education, and medical care in the interests of growing a healthy workforce for the mines. It also brought in laborers from other areas, mostly from the neighboring Kasai region, eventually forming a majority immigrant pool of employees. In 1960, UMHK "presided over the destiny of a society numbering 100,000 people within its cities, 20,0000 of which were workers."[18]

Soon after gaining its independence from Belgium, the Democratic Republic of the Congo was rocked by instability due to a military coup by Mobutu Sese Seko and the assassination of the country's first prime minister, Patrice Lumumba. When Katanga declared itself an independent state under the political leader Moise Tshombe, there was a civil war (1960–63). In 1965, Sese Seko took permanent control of the country and implemented his campaign of Authenticité (authenticity). As part of his efforts to rid the nation (renamed Zaire) of European influences, he seized control of foreign-run operations. By 1967, the state had taken over UMHK and renamed it La Générale des Carrières et des Mines (General Company of Quarries and Mines), or Gécamines for short.

Gécamines was not as stable as the former UMHK and began to decline in the 1980s. The company was financially insecure, which resulted in delayed wage payments and layoffs, in addition to

deteriorating conditions at its worksites. As Gécamines continued to decline in the 1990s, regional politics preyed upon ethnic divisions between those native to Katanga and the Kasaian immigrants, as well their descendants. The provincial governor, Gabriel Kyungu wa Kumwanza (1938–2021), confiscated the company's remaining operations, housing, and equipment, and gave control to the "native" Katanganese. Following the secessionist movement of the early 1960s, many Kasaians were forced to leave the area for the second time, as Katangans considered them "outsiders."

Baloji was personally affected by these developments. The artist's parents were originally from the Kasai region and had immigrated to Lubumbashi.[19] When Governor Kyungu took over the mining operations and its related possessions, Baloji's family lost their home and he had to leave the best school in town. By the time the artist began to work in photography, regional unemployment was high and many Kasaians and Katangese tried to support their households through artisanal mining. Local individuals lack the correct equipment, which makes the work dangerous, and the compensation is limited to whatever dealers are willing to pay. Baloji attempts to capture this precarious existence alongside the fractured remnants of the mining structures in his photomontages.

The visual cautionary tale that makes up the *Mémoire* series relates to the concept of sankofa. The artist includes disturbing colonial-era elements of African children, women, and men, some of whom are naked, wearing neck shackles and marked with numbers, and snippets of European men in relaxed and dignified poses. He also minimizes the archival elements in the majority of his photocollages to emphasize present-day Lubumbashi and the current status of the region's natural resources. Baloji asserts, "I'm not interested in colonialism as nostalgia, or in it as a thing of the past, but in the continuation of that system. My work is really about what is going on now."[20] He is neither romanticizing the colonial past, nor pointing fingers at postindependence generations. He is raising the question of how the cycle of exploitation can be broken so that the people of Lubumbashi might have a better future.

Baloji's technological and temporal remix are characteristics of Africanfuturist production. He mimics mining the Democratic Republic of the Congo's natural resources by removing elements from historical images, which he then inserts into his own digital

photographs. He also disrupts linear time and the idea of progress in his work. Following advances in mining technologies, industrial mining superseded manual excavation. However, Baloji shows vestiges of earlier heavy equipment and operations alongside contemporary artisanal miners, whose tools frequently consist of solely a shovel. What the viewer expects to associate with the past is actually a marker of the present and vice versa. Baloji also uses remix as an artistic technique to create visual amalgamations that do not blend in an easy way. He manipulates scale and makes no attempt to meld the black-and-white elements from the older photographs with the larger color images. The photomontages are intentionally disjointed.

Baloji drew on indigenous beliefs to imbue *Mémoire* with another layer of meaning. Many viewers would connect the individuals from the archival images to a distinct period—the past. They may exist in the photomontage in a visual sense, but otherwise naught. However, Baloji says of his series and local concepts, "For Congolese people, the dead are not dead at all. They are still with us."[21] Thus, the artist is simply making those early twentieth-century individuals visible, laying bare the thread that connects workers from earlier decades and generations with those who labor today.

Though the exploitation of Africa's natural resources is not unique to the Democratic Republic of the Congo, Baloji's focus is his home country, specifically, his local area. Lubumbashi cannot be separated from its mining history, first as UMHK and later as Gécamines, or from its mining present. The artist is not engaging with an issue from afar or grounding his photomontages in fantasy. Industrial remnants dot the regional landscape, and various decaying structures evidence the resonance of colonial history in the twenty-first century. Baloji, in turn, incorporates these extant remains in his technological amalgamations in the spirit of sankofa and the desire for a better future for the local population.

Ivorian photographer and visual artist Joana Choumali similarly remixes manual and technological processes to bridge the past and present. Choumali experimented with photography when she was studying graphic design and advertising in Casablanca, Morocco, in the 1990s. After returning to Abidjan, where she currently resides, she was an art director at an advertising firm for five years before dedicating herself to freelance photography in 2008. Choumali became internationally known for her studio portraits comparing Abidjanais

of different generations through cultural identifiers such as scarification and clothing. She then explored presence, absence, and connections to the past in her series *Ça va aller*, which is a quotidian expression meaning "It's going to be OK." The series was produced between the years 2016 and 2019 and consists of approximately 150 mixed-media works.

Ça va aller was born from Choumali's reaction to a catastrophic national event. On March 13, 2016, a terrorist attack took place in Grand-Bassam, a tourist town located approximately thirty miles from Abidjan. Choumali was familiar with the location from years of family outings. Al-Qaeda claimed responsibility for the assault in which three men opened fire at guests on the beach of a resort hotel. A gunfight with police ensued and ultimately nineteen civilians were killed and more than thirty people were injured. Less than a month later, Choumali traveled to Grand-Bassam. Breaking with her usual approach, she left her camera equipment at home and took pictures with her iPhone. She photographed mainly vacant places that captured the pain and loneliness that resonated in the area. Initially immobilized by illness and struggling to process the events that rocked Grand-Bassam, she began to create *Ça va aller*.

This *Untitled* work demonstrates Choumali's exploration of the themes of presence and absence, in addition to ephemeral existence (fig. 5.4). The backdrop is an image of a young woman, who appears to have just exited the gated building behind her. Her body is at a forty-five-degree angle, and she casts her gaze downward at the ground in front of her. Layered onto this scene is a corpus of green, white, and gold stiches. They transition from interspersed droplets to the outlines of legs and feet wading into shallow waves that break on the sand. The viewer occupies a space further out in the water and faces the shoreline. Read from the top down, Choumali's stitched raindrops progressively assemble to reveal partial bodies. These outlines might represent tourists who visited Grand-Bassam's famous beaches previously or suggest individuals drawn to the area in the future. Read in the other direction, the figures steadily dematerialize into the atmosphere, eventually slipping out of sight. Their fading presence parallels the loss of life that occurred on March 13.

Choumali created the works in *Ça va aller* through an artistic remix of both manual and technological processes. She printed the pictures of Grand-Bassam from her iPhone on cotton canvas. She

FIGURE 5.4. Joana Choumali, *Untitled* from *Ça va aller*, 2016, embroidery on digital photography printed on canvas, 24 × 24 cm. *Courtesy of the artist.*

then forwent the use of additional mechanical processes and altered the images through hand embroidery. Because most of the pieces only measure about 9.5 inches square, Choumali was able to work on them everywhere from sitting in traffic to standing by in a hospital waiting room. Nonetheless, remixing the printed images with hand stitching was labor- and time-intensive, often taking months to complete a piece. Rather than a compartmentalized act of artmaking in the studio, working on *Ça va aller* became a way for Choumali to process her feelings regardless of time or place.

While her creative process involved a form of "downloading" both pictures and emotions, the latter was significantly more complex and prolonged. Embroidery became a method for addressing pain in a concrete way. Choumali sewed the same stitch again and again without varying her technique. Each stich was a visible acknowledgment

of her feelings. The physical repetition helped to alleviate her inner turmoil, almost luring the artist into a meditative state and providing a mental escape.

Choumali, who is of Akan heritage, used the principle of sankofa to guide her creative objective. She states: "I recognized and captured a point of hope in these difficult times by reminding myself of what this space was before, by acknowledging the contrast of what it had become following the terrorist attack, and by visualizing, projecting in the aftermath, while accepting the fact that it may never be the same.... It is an act of hope and resilience."[22]

Moving through a healing process requires the recognition of difficult topics and feelings. Choumali promoted the importance of addressing pain rather than suppressing it by participating in a conference that encouraged residents to take advantage of free mental health services at Grand-Bassam's hospital and by creating *Ça va aller*. The artist admits that her works were a way for her to process emotions that she could not verbalize and hopes that they will encourage others to talk about their feelings. People cannot always prevent bad things from happening in the world, be it political violence, such as the civil war that broke out in Ivory Coast in 2011 after President Laurent Gbagbo refused to concede the general election, or a global pandemic; however, by acknowledging painful emotions and recognizing how trauma affects us, individuals will be better prepared mentally to face future challenges.

Choumali's use of remix makes her works relatable to Africanfuturism. To create the *Ça va aller* pieces, the artist used technological equipment in the form of the iPhone and printer. Then she transformed her images through hand embroidery. According to the artist, "The Akans believe that there is much movement and new learning as time passes, but as this forward march proceeds, the knowledge of the past must never be forgotten."[23] Choumali elicits the principle of sankofa to show the possibilities offered by traditional concepts and approaches and to emphasize that a better future means looking forward and backward.

Choumali's series is informed by direct knowledge of the community and indigenous practices. Her choice of title has local significance. The reluctance of Grand-Bassam's residents to talk about the trauma was not unusual given that Ivorians don't generally "discuss their psychological issues, or feelings. A post-traumatic [shock] is considered as weakness or a mental disease."[24] Ivoirians utilize the

expression "Ça va aller" to end a conversation instead of confronting difficult emotions. However, the phrase also indicates an air of optimism about what lies ahead through the simple future tense—it's *going to be* OK—and is a way to leave things on a positive note.

Choumali similarly posits both pragmatic and encouraging visions of Grand-Bassam in her embroidered pieces. The initial period of grief seems to find a parallel in some of the works with rows of stiches that form a semitransparent veil of affliction over entire scenes of the area and its people. The intensity of this feeling often dissipates over time, though it never fully leaves. Many of the pieces in the series include embroidery in minor details of a scene as well as in geometric shapes around individuals and as landscape. Like the warmth from Grand-Bassam's sun, the presence of those who were lost during the attack is palpably felt but not concretely tangible. The artist uses colored thread to fill the voids, adding another dimension to the photograph's flat surface and populating Grand-Bassam with the human presence for which it is known.

Choumali's detailed, small-scale pieces cannot be fully absorbed from a distance. They draw the viewer in and require close inspection. The artist invites her audience to contemplate the relationship between the series title and the scenes. The works are small acts of healing and recovery on a national, regional, and individual level.

CONNECTIONS ACROSS AND BEYOND THE CONTINENT

These various examples of Africanfuturist expression linked with sankofa and remix have several common characteristics, including a focus on real-world issues that resonated with the creative producers on a personal level. Towfik viewed social polarization as a disease like any other capable of wreaking havoc on a population. Vortex Comics, in its collaboration with Brown and through its own original products, sought opportunities to "pass on valuable messages to [its] young readers and at the same time raise heroes who tackle real life evils personified in comic book villains."[25] For Kéré, education wasn't accessible locally due primarily to lack of a school building. Baloji witnessed the economic devastation and ethnic division caused by the exploitation of the region's minerals. Choumali was among many individuals who dealt with mental health challenges following the traumatic attack in Grand-Bassam. Through their works spanning different mediums, these creatives

promote looking to past practices and concepts to help one prepare for future challenges.

We can identify additional commonalities in Africanfuturist expression across and beyond the African continent by comparing the examples from this chapter with other works. Both Towfik and Baloji suggest that history will repeat itself unless people change their behaviors. A fellow cautionary tale is found in Fabrice Monteiro's images of environmental degradation (figs. 5.3, 6.3). Brown/Vortex Comics and Baloji address harmful practices related to control over Africa's oil and copper, respectively. Kamuanga Ilunga, who like Baloji is from the Democratic Republic of the Congo, is also concerned with local natural resources (figs. 5.1, 5.3, 4.3). Further, both Baloji and Kamuanga Ilunga visually liken humans to machines to highlight how Africans have been used in various types of labor.

The Africanfuturist works from this chapter, similar to others, also involve technology. Brown and Vortex Comics, like Leti Arts, make their African-focused narratives accessible and appealing to a contemporary global audience by publishing comic books on online platforms (figs. 5.1, 6.1). Both Baloji and Kenyan artist Jacque Njeri use digital processes to create photomontages from disparate sources (figs. 5.3, 2.2). Whereas Baloji brings historical elements into representations of the present, Njeri propels aspects of the present into her images of the future.

Sankofa and remix may be useful entry points to identifying and analyzing similarities between Afrofuturist and Africanfuturist expression. Because sankofa is a familiar concept across different geographical areas, it may manifest itself more diversely than the small number of common tropes used to indicate space exploration or aliens, for example. Western and African journalists have linked Vortex's comic books with Afrofuturism, as has company founder Ajuluchukwu. African and Western individuals in the fields of architecture and design have linked Kéré with Afrofuturist expression and Kéré Architecture's web page states that it creates "sustainable solutions that project an afrofuturistic vision."[26] To date, Towfik, Baloji, and Choumali have not been included in Afrofuturist discourse.

AFRICANFUTURIST REVELATIONS

These examples encourage consideration of how African creatives imbue their works with the principle of sankofa in ways that are both

visible and visually imperceptible. One sees the clay bricks used to construct the Gando Primary School, which are traditional building materials. The unseen is Kéré's validation of the community-oriented approach to producing structures. Baloji's photomontages offer a lesson in regional history that makes visible the contributions of now-absent workers. Concealed within the scenes is the implicit warning about allowing patterns of exploitation to continue. Choumali's hand-stitched details give a physical form to the terrorist attack's marks on the people. The psychological and emotional scarring, however, is visually undetectable.

These works that are informed by history also show an interest in addressing the needs and interests of Africa's younger generations who will lead the continent going forward. Towfik wanted Egyptian youth to see themselves in the youthful protagonists of *Utopia* and realize what the future would hold for them if they did not help move their country in another direction. Ajuluchukwu and his colleagues have identified their primary intended audience as young readers. Vortex encourages local youth to buy its products and find a future career in the industry by holding afterschool programs to teach students how to create cartoons and comics. Kéré's project prioritized the educational needs of the community's children by building a primary school. Baloji encourages younger generations of Congolese to find a way out of the systems of oppression that originated in the colonial era and continue today. Similarly, Choumali wants Ivoirians to seek help for their mental health issues even if that means going against older generations' ideas about suppressing psychological and emotional struggles.

Africanfuturist creations that advance indigenous strategies, concepts, and perspectives reflect a decolonial approach to speculative expression. Kéré's use of clay encourages Africans to reject the ideology that foreign materials and methods are superior to those from the continent. Likewise, Choumali shows that there are ways to practice mental health self-care that predated Western-developed medications and are still relevant. Brown and Vortex's collaborative project counteracts the characterization of Africans always needing to be saved by the Western world. Baloji's work is grounded in an African understanding of time that is not exclusively linear. Additionally, both he and Towfik push back against the Western concept that forward movement through time is tied to ideas of progress and development.

These and other African creatives largely draw from a specific local history or cultural past. They take from the traditions that have proved their worth over years, decades, and sometimes even centuries, carrying them into the present and future. As per Sarr, it is these cultivated values and traditions that have given the continent its social resilience and which will be equally important moving forward.

CONCLUSION

The Africanfuturist demonstrations of sankofa and remix discussed in this chapter reveal personal connections and objectives that shift the emphasis away from the predominantly fantastical. Towfik wanted to shine light on the growing disconnect in Egyptian society. Through his character Dr. Derek Daren, Brown sought to show "a man very much invested in science, research, wonder, what will be—and yet also on a journey of embracing one's heritage," which, he says, was essentially like writing about himself.[27] Through Vortex's comic books, Ajuluchukwu endeavored to show Africans that power can be found in indigenous beliefs and traditions. Kéré desired to create a school for his home village. Baloji wished to call attention to the lived environment of Lubumbashi and the local mining history, and Choumali wanted to help herself and Grand-Bassam's community to heal.

SUGGESTED ADDITIONAL RESOURCES

In addition to the materials cited in this chapter, here are suggested additional resources. Full details for each source can be found in the bibliography.

Delphine Pagès-El Karoui's article "*Utopia* or the Anti-Tahrir: The Worst of All Worlds in the Fiction of A.K. Towfik" contains a brief analysis of Towfik's novel. Herbert M. Cole and Doran H. Ross's chapter "The Verbal-Visual Nexus," in their publication *The Arts of Ghana*, is a useful discussion of adinkra as a communicative system. Alyssa Klein's article "Nigerian Superheroes Set to Take Over the Comic Book World" provides additional details about Somto Ajuluchukwu and Vortex Comics, as does Ajuluchukwu's TEDx talk "The Revolutionary Power of Comics." The essays in Andres Lepik and Ayça Beygo's edited publication *Francis Kéré: Radically Simple* are in-depth discussions of Francis Kéré's work.

For an overview of the history of mining in the Democratic Republic of the Congo from the colonial era through the present, see

Sarah Van Beurden, "A New Congo Crisis?" Additional information about Sammy Baloji and his work can be found in the artist's interview "Colonial Extractivism and Epistemic Geologies in the Congo" in *The Funambulist* and in Gabriella Nugent's article "Mining Time in Sammy Baloji's *Mémoire*." Naomi Rea's article "'It Was a Sort of Therapy for Me': Joana Choumali, the First African to Win Europe's Top Photography Award, on Her Emotive Work" and Amy Parrish's article "Responding to Tragedy with Art and Hope" are useful sources on Choumali and her *Ça va aller* series.

DISCUSSION QUESTIONS

How important is geographical or cultural specificity to making these Africanfuturist works effective examples of sankofa?

How do these Africanfuturist works involve the theme of labor in both positive and negative ways?

How do Baloji and Choumali use remix as a "communicative practice" in their Africanfuturist expression?

How do these Africanfuturist works relate to the concept of the supernatural?

How can we understand these Africanfuturist examples of sankofa and remix as empowering?

CHAPTER SIX

Mythmaking

MYTHS MOST often explain the origins of a people or an event; that is, they tell how something came to exist. They reflect beliefs and values, and sometimes provide models for human behavior. Think about Icarus being warned about flying too close to the sun or cautioning someone against opening a Pandora's box. Myths can be focused on the preexisting world. They can also address supernatural beings and occurrences.

Like other societies worldwide, many African peoples have their own myths. These narratives may deal with a universal theme such as the creation of the world, which is a cosmogonic myth. In the case of a heroic myth that details the great feats of an ancestor, the theme may be geographically or culturally specific. Regardless, a society most often shapes its myths according to its physical location, relative conditions, and history. Further, authorship is attributed to a group rather than a single individual.

In Africa, most myths were, and to varying degrees still are, communicated orally. This orality allows for—even encourages, one might argue—variations between regions, individuals, and situations. Myths are not meant to be taken literally, but rather valued for the underlying meaning or message they convey. Like most social practices, myths are not stagnant; they change over time. The most important points stay the same, but some details might be modified.

In the West, most myths were recorded in the written form, as books, long ago. As a result, Westerners tend to think of myths as

belonging to ancient history—archaic stories that don't hold up against scientific rationalism. Westerners have also been responsible for most of the written records of African myths, especially during the colonial era, which were made in European languages. Not only does this go against the way African myths are traditionally communicated in their respective spoken languages but such a permanent record does not enable regional or temporal variations. Instead, the myth is locked into a static existence. It becomes another item for Westerners to collect as opposed to the permeable thing it is to its own people. Moreover, in many African societies, myths continue to be widely repeated and appreciated. They are very much contemporary points of reference for the way some Africans think about the world and their position in it.

Pamela Phatsimo Sunstrum is a multidisciplinary artist who explores the relationship between African myths and futurist expression from the African continent. In her article "Afro-mythology and African Futurism: The Politics of Imagining and Methodologies for Contemporary Creative Research Practices" (2013), she emphasizes how the distinctly African origins and concerns of what she calls "Afro-mythology" likewise lend themselves to imaginings of African futures. African mythology and science fiction, which may on the surface seem unrelated—one often thought of as old and the other new—frequently employ common ideas and representations of "futuristic settings, advanced science and technology, space travel, parallel dimensions, alien species, [and] the paranormal."[1] Further, by looking at how Africanfuturist production from the continent involves the act of mythmaking, we see that neither is African Futurism exclusively a forward-oriented exploration, nor is Afro-mythology exclusively historically bound. Rather, African mythic modes are just as likely to be about alternate versions of the present and that which lies ahead.

Numerous African creatives, including Phatsimo Sunstrum, meld myth and science fiction in their work. They often use myths with which they have a geographic, ethnic, or cultural affiliation as the foundation for their own mythmaking in their Africanfuturist expression. They take preexisting myths and modify them to fit their own imaginings of African presents and futures. They may also refashion elements of European mythology for the same purpose. In this interpretive act, African creative producers demonstrate agency by crafting and telling their own stories, using and discarding mythological elements as they so choose in the process. Although they, too,

may create a permanent record, whether through film, photography, graphic literature, or any number of other forms, they are not aiming to capture any myth verbatim. They are using Afro-mythology as a source of inspiration for their creative process—incorporating, transforming, inventing, and ultimately showing mythmaking to be a contemporary endeavor.

Sarr identifies myths alongside cosmogonies, linguistic sources of African languages, and other forms of cultural expression as various forms of knowledge that have ensured the survival, growth, and durability of African societies and which African peoples should continue to consider in centering the continent.[2] Mythologies are a way for Africans to understand themselves. They are sources that inform one's worldview, and which help one decipher the enigma that is this world. Myths are as important as Western forms of conveying knowledge. Social, political, and educational systems frequently change over time. Nevertheless, Africans' worldviews and systems of thought, including myths, will continue to be driving forces for their respective societies, carrying them into the future.

Nigerian author and journalist Chiagozie Fred Nwonwu, who frequently writes under the pen name Mazi Nwonwu, weaves together aspects of Igbo mythology and aliens in his short tale "Masquerade Stories" (2012). Born in Nkwe, in Enugu State, Nwonwu earned his BA in linguistics (2004) from Nnamdi Azikiwe University in Anambra State and dabbled in writing science fiction. Upon participating in some of the earliest national and Pan-African endeavors to support African science fiction writing, he quickly established himself as one of Nigeria's best-known authors of this genre. His "Masquerade Stories" was published in the first anthology of science fiction tales by African authors.

"Masquerade Stories" tells of an encounter between three young men and an alien in late twenty-first-century Nigeria. Rex and Ebuka, twin brothers from the United States, have returned to their family's ancestral home region to participate in an Igbo male initiation ceremony that involves masquerade performances, or *Mmanwu*. The morning after the rite, Rex realizes that his ocular implant has inadvertently captured the presence of a foreign being among the human masqueraders. In a quest to find out if this being's presence can be traced back to their ancestors' time and understanding of deities, the twins travel with Chinedu, their Nigerian cousin, to a library that houses a school for ancient Igbo mythology. After discovering a

drawing of a similar nonhuman in an ancient book and debating what to do with the information, the story ends when the men unexpectedly find themselves face-to-face with aliens.

Nwonwu's main theme is cultural revival, which he expresses through a series of contrasts between modernity and foreign ways or influences versus tradition and indigenous ways or practices. For example, technology provides the young men a simple and direct way to access the foreign being through the recording, albeit unintentionally made. The author juxtaposes this relative ease with the physical effort the men must exert to reach the initiation site, which acts as another representation of the foreign or unknown. Because in the story, the Igbo outlawed technology from their masquerades during the earlier cultural revival period of the men's grandfather, we understand that technology isn't always desirable. It's incongruous with indigenous practices that are not meant to be preserved in the form of a permanent record. Here technology belongs in the same Western-introduced category as the new European-influenced religions and GMO farms versus African traditional religion and forests. The Igbo have their own ways and systems. They convey knowledge via the graphic visual language of *nsibidi*, whereas Westerners recorded information in books. In the United States, Ebuka's social status is a result of his professional accolades and awards. In Nigeria, an Igbo person's position as an adult in the community is earned by undergoing the appropriate required initiation rituals.

In his story, Nwonwu uses indigenous Igbo mythology as the foundation for his own mythmaking. Many African societies have their own traditions in which men perform masquerades. Across religions and cultures, people believe that when a man puts on a consecrated mask, he ceases to be a mortal and instead "becomes" whatever spirit or deity the mask represents. Nwonwu uses this transformational concept as an opportunity to insert an otherworldly element into his tale. Ebuka, the narrator, wonders about the foreign presence in the recording and any possible historical contact with his people: "Could it be that this is actually an alien and my ancestors encountered them and thought them to be spirits, I pondered. Somehow, that did not sound strange to me."[3] The suggestion that Ebuka's ancestors would have accepted an unfamiliar form is plausible given the widely held belief across Africa that deities, spirits, and ancestors are associated with an otherworldly realm, different from the human realm. Further,

the creature in Rex's recording looks similar to the Igbo *Agaba* masquerade, with its huge jutting teeth and fierce expression. If the ancestors modeled one of their masks on the foreign form, believing it to be a spirit, then aliens may have influenced an Igbo masquerade. Regardless, the story suggests that an encounter with an extraterrestrial being is neither new nor fantastical but a part of Igbo history.

"Masquerade Stories" features several common characteristics of Africanfuturist expression, including a future time setting, as well as inclusion of technological and fantastical elements. By placing his tale in the late twenty-first century, the author emphasizes the near future over the far-off future. In this way, he plays with the idea of the here and now versus the yet to come, as Rex and Ebuka's "grandfather's time" is the reader's present. Because of this, we might wonder if Nwonwu is indirectly suggesting that a concerted "cultural revival," which rejects using technology as a tool for the preservation of indigenous practices, is something that should be taking place now.

In choosing to set his story in the late twenty-first century, the author also offers ideas about the role that technology might play in people's lives in the future. Nwonwu includes sensory-enhancing implants, a brain memory chip, and a holographic projection. These are sophisticated examples, yet they are not totally out of the realm of possibility given the existence of Google glasses, insulin-producing and cochlear implants, and holograms for use in musical performances and television commercials. Further, the author locates technology, in the form of the holoprojector, in the Igbo home. This differs from the more frequent association of technology with a lab setting in Western speculative representations and challenges narrow Western perceptions of African housing as rudimentary and lacking modern features such as electricity. One thing Nwonwu suggests won't change going forward is the embrace of technology by some, here symbolized by Rex and Ebuka, and the rejection of it by others, demonstrated by Chinedu and likeminded individuals who share old ways of thinking and living.

Nwonwu spotlights indigenous African cultural practices and beliefs in a reflection of contemporary life on the continent. Westerners' exposure to masquerades is often limited to the physical mask itself, which is most often viewed in isolation in a museum or gallery setting. In context, the mask is one part of a larger ensemble and the associated representative spirit or deity "takes over" the body of the human performer who wears it. In the twenty-first century, masquerades

as well as male and female initiation ceremonies still have a place in many African societies. Participants take these practices as seriously as the young men in "Masquerade Stories," who swore to uphold the oath of secrecy surrounding the *Mmanwu*.

However, he juxtaposes these indigenous aspects with the lingering effects of Western colonial projects on the continent and shows how Africans might mitigate them. The author indicates that in the postcolonial era, Africans can strategically appropriate foreign concepts and practices that were once forced upon them for their own benefit. The twins' grandfather did this when he successfully used European conservationism to promote reforestation. Nwonwu also suggests that Africans must play an active role in the preservation of their indigenous cultures. What is often of interest to Western researchers, including those who consult the Igbo archives in the library in "Masquerade Stories," should be of interest to Africans. The author is no exception.

Nwonwu's tale is not just inspired by Igbo culture, but also about his personal journey to gain a better understanding of his heritage. The author was born in the ethnically Igbo area of southeastern Nigeria, where he lived with his mother. During his childhood, he moved to the ethnically Hausa North of the country to be with his father. When he went to university, he returned to the Southeast. When he authored "Masquerade Stories," Nwonwu was trying to reconnect with his Igbo heritage through language acquisition. As part of his cultural awakening, he also became a member of a masquerade society. His story became another way for him to connect with his heritage and to help others who found themselves in a similar situation. If someone like him wanted to understand the culture's masquerades, his narrative would be a "form of depiction" that they could utilize as a point of access.[4]

In "Masquerade Stories," Nwonwu practices his own form of mythmaking, utilizing indigenous Igbo beliefs and, to a lesser extent, Western elements. He drew inspiration from overlapping fantastical aspects found in folk tales his mother told him as a child, comic book stories, and science fiction.[5] He then combines aspects of Igbo mythology and speculative fiction tropes, including aliens. The Igbo believe that masquerades represent the earthly representatives of spirits and ancestors.[6] These ancestors do not represent individual people, but rather are more general forces that appear to humans for benevolent

and malevolent purposes. The masquerade allows for the merging of human and spirit, bringing together the realm of the living with that of the dead. "Masquerade Stories" provides contemporary readers an entertaining way to learn about Igbo masquerades, even if they are not aware of the mythological concepts. Nwonwu's approach toward indigenous beliefs and customs locates his narrative outside the realm of the purely didactic. Further, without providing a firm conclusion, he leaves his readers to imagine their own ending to the story, much like a comic book's cliffhanger ending.

Author Lauren Beukes somewhat similarly combines mythology with science fiction in her novel *Zoo City* (2010) to comment on contemporary South Africa. Raised in Johannesburg, Beukes worked as a freelance journalist nationally and internationally for over a decade before earning her MA in creative writing (2006) at the University of Cape Town. Her first dystopian novel, *Moxyland*, was published in 2008, and she worked on the South African science fiction animated television show *URBO: The Adventures of Pax Afrika*, while she wrote *Zoo City*.

Beukes's novel is set in 2011 in an alternate Johannesburg. Criminals are identified by a physical manifestation of their offender status in the form of an animal. The protagonist is Zinzi December, a thirty-two-year-old former journalist and ex-addict who was indirectly responsible for the death of her brother during a drug deal. Because of this, she is among the "animalled" and is paired with a sloth. She earns money to pay off her drug debt by tracking down lost objects for people and writing scam emails aimed at getting Westerners to send money to a variety of fabricated Africans in need. December is hired by Odi Huron, a famous music producer, to find the missing female sibling of a teenage singing duo. The novel tells the story of December's quest to locate the singer, introducing the reader to different characters and parts of Johannesburg in the process.

The key premise of *Zoo City* is aposymbiotic familiarism, or the matching of an animal with an individual who caused the death of another person. According to the novel, this worldwide phenomenon dates to the 1980s. Individuals do not get to choose the type of animal they are coupled with and experience severe separation anxiety when distanced from it. Any attempt to physically hide their animal from view is only temporarily successful. These socially marginalized people form their own subgroups and reside in certain areas. In the

novel, December lives alongside other "animalled" individuals in the neighborhood known as Zoo City.

The main theme of Beukes's novel is one's inability to divorce themself from their connection to another person's death. Even if the "animalled" person was only indirectly responsible for someone else's death and has paid their debt to society by serving prison time, as in the case of the protagonist, they will forever carry the burden of their transgression, both figuratively and literally. Because the animal is an outward physical manifestation of the individual's guilt or sin, the person is visually identifiable as a criminal. As December describes it, her sloth is her "own personal scarlet letter," in reference to Nathaniel Hawthorne's famous novel.[7] Beukes further underscores the tie between criminal and animal by sometimes referring to a person by the name of their animal. Aposymbiotic familiarism forces resourcefulness both at the individual and group levels. Regardless, the "animalled" will never be able to rid themselves of their social stigma.

Zoo City was inspired by the mythology of the Shona peoples of South Africa. Most Shona convictions and practices pertain to navigating a variety of spirits that influence the realm of the living and which are accessed through a diviner or medium. A *shavi* (plural *mashavi*) is the spirit of an individual who died far from home. Because the appropriate death ritual was not performed for the person's spirit, it wanders until it inhabits another individual or "host."[8] More broadly, a shavi can also be the spirit of an animal or object, which provides its host with some related skill. In *Zoo City*, the mashavi is a wandering spirit that takes up residence in a human, as well as the animal with which they are paired. The animal familiar enables its human with some type of psychic power or shavi. For example, in the story, the protagonist has a special ability to find things that are lost. In this way, Beukes uses the Shona principle of the mashavi to explain the animal familiar phenomenon.

Though the author draws heavily from these Shona beliefs, she also does her own mythmaking in her story. She retains the concept of the wandering spirit but gives it a physical presence in the form of the animal. As such, she creates a new myth that is similar to Shona beliefs and yet also different. For a reader who is unfamiliar with the Shona idea of the mashavi, the animals in Beukes's *Zoo City* appear to be wholly fantastical aspects of the story. Animals who possess special powers are common features of African myths and folktales,

which locate these creatures within the realm of the possible from an African perspective. Nevertheless, only someone who is knowledgeable about Shona concepts would be able to discern how the author has modified them to create her own myth.

Beukes is not trying to simply build her story around preexisting beliefs but rather to incorporate aspects from various mythologies and shape them to fit the social and political climate of postapartheid South Africa. The author cites books on South African and Greek mythologies she encountered as a child as influences on her writing.[9] The latter is evidenced in the character of Odi Huron, whose first name is short for Odysseus. In Greek mythology, Odysseus was a trickster who was king of Ithaca and the protagonist of Homer's epic poem the *Odyssey*. Beuekes turned to these childhood sources to write about contemporary South Africa. According to the author, most national literature from the early twenty-first century dealt with apartheid, with "growing up white and coming to terms with being complicit in this system," and "pars[ing] this new reality in a realistic way."[10] Beukes addresses South Africa's "new reality" through a speculative lens.

Through the concept of aposymbiotic familiarism, she explores how people treat each other and how South Africa, as a nation, can move forward in the process of postapartheid reconciliation. Only late in the novel is Odi Huron revealed to be one of the "animalled." It is not by chance that the character named for the Greek mythological trickster has a white albino crocodile as his animal familiar. In South African history, Pieter William Botha held several prominent positions during the apartheid era, including prime minister (1978–84) and president of South Africa (1984–89). He was widely referred to as Die Groot Krokodil (the Big Crocodile) in the Afrikaans language, for his temperament and belligerence. Botha was unapologetic about his politics and the role he played in the deaths of numerous South Africans, refusing to testify before the Truth and Reconciliation Commission. Beukes was among many South Africans, as well as individuals from other nations, who were bewildered by the extremely gracious and generous comments and actions of the African National Congress following Botha's death in 2006.[11] In the novel, Huron's lack of remorse for his "sin" causes his own demise, while December continues to struggle to forgive herself for her brother's death. In her own life, Beukes was grappling with absolution and reconciliation

following decades of repression, killing, and human rights violations in her home country.

The author demonstrates her intimate familiarity with contemporary South Africa by portraying a microcosm of the nation in her novel. The area of Zoo City is based on the inner-city residential neighborhood of Hillbrow in Johannesburg. Its issues, including a high crime rate, dilapidated structures, poverty, and population density, are indicative of social and economic discrepancies that continue to plague much of the country well after the end of apartheid. In contemporary South African society, indigenous beliefs and healing practices coexist alongside Western-influenced doctors and medicines. Although access to the latter is frequently determined by economic status, there is also a cultural factor. Western readers might interpret Beukes's multiple references to the *sangoma*—an indigenous healer who performs rituals, including divination, and their *muti* (traditional medicine)—as fantastical elements; however, these individuals are commonplace throughout Southern Africa. Both in the novel and in contemporary society, *sangomas* range from fraudulent scam artists to individuals who are highly respected and frequently consulted by members of their communities.[12] Thus, although some of South Africa's characteristics are more universally understandable, there are other ways that the country is characterized by its own mixture of indigenous, traditional practices and influences, and Western-influenced customs and beliefs.

Zoo City can be considered Africanfuturistic expression due to its emphasis on African themes and features portrayed from the perspective of an African author and its setting in an alternate version of Johannesburg. According to Beukes, her novel is an apartheid allegory, which explores how society deals with crime and criminals.[13] In making the Shona concept of spirit possession fit her contemporary commentary on guilt and accountability, the author practices her own mythmaking. Additionally, she pokes fun at the Western stereotype of Africans in need of saving, which is another kind of myth in and of itself, through Zinzi December's email scams. Beukes's speculative Johannesburg also distances itself from a positive postapartheid South Africa and instead presents a dystopia in which people remain heavily divided.

Leti Arts is a company that features African mythologies in its digital comics and games. Ghanaian entrepreneur Eyram Tawia and

Kenyan entrepreneur Wesley Kirinya cofounded the business in 2009 with its headquarters in Accra. *The True Ananse* (2013) is a Leti Arts digital comic book series dedicated to the Akan folk character Kweku Ananse. This figure is known throughout Ghana and much of West Africa for his intelligence and cunningness. The comic reimagines Ananse as a contemporary superhero. In 2014, Leti Arts released the mobile game *Ananse: The Origin*, based on the pilot issue of the comic book series. Ananse is one of eight superheroes from Leti Arts who fight crime in modern-day Africa and who together form the company's *Africa's Legends* franchise.

In the comic book's pilot issue, *Ananse: The Origin #1*, Kweku Ananse tries to rise from his place among the lesser gods to a higher position as one of the four paramount gods of the Sky Kingdom. The King of the Gods (Odumankoma) seeks one additional deity to support his rule over humankind and the lesser gods, after already having secured the Goddess of the Earth, God of Waters, and God of Fire. To win the position, the King of the Gods challenges Ananse to capture and bring back the most dangerous forces on the earth—the python, the leopard, the hornets, and the dwarf. In the guise of a superhero, Ananse uses his trickery and intelligence to outsmart all four and deliver them to the King. As a result, he is made God of Wisdom, which is the fourth pillar of the Sky Kingdom and mediator between humankind and the King. Soon thereafter, Odumankoma learns of Ananse's plan to create his own kingdom. The enraged King of the Gods punishes Ananse by turning him into a spider and banishing him to the terrestrial realm of humans, where he is nevertheless revered. Over time, humankind comes to think of this story about rulership and the Sky Kingdom as a mere folktale; however, the pilot issue ends with the suggestion that Ananse will return.

This page from the *Ananse: The Origin #1* comic book captures the moment when the King of the Gods gives Kweku Ananse his challenge (fig. 6.1). In the left panel, Odumankoma points one arm at Ananse, who kneels before him. In his other arm, he grasps his staff with the Akan adinkra symbol for *gye nyame*, or "except God." This motif relates to the concept of fearing nothing and no one other than God and alludes to Odumankoma's omnipotent and supreme position. The ruler lists the four most dangerous creatures, which Ananse will have to capture and bring to him, by both their Akan and English names. In the right panels, Odumankoma bids Ananse

Mythmaking 143

FIGURE 6.1. Leti Arts, *Ananse: The Origin #1*, 2013, digital comic. *Courtesy of Leti Arts.*

farewell, and the ever-cunning Ananse, in turn, expresses confidence in his abilities. In the bottom right panels, the King of the Gods' flowing robe spills beyond the edges of the picture plane, which gives him a commanding presence. Whereas thus far in the comic Ananse has appeared dressed in a purple robe and spider necklace, here he is

wearing an eye mask and green unitard decorated with a red sash and bright yellow spider. The outfit resembles those worn by Western comic book superheroes that accentuate their sleek, muscular bodies, and signals a shift from Ananse as lesser god to Ananse as superhero. The images highlight the figures' gray hair, which is both a sign of their age and a symbol of wisdom.

Leti Arts has based its comic book storyline on the Akan mythology of Ananse, the trickster. The Akan peoples of West Africa, the majority of whom live in Ghana, traditionally communicated their various tales featuring Ananse orally. In those stories, known collectively as *Anansesem* (Ananse's stories), Ananse appears in the shape of a human being or a spider. Leti Arts presents its own version of Ananse through a visual narrative with the character as a god-turned-superhero-turned-spider in the pilot issue.

Though Leti Arts is headquartered in Accra, this was not the only reason it selected an Akan character. It was also a strategic decision driven by the company's marketing goals. Leti Arts chose all of their *Africa's Legends* characters based on how well they were known across and beyond the African continent. Thus, they selected those with the best potential to build the franchise into a global brand.[14]

Guided by this mission, the company practices its own mythmaking through its digital Ananse products. The company selectively combines themes from folktales of the trickster's origins and escapades, with the visual conventions of international comic book superheroes. Leti Arts takes its influences for the storylines from Akan, and even more broadly African, sources. *Ananse: The Origin #1* tells the origin myth of how long ago, Kweku Ananse was turned from a god into a spider and came to live among humankind. In contrast, the company looked to both regional and global models when making decisions about Ananse's physical appearance.

The company's take on the Ananse character, in particular, was shaped by Tawia's exposure to new forms of media that became available during his formative years. In the late 1980s and early 1990s, the Ghanaian television program *By the Fireside* featured children acting out the *Anansesem*, which had been adapted to fit contemporary social issues.[15] As a child, Tawia also became familiar with international superheroes through imported TV programs and comic books. By the end of middle school, the budding entrepreneur and his friends were educating themselves about digital technologies via the internet

and experimenting with different software. Tawia went on to earn a degree in computer science (2006) from Kwame Nkrumah University of Science and Technology in Kumasi, Ghana. When he and Kirinya, who had studied actuarial science at the University of Nairobi in Kenya, created Leti Arts, they combined their digital expertise with their knowledge of indigenous African mythologies to create African-centered products.

Through its Ananse comic book series, Leti Arts demonstrates the type of foregrounding of African indigenous characters, beliefs, and communication systems that characterize Africanfuturist expression. The story is a distinctly African narrative. In the origin story pilot issue, the setting is based on Akan cosmology, which has two realms: the Sky Kingdom, where the gods reside, and Earth, where humans and animals live. Akan knowledge and communication systems are demonstrated through different languages. The verbal-visual system of adinkra, in the form of Odumankoma's *gye nyame* staff, relates to Akan proverbs and other oral art forms. Names appear in both Akan and English, which evidences the history of colonization, including the introduction of Western languages. Further, there is an aspect of possession. As alluded to in the pilot issue cover art and in the text of subsequent issues, readers learn that Kweku Ananse returns when his spirit takes over the body of Ghanaian schoolboy Selasi Rockson.

The series is an African product made for international audiences rather than a Western-designed representation of an African character made for Africans. The company's version of the Ananse stories is far from the first visual representation of the traditionally oral folktales. However, in discussing what might be considered their interpretations of African mythology, Tawia and Kirinya stress how their products fill the gap resulting from Africans' failure to keep "pace with modern formats and genres for telling stories" and from consumer trends among Africa's youth that favor electronic formats such as digital comics and games.[16] Instead of limiting technology to an aspect of a comic book storyline, the entrepreneurs use technology as their platform, producing African-originated, high-quality online products that keep their content relevant for contemporary audiences.

Leti Arts builds upon the foundation of the Ananse stories and turns the narrative into sequential art. Further, it uses the Akan myth of Ananse as the base for its own mythmaking. The company expands the range of Ananse's transformations to include a superhero, which

it then features in a rather conventional (digital) comic book. The end product is familiar at the same time that it is unique and exemplifies how African myths lend themselves to speculative modes of storytelling.

Athi-Patra Ruga is a multidisciplinary artist who incorporates national, rather than ethnic, mythology in his creative commentary on postapartheid race relations. Ruga was born in Umtata, in the Republic of Transkei, which was one of two Xhosa homelands established by the apartheid government to keep Blacks isolated in semiautonomous nation-states. He was able to attend school in South Africa by crossing the border daily as an "outsider" but not residing there. Nearly a decade after the end of apartheid, Ruga relocated to Johannesburg. He studied fashion at the Gordon Flack Davison Academy, where he graduated with a diploma in 2004, and subsequently launched his own fashion label—Just Nje.

In 2010, Ruga embarked upon his series *Future White Women of Azania* (*FWWoA*), which manifested in such diverse forms as performance, photography, tapestry, sculpture, and stained glass. The *FWWoA* works highlight one of Ruga's characters, which he calls avatars. It can appear singularly or, as the series title indicates, in multiples. Most of the avatar's body is concealed within a shell of multicolored balloons, while the exposed lower portion of the body is dressed in brightly colored tights and high heels. Despite Ruga's inclusion of gender and racial terms in the series' title, there is a deliberate air of ambiguity surrounding this character. This lack of clarity is juxtaposed with a clear national association through the word *Azania*.

Various groups have used the concept and term *Azania* to represent different things at different times. Azania is a place-name that refers to the lands of southern and eastern Africa and which first appeared in *The Periplus of the Erythraean Sea* (AD 40), by an unknown author. In the mid-1960s it took on a different meaning when the Pan-Africanist Congress appropriated the name during the apartheid era to represent an ideal future South Africa characterized by Black rule. This concept of a utopian country that would offer racial equality was still alive and well during the dismantling of apartheid and the 1994 elections. Archbishop Desmond Tutu famously expressed the idea of a new multicultural South Africa using the metaphor of the Rainbow Nation. However, those ideas of egalitarianism did not come to fruition during the postapartheid

era. Ruga says that Black South Africans of his generation who were "spoon-fed the rainbow nation" fantasy were left in a state of disillusionment.[17] Through his artistic work, he exposes and critiques this disappointment over the country's current state of affairs. His production is, in some ways, also a challenge to individuals who still refer to South Africa by the name Azania to suggest that the imagined nation might still be realized.

Ruga's *Invitation . . . Presentation . . . Induction* (2013), from the *FWWoA* series, is a complex piece that brings together the themes of gender, race, nationalism, and belonging (fig. 6.2). The sizable wool and thread on tapestry canvas shows a battle scene between the White Women of Azania and members of a hostile group. The opposition consists of three men who wield spears and animal skin shields. They are dressed in loincloths bearing the Azanian flag. While one or more White Women attack the men from behind by kicking up their sharp stilettos, another White Woman positions herself between the men and a fallen colleague. She takes the brunt of a flying spear, which pierces one of her balloons. The composition is set along a strong diagonal line from the lower right to upper left, which is dissected by the horizon line that divides the earth and the blazing sky.

Ruga combines aspects of fantasy and reality in this historic-futuristic battle. The animal hide shields are typical of colonial-era

FIGURE 6.2. Athi-Patra Ruga, *Invitation . . . Presentation . . . Induction*, 2013, wool and thread on tapestry canvas, 175 × 300 cm. © Athi-Patri Ruga. *Courtesy of Athi-Patra Ruga and WHATIFTHEWORLD.*

depictions of the Xhosa and Zulu peoples of South Africa. As a whole, the depiction "recalls historic representations of skirmishes between colonials and indigenous South Africans, causing an uncanny inversion of Azania and Azanians" as the would-be indigenous people of this fictional nation.[18] Ruga's scene is visually similar to that on the Voortrekker Monument located outside Pretoria, a public sculpture that commemorates the 1838 battle between Zulu warriors and Voortrekkers or "pioneers." The memorial is a testament to the myth of the Afrikaner as the founder of a new nation.

In this and other works from the *FWWoA* series, Ruga practices his own mythmaking by building on the concept of Azania. Large-scale public monuments and tapestries are types of artworks that have been used historically to give visual form to an ideological construct of the nation-state. Ruga utilizes the tapestry to represent a revisionist history. In his version of a battle over Azania, he effectively erases the White Voortrekker presence, breaking with White control over both the land and the "official narrative" of South Africa's past. He creates a counter myth to that concretized by the Voortrekker Monument and other such representations of White control. He symbolically erases the history of colonialism by removing the colonizer, visually charting a path back to a *pre*colonial Azania that was the aim of various *post*colonial liberation movements.

Ruga's *Invitation . . . Presentation . . . Induction* might be discussed as Africanfuturist expression for its connection to the idea of the alien. Primary to Ruga's body of work is the avatar, which is otherworldly in nature. What appears to be a light-hearted, fantastical character has its origins in a more serious desire to transform into someone or something else. Ruga created fantasies in his head as a coping technique when his peers harassed him for coming out as gay at the age of eleven and to mentally escape the corporal punishment of the rigid Anglican educational system.[19] The idea of becoming someone or something else was also spurred by the daily back-and-forth between Transkei and South Africa. Once only a childhood dream, through his creation of avatars the artist shows that he now has the agency to be whatever he chooses in terms of gender and race and to go wherever he pleases.

Invitation . . . Presentation . . . Induction also experiments with the idea of linear time that is characterized by distinct periods. The scene appears anachronistic. The balloons, colored tights, and high heels seem to be from a later era than the "traditional" warrior dress and

weapons. The tapestry portrays both a visual and temporal struggle between the two groups. Ruga seems to be writing and rewriting South Africa's past, present, and future at the same time, leaving his viewer unsure of who the victor was, is, or will be.

In this work, Ruga references South African history, mythology, and peoples in ways that would resonate with national audiences. Although he gives no overt indication of the setting, he uses skin color, personal adornment, shields, and poses that visually resemble other artistic renderings of Southern African battle scenes, thereby suggesting that the fight at hand is over the same country. The artist also underscores the mythicization of South Africa over time through his use of the term *Azania* in the series title and the inclusion of the multicolored balloon-clad figures, who are symbolic of the "Rainbow Nation." Further, he creates his own myth, placing greater emphasis on the people in or of Azania over Azania as a whole. In so doing, he privileges the individuals who compose the population over the concept of the nation-state.

Ruga's demonstration of artistic and personal agency is only possible in a postapartheid South Africa. Nevertheless, the nation is far from the utopian country many people worldwide hoped it would be. Black liberation is still elusive. Through his own act of mythmaking, Ruga shows that Azania remains exactly that—a myth.

Fabrice Monteiro is a Dakar-based artist who also takes influence from his lived experience, mixing elements from European and African mythologies in his photographic series *The Prophecy* (2013). Born in Namur, Belgium, to a Belgian mother and Beninese father, Monteiro was raised in Oudiah, Benin. After studying industrial engineering in Belgium and traveling internationally for over a decade as a professional model, he began to experiment with photography in the United States under the wing of American photographer Alfonse Pagano. Monteiro traveled to Senegal for a photo shoot in 2010 and permanently relocated to Dakar the following year. The artist's dual Western and African heritage would inform his approach to his artistic project.

The aim of Monteiro's *The Prophecy* series was to call attention to Senegal's environmental issues. The artist solicited a list of the country's twenty most significant ecological problems from Haïdar el Ali, an ecologist, environmental activist, and documentary filmmaker who served as Senegal's minister of ecology from 2012 to 2013. Monteiro then selected the nine that most resonated with him and

which he thought he could best represent visually.[20] Each of the color photographs in the series was shot in a different location in Senegal and features the personification of an environmental issue, including automotive exhaust pollution, water pollution, coastal erosion, slaughterhouse runoff, illegal fishing, slash-and-burn agriculture, oil spillage, flooding, and plastic waste.

Monteiro combined the scientific data from el Ali with different mythologies to create his visual project. In Greek mythology, Gaia is the personification of Earth and the ancestral mother to the Sky and the Sea, among other deities. Throughout West and North Africa, practitioners of Islam and animism believe in *djinn*, which are invisible spirits that can be benevolent or malevolent. Senegal is an overwhelmingly Muslim country, and a large part of the population also holds animist beliefs. Monteiro incorporated aspects from these disparate sources to construct his own mythical narrative, expressed in photographic form. He explains: "Gaia, the mother earth, (is) exhausted by her incapacity to maintain the natural cycles of the planet in front of new modes of life and consumption. She resolves to send her djinns (children), to let them appear to the humans and deliver a message of warning and empowerment."[21]

This untitled work from *The Prophecy* series exemplifies how Monteiro blurs the line between reality and fiction, and fact and perception, in his images (fig. 6.3). A female figure emerges from a seemingly apocalyptic heap of garbage. Only her upper body is discernible. Brightly bound sections of hair protrude from her head. Her face is covered in a thick black matter that obscures her identity, and she appears poised to drop a plastic baby doll onto the rubbish below. She stands high off the ground wearing a voluminous skirt composed of accumulated potato chip bags, synthetic containers, and pieces of plastic. The overall effect is dramatic. Close inspection reveals that the rubbish on the skirt reflects a loose patterning in color, shape, and material. Smoke-filled air and a pool of liquid on the left eventually give way to a forested landscape and a single bird in the sky.

The otherworldly appearance of Monteiro's image belies the real-world aspects contained within it. The setting for the photograph is Mbeubeuss, a well-known dump approximately seventeen miles outside of Dakar. Founded in the 1960s, the landfill now supports an entire economy of waste pickers who scavenge the site for materials they can resell. At the same time, the ever-growing dump pollutes

FIGURE 6.3. Fabrice Monteiro, *Untitled #1* from *The Prophecy*, 2013, C-print, dimensions variable. *Courtesy of the artist.*

the surrounding water, air, and land, compromising the health and well-being of those who live in and near the site. As with all the photographs in the series, the elaborate costume is composed of materials related to the theme. The skirt is covered in copious pieces of actual garbage. The photographer collaborated with Senegalese fashion designer Doulsy (a.k.a. Jah Gal), who is known for his use of recycled fabrics on this and the other outfits.

Monteiro took his target audience, the Senegalese public, into consideration when creating *The Prophecy*. In contemplating how to execute his project, he decided that making visual representations of the djinn—a mythological concept that would likely be familiar to most Senegalese—was the best way to reach a population characterized by a high level of both animism and illiteracy.[22] Monteiro was ultimately able to exhibit his photographs on a main avenue in Dakar with the support of EcoFund.org, a private nonprofit organization that helps to crowdfund ecological projects. Showing the images outdoors was the best way to share his work with the general population. He also paired each of his images with information about the relevant environmental issue, which allowed literate viewers another level of access to the work that they might chose to share with fellow viewers.

At first glance, the images in Monteiro's *The Prophecy* series seem to be an obvious fit with Africanfuturist expression for their fantastical aesthetic. The outfits have a theatrical effect and appear to be works of art in the vein of haute couture fashion even though they are created from low-cost, locally sourced materials specifically for the project and are the results of Doulsy's ingenuity and talent. Similarly, the various settings are visually striking and reminiscent of stills from science fiction films. The scenery is real, however. The fantastical feel of the photographs is the product of the photographer's creative vision rather than utilization of digital manipulation software.

Monteiro's *The Prophecy* is concerned with the local population. The artist designed his visual images in a way that would communicate the theme to a largely illiterate Senegalese audience in Dakar. Further, he capitalized on the population's familiarity with the otherworldly djinn to introduce that element into his work. The artist elected to make his subjects recognizable as humans in keeping with local beliefs about spirits, rather than utilize common speculative tropes such as aliens. He had to balance producing visually captivating images with effectively conveying messages about real-world behaviors and consequences.

Monteiro also needed to be mindful of viewers beyond his primary audience. As an internationally traveled model and artist, the photographer was aware of predominantly negative Western perceptions about Africa. Though he felt that Senegal's environmental issues were somewhat due to lack of education, he also wanted to avoid the pitfalls of pointing fingers and turning the country's ecological challenges into mere spectacle.[23] After all, many nations around the world face the same types of issues. As a result, Monteiro has continued to build on the original nine images of *The Prophecy*. He has created photographs related to e-waste in Ghana, coal mining in the United States, gold mining in Colombia, and global warming and the ill effects on the Great Barrier Reef, among others.

In *The Prophecy* series, Monteiro personifies deities, spirits, and ecological problems. His arresting images reveal the otherworldly appearance of various locations within Senegal as they exist in the here and now. Influenced by his personal connections to Europe and West Africa, in addition to his familiarity with their respective perspectives and beliefs, he carefully selected elements from Western and indigenous

African mythologies that would serve his project. He then artfully combined aspects of the myths with hard science in his own mythmaking practice.

CONNECTIONS ACROSS AND BEYOND THE CONTINENT

The African creatives discussed in this chapter use preexisting mythologies with which they have some type of personal connection as a foundation for their own mythmaking acts. Nwonwu and Tawia have ethnic links to their respective myths. Buekes, Ruga, and Monteiro have geographic ties to their base mythologies. Additionally, most of these creatives were first exposed to those myths during their formative years. Nwonwu was inspired by the Igbo tales told to him by his mother whereas Beukes learned about Shona and Greek mythology through books. Tawia learned about Akan myths through children's television shows that aired in Ghana.

These examples of Africanfuturist mythmaking underscore the breadth of African myths across regions and cultures and feature the common aspect of possession. Nwonwu's narrative includes masquerades in which humans are taken over by whatever deity or ancestor the mask represents. Beukes incorporates Shona beliefs about wandering spirits that take up residency in humans. In the comic book series, Ananse ultimately takes over the body of a Ghanian schoolboy. Ruga experiments with an avatar in his *FWWoA* works, which allows him the ability to embody a different race and gender. Lastly, Monteiro uses the human being as a vessel for the djinn. As such, African creatives draw from a wide range of indigenous mythologies and indirectly demonstrate how possession is a concept within the range of the possible from the African perspective.

Consideration of these works in relation to additional Africanfuturist examples makes other shared characteristics and influences apparent. For example, both Nwonwu and Zimbabwean artist Machona use masquerades in their respective works as an aspect associated with cultural preservation (fig.2.1). Nwonwu's inclusion of nsibidi and Leti Arts' inclusion of adinkra link the works to the adinkra in Vortex Comics' *Saankofamaan*, and thereby highlight indigenous African graphic languages and communication systems (figs. 6.1, 5.1). Beukes's inclusion of divination and traditional medicines dialogues with multimedia artist Masiyaleti Mbewe's interest in nature and healing in *The Afrofuturist Village* (fig. 2.3). Both Monteiro and Mbewe take

advantage of African spaces that on the surface may look out of this world but are real (figs. 6.3, 2.3). Lastly, Monteiro's preoccupation with environmental issues intersects with Kenyan director Kahiu's focus on water scarcity in her film *Pumzi*, which is discussed in chapter 3, and Vortex Comics' address of oil pipeline spills in the Niger Delta (figs. 6.3, 5.1).

Ruga's work demonstrates overlapping concerns, approaches, and subject matter with other speculative production across and beyond the African continent. He, like fellow artist Mary Sibande, uses an avatar or alter ego to engage the history of racial and social division in South Africa (figs. 6.2, 3.2). Both Ruga and Sibande also strategically use space and color as elements with national significance and demonstrations of agency to counter indigenous Africans' subordinate position during the apartheid era. In his *FWWoA* series, Ruga rejects the notion of fixed racial and gender categories, as does multimedia artist Mbewe in her *The Afrofuturist Village* (figs. 6.2, 2.3). Lastly, in referencing Azania, Ruga inserts himself into a larger international body of production that uses the mythological term as a metaphor for South Africa, including Marvel's *Black Panther*.

Several of these creatives have been linked with Afrofuturism or, in the case of Nwonwu, the comparatively newer term *Africanfuturism*. Nwonwu's writing appeared in *Africanfuturism: An Anthology* (2020), published by the online literary magazine for readers of African literature, *Brittle Paper*. He has been vocal about his feeling that the term *Afrofuturism* does not apply to the production of African creatives.[24] Beukes's writing has only rarely been referred to as Afrofuturist, and she does not use that term when discussing her work.[25] Both the media's association of Leti Arts with Afrofuturism and the company's utilization of that term is recent.

Some curators and art historians have characterized Ruga's *FWWoA* work as Afrofuturism, though the artist does not embrace the Afrofuturist label. He says, "With my work I want to create new mythologies and stories to disrupt the body national, I want to disrupt elements of taste, especially when taste is used nationalistically, like with Afrochic or Afro-futurism, from which I distance myself."[26] Westerners have frequently characterized Monteiro's *The Prophecy* within the realm of Afrofuturism due to its otherworldly appearance, including in the 2018 exhibition *In Their Own Form: Contemporary Photography and Afrofuturism*, organized by the Museum of

Contemporary Photography in Chicago. Nevertheless, the photographer does not feel an affinity with this body of production. When asked if his work can be linked with the aesthetics of Afrofuturism, he replied, "I hear this comment about my work a lot. For me, it is just another box that people feel the necessity to put you into in order to 'define' you."[27] Both Ruga and Monteiro intimate that the Afrofuturist label has the adverse effect of shifting the focus away from the artistic interferences they seek to make with their work.

AFRICANFUTURIST REVELATIONS

The Africanfuturist examples discussed in this chapter suggest the creative producers have a common objective in their choice to engage in mythmaking. Their decision was influenced by a desire to speak primarily to African audiences, and only secondarily to audiences beyond the continent. As such, these African creatives use forms and modes that will resonate with fellow Africans, including Nwonwu's use of the masquerade and Monteiro's visual allusions to the djinn. They recognize that Africans want storylines and representations generated by Africans rather than African copies of Western originals. Beukes does not sensationalize or romanticize traditional healing and medicines in *Zoo City*, but rather portrays their ubiquitous presence in South Africa. Leti Arts designs comic books and mobile games based on African mythologies for contemporary African audiences who prefer digital formats. Lastly, Ruga demonstrates that Africans have the power to choose their race and gender, as well as decide where they want to go without restriction, in his own imagined Azania. In a country where many individuals still face social and economic challenges, the artist's demonstration of agency functions at a much deeper level than simply art for art's sake.

Because of their concerns, these Africanfuturist works can also be understood as decolonial acts. The creative producers do not treat European mythologies as universal. They foreground African myths in their work and only include elements from Western myths when it serves them. Moreover, they engage with mythologies that have local and regional relevance, tapping into more immediate relationships with these beliefs both on the part of the creatives and their audiences. Nwonwu and Monteiro move the needle away from Western views of Africa that suggest the continent and its populations are somehow lesser than the Global North. In "Masquerade Stories," the

author contrasts the career-oriented endeavors that gain someone status in the West with the more community-focused efforts required to earn one's place in their African society. For his part, Monteiro avoids feeding into pessimistic perspectives that suggest the African continent is the only part of the world whose human behavior is causing environmental issues.

These creative producers also encourage us to revisit Phatsimo Sunstrum's ideas about the connections between Afro-mythologies and futurist expression as they relate to the act of mythmaking. For example, "Masquerade Stories" highlights how nonhumans and other science fiction tropes are parts of Afro-mythologies and religious beliefs, including for the Igbo of Nigeria. Nwonwu's story demonstrates that the combination of mythology and speculative elements is not an exclusively new phenomenon but one also present beyond the Egyptian, Yoruba, and Dogon cultures that US Afrofuturists most frequently cite. Further, Nwonwu's tale, which is set in the late twenty-first century, suggests how "traditional" practices may exist in the future. Beukes set her story of Shona-based spirit possession in a parallel Johannesburg. Her novel exemplifies the applicability of African mythic modes to alternate versions of the present, which Phatsimo Sunstrum also emphasizes.

Lastly, these works across different mediums reveal that although Africanfuturist expression can be empowering, it need not always be uplifting. If we return to the idea that myths can serve as models for human behavior, we know that they can communicate how *not* to act. In this sense, they function as cautionary tales. African creatives are crafting their own warnings and incorporating fantastical beings, animal symbolism, and possessed humans. Through otherworldly elements, they attempt to shape human behavior regarding real-world issues, including cultural preservation, racial reconciliation, and ecological degradation.

For many Africans, myths provide guidance and knowledge about how to navigate one's existence. Mythologies may offer an anchor in an ever-changing and frequently turbulent world. According to Sarr, "Today, Africa's task could perhaps be understood thus: in these times of a crisis for meaning within a technical civilization, Africa can offer different perspectives concerning a social life, emanating from other mythological universes, thereby continuing to support, promote, and be an exemplary instance of the shared notion for the

common dream of balanced and harmonious life imbued with meaning."[28] Those mythologies and mythological universes will serve as Africans' moral and epistemological compass. They will help them to achieve a better quality of life in the future, a desire shared by many worldwide.

CONCLUSION

These works demonstrate a range of approaches to Africanfuturist mythmaking. Creative producers vary in how closely they follow their respective base African myths in practicing their own storytelling. Some individuals elect to incorporate elements of European mythology, as well. Creatives may choose to utilize African mythic modes because they recognize the relevant place that mythology holds in many contemporary societies, thereby showing that African audiences are their primary concern. In the twenty-first century, many people across the continent take myths seriously and view them as models of both positive and negative human behavior. For contemporary Africans, myths are not exclusively within the realm of history but have a place in the present and future.

SUGGESTED ADDITIONAL RESOURCES

In addition to the materials cited in this chapter, here are suggested additional resources. Full details for each source can be found in the bibliography.

Herbert M. Cole's introduction in *I Am Not Myself: The Art of African Masquerade* is a useful general resource. For information on Igbo masquerades, including their use in initiation ceremonies, see Cole and Chike C. Aniakor, *Igbo Arts: Community and Cosmos*. Simon P. X. Battestini's chapter provides an overview of the graphic language of nsibidi. For additional information on Shona spirits and spirit possession, as well as divination practices, see Michael Bourdillon's *The Shona Peoples* and S. A. Thorpe's *African Traditional Religions: An Introduction*. Cole and Doran H. Ross's chapter "The Verbal-Visual Nexus" in *The Arts of Ghana* discusses adinkra as a communicative system.

Andrew J. Hennlich's chapter "'Touched by an Angel' (of History) in Athi-Patra Ruga's *The Future White Women of Azania*," explores Ruga's series. For information on Azania in Marvel's version, see the entries "Azania" and "Supremacists [Earth 616]" in the

Marvel Fandom Database. The introductions to Robert Lebling's *Legends of the Fire Spirits: Jinn and Genies from Arabia to Zanzibar* and Amira El-Zein's *Islam, Arabs, and the Intelligent World of the Jinn* provide an overview to the djinn. YouTube videos, including Maria Juzga's "Documentary The Prophecy/Dakar, Senegal" and 3F Media's "The Prophecy N°1 by Fabrice Monteiro," offer engaging behind-the-scenes footage of the making of Monteiro's photographic series.

DISCUSSION QUESTIONS

What do these Africanfuturist works reveal about how African creatives use animals in their mythmaking?

What is the role of conflict in these Africanfuturist examples?

What behaviors do these Africanfuturist works suggest humans should and should not practice?

How have these African creatives used symbolism in their Africanfuturist production?

What roles do nature and the natural world play in these Africanfuturist examples?

Epilogue

WHEN WESTERN academics began to identify examples of Afrofuturism from points outside the United States, including the African continent, it was done in the spirit of intellectual curiosity. African American creatives whose production had been recognized as falling squarely within the realm of Afrofuturism such as Sun Ra and Octavia E. Butler, among others, had referenced African peoples and cultures, both real and imagined. Additionally, some Western scholars had included African cultural producers who were based in the United States in their Afrofuturist discussions, exhibitions, and publications. It was a natural and exciting progression, then, to begin discussing how Africans were experimenting with envisioning and inserting themselves in the future, thereby defying the West's predominantly pessimistic projections for the continent.

In their enthusiasm for exploring overlapping themes and characteristics between expression from the United States and Africa, however, many Westerners have neglected to give equal consideration to the distinctions. As a result, Africans and Africanists have rebuked the way African creatives, especially those based on the continent, have been indiscriminately absorbed into Afrofuturism and its discourse without a more nuanced discussion of the concomitant factors that distinguish their pasts, presents, and visions of the future. Given the ways African American creatives have utilized Afrofuturism as a mechanism for fantastical representations of Africa, artist and filmmaker Jim Chuchu wondered who exactly benefited from the construct of Afrofuturism. Was it, similarly, "an imaginary audience of Africans in need of utopias?"[1]

In highlighting African American narratives and experiences in the United States, Afrofuturism is empowering. It is a form of Black creative and intellectual liberation in a White hegemonic country. Therefore, when art historian Elizabeth Hamilton analyzed the Afrofuturist trope of the afronaut in the work of diasporic and African creatives, including Machona, she framed it in terms of racial oppression (fig. 2.1). Because the South African perpetrators of xenophobic acts, to which Machona reacted with a protective space suit, used darker skin color as one of the ways to identify their foreign victims, Hamilton stressed that such a "racial and social hierarchy [was] similar to apartheid," even though the attackers were Black.[2] Pervasive racially based repression, in all its forms, is a social reality for many—perhaps even most—African Americans as well as Black Africans and those of African descent in the West but not necessarily for most Africans on the continent. A nuanced discussion of Machona's work in relation to his situation spotlights, instead, the issue of colorism. African creatives produce speculative expression based in their own contexts, and careful consideration of individual environments and motivations should not be sacrificed in the interests of framing discourse foremost on a collective Black oppression or liberation.

Because Afrofuturism is rooted in a diasporic perspective, some African creatives have distanced themselves from it. With its US ties, the category seemed reductive of Africans' experiences. Given the history of foreigners naming and categorizing Africa and Africans, Westerners' indiscriminate application of the Afrofuturist label to African production appeared to be a contemporary iteration of this pattern. Furthermore, some African intellectuals and creatives found the term *Afrofuturism* itself problematic in that the prefix *afro* denotes a link with Africa that means one thing for African descendants in the United States and different things for Africans on the continent and abroad.

The debate about Western-originated terms and labels must be considered in relation to the history of the African continent, including colonialism. Westerners have long named and described Africa and its peoples based on their own ideas and for their own interests. In the twenty-first century, Western sources characterized Africa as the "new" home of science fiction. In response, many African creatives contended that Africans had *always* been doing science fiction, just not calling it by that term. Thus, the questions that have arisen

about including African expression under the umbrella of Afrofuturism lend themselves to broader conversations about Africans having a voice in describing themselves and their worlds.

The lumping of African production under the catchall label of Afrofuturism also hinders exploration of how African speculative expression is related to the process of decolonization. The African-originated terminology of *Africanfuturism*, as well as *African Futurism*, recognizes African-centered production that upsets lingering dominant Western influences. African creatives' highlighting of indigenous concerns, subjects, and strategies in their work has a twofold effect: first, it signifies to the rest of the world that Western cultures and interests are not universal; and second, it reaffirms for fellow Africans that Africa is worthy of futurist projections. Moreover, as many African creatives indicate that Africans are their primary target audience, the speculative expression may elicit concrete actions that transform the hypothetical into existence.

Adoption of the African-originated terminology *Africanfuturism* (or *African Futurism*) does not imply an incompatibility with Afrofuturist themes and desires in the United States. For example, whereas Sun Ra drew inspiration from ancient Egypt, South African multimedia artist Dineo Seshee Bopape drew inspiration from Sun Ra's poetry for her video *I Am Sky* (2013).[3] Masiyaleti Mbewe worked through various terms to find the one she felt most accurately reflected her experience; and though she recently indicated that it is still often difficult to discuss the distinctions between Afrofuturism from the United States and Africa "without sparking a diaspora war of sorts," her continuing exploration of Afrofuturist terminology put her "in community with an amazing group of Black activists, scholars, and artists (Ingrid LaFleur, Alexander G. Weheliye, Nashilongweshipwe Mushaandja, Philipp Khabo Koepsell, and many more) who operate in these spaces that are constantly revolutionizing and constructing Black futures."[4]

Individual African creatives formulate their own thoughts, which sometimes change over time. In this publication, I have featured not just works by Africans but also their ideas and opinions about Afrofuturism. Africa's population is diverse and complex, and composed of approximately over 1.2 billion individuals on the continent alone. The variety of ways that African creatives may engage with speculative themes and subjects is matched by their range of feelings about Afrofuturism.

In following a growing number of Africans and Africanists, I have based my study on Africanfuturist expression and organized the chapters of this publication on some of Africanfuturism's most common themes and characteristics. I analyze each work individually, and then compare it to the other examples from that chapter. This approach provides a focused examination of each work, as well as shines light on similarities and differences across disciplines. Sarr's ideas and arguments, among other Africans', underscore the real-world issues, objectives, and effects that are at stake for the continent's population in the twenty-first century, encouraging contextualization of US Afrofuturist imaginings of Africa and Africans beyond *Black Panther*.

Because many of the creative works I feature in this publication relate to more than one theme, they could be discussed under more than one strain and, thus, across multiple chapters. For example, Sibande's representation of an apartheid-era alter ego, Huchu's futuristic extraterrestrial extraction in "Egoli," Baloji's photomontages of mining past and present in Lubumbashi, Towfik's representation of Egyptian society in 2023, Ruga's historic/futuristic battle scene, and Beukes's *Zoo City*, which takes place in an alternate Johannesburg, could have been examined in chapter 2 on space and time exploration (figs. 3.2, 5.3, 6.2). Leti Arts' *Ananse: The Origin #1* comic book could have been discussed in chapter 4 due to its digital format (fig. 6.1). Additionally, Kamuanga Ilunga's incorporation of traditional Mangbetu body arts and Nwonwu's focus on the preservation of long-standing cultural customs, including initiation ceremonies and masqueraders, could have been included in relation to chapter 5 on sankofa (fig. 4.3).

While the examples featured in this publication are not meant to be an exhaustive representation of Africanfuturism to date, they and other works suggest how African creatives are likely to continue to participate in Africanfuturist production going forward. First, speculative expression related to the ideas of space exploration, astronauts/afronauts, and foreign beings will likely remain popular subjects. In addition to the examples discussed in chapter 2, we could add Angolan artist Kiluanji Kia Henda's multimedia work *Icarus 13* (2008) of a fictional Angolan mission to the sun. Both Zambian-born Mwenya B. Kabwe's play *Afronautus Afrikanus* (2015) and Ghanaian interdisciplinary artist Steloolive's installation, sound piece, and performance *Oracle Afronaut* (2021) were inspired by Nkoloso's Zambia Space Program. Other examples are Kenyan artist Muchiri Njenga's short

film *Kichwateli* (2011), which follows a young boy in an astronaut suit whose helmet is replaced with a television set, and Nigerian photographer and art director Daniel Obasi's short film *An Alien in Town* (2017). Select examples of South African designer Atang Tshikare's sculptural furniture and Nigerian multimedia artist Joseph Obuanbi's collages could also be included in this category. Additionally, the Kinshasa-based artists' collective Kongo Astronauts has produced a variety of works in photography, film, sculpture, and performance that deal with extraterrestrial travel, a space station, and astronauts.

An area of Africanfuturist expression and scholarship that is prime for further development is that which overlaps with the academic fields of feminist, gender, and sexuality studies. Mbewe, who is featured in chapter 2 of this publication, has continued to shed light on inclusivity and queer futurist production through her creative and scholarly work. Additionally, in the short story "Ofe!" (2012) by Nigerian speculative fiction author Rafeeat Aliyu, the protagonist becomes a data thief after her parents disown her due to her sexual orientation. One could also look at Zambian-born artist Milumbe Haimbe's graphic novel *The Revolutionist* (2013–16), which features queer heroes and same-sex love. South African digital artist Tiger Maremela explores multiple themes, including reimagining Black masculinity postapartheid in the eight-part multimedia series *roygbov* (2016). Lastly, a recent issue of the journal *Feminist Africa*, housed at the Institute of African Studies of the University of Ghana, was dedicated to gender and sexuality in African Futurism.[5] African and American intellectuals contributed articles that examined the works of African and diasporic cultural producers, cementing the issue as an important reference. On the African continent, exploration of these topics in both creative expression and scholarly pursuits must be contextualized within the local social climate, however, including factors such as antihomosexuality legislation.

A final area that will unquestionably proliferate is collaborative projects involving African creatives that go beyond inviting Africans to participate in American-organized exhibitions, publications, and talks. In this book, I discuss the partnership between American comic book creator Akinseye Brown and Nigerian Vortex Comics through which the comic book company acquired the rights to publish colored, digital versions of Brown's *Sannkofamaan* (fig. 5.1). Recently, Los Angeles—based Emagine secured a production deal to adapt Vortex's

catalog of African superhero comics for film and television, which will further bolster Vortex's position on the global market.[6] Additionally, Kahiu is cowriting with Nnedi Okorafor the drama series *Wild Seed* based on Octavia E. Butler's book. In this story, two African immortals travel the ages from precolonial West Africa to the far future. "Kahiu and Okorafor both attribute aspects of their career paths to reading Butler's *Wild Seed*, in which they saw that there was a voice for women of color and that they too could be that voice."[7]

The individuals and works discussed in this publication suggest that Africanfuturist expression and related discourse will only continue to grow in the years to come. A focused exploration of examples across mediums and geographic locations reveals new insights into the range of ways that intellectuals and creatives engage with Africanfuturism's main themes and concerns. By recognizing and analyzing Africanfuturist production independently, both Africa and the West gain a greater understanding of how Africans are contributing to global creative and intellectual nexuses, as well as articulating, representing, and shaping African futures.

NOTES

INTRODUCTION: AFROFUTURISM AND AFRICANFUTURISM

1. Mark Dery, "Black to the Future: Interviews with Samuel R. Delany, Greg Tate, and Tricia Rose," in "Flame Wars: The Discourse of Cyberculture," ed. Mark Dery, special issue, *South Atlantic Quarterly* 92, no.4 (1993): 736.
2. Alondra Nelson, "Afrofuturism: Past-Future Visions," *Colorlines* 3, no.1 (2000): 35.
3. Alondra Nelson, "Introduction: Future Texts," in "Afrofuturism," special issue, *Social Text* 20, no.2 (2002): 9.
4. Ruth Mayer, "'Africa as an Alien Future': The Middle Passage, Afrofuturism, and Postcolonial Waterworlds," *Amerikastudien / American Studies* 45, no.4 (2000): 555.
5. Lisa Yaszek, "An Afrofuturist Reading of Ralph Ellison's *Invisible Man*," *Rethinking History* 9, no.2/3 (2005): 297.
6. Jared Richardson, "Attack of the Boogeywoman: Visualizing Black Women's Grotesquerie in Afrofuturism," *Art Papers* 36, no.6 (2012): 19.
7. Ytasha Womack, *Afrofuturism: The World of Black Sci-Fi and Fantasy Culture* (Chicago: Chicago Review Press, 2013), 9.
8. James Hodapp, "Fashioning Africanfuturism: African Comics, Afrofuturism, and Nnedi Okorafor's *Shuri*," *Journal of Graphic Novels and Comics* 13, no.4 (2022): 610.
9. Alan Muller, "Futures Forestalled . . . for Now: South African Science Fiction and Futurism," *Current Writing: Text and Reception in Southern Africa* 34, no.1 (2022): 76–77.
10. Womack, *Afrofuturism*, 80.
11. Mohale Mashigo, "Afrofuturism Is Not for Africans Living in Africa," *Johannesburg Review of Books* 2, no. 10 (2018), https://johannesburgreviewofbooks.com.
12. Pamela Phatsimo Sunstrum, "Afro-mythology and African Futurism: The Politics of Imagining and Methodologies for Contemporary Creative Research Practices," *Paradoxa* 25 (2013): 114.

13. Tegan Bristow, "From Afro-Futurism to Post African Futures," *Technoetic Arts: A Journal of Speculative Research* 12, no.2/3 (2014): 170.
14. Sofia Samatar, "Toward a Planetary History of Afrofuturism," *Research in African Literatures* 48, no.4 (2017): 176.
15. Namwalli Serpell, "Africa Has Always Been Sci-fi: On Nnedi Okorafor and a New Generation of Afrofuturists," Literary Hub, April 1, 2016, https://lithub.com. Afropolitan is a concept championed primarily by Selasi and Achille Mbembe. In her essay "Bye Bye Babar," Selasi explores how a young generation of cosmopolitan African émigrés or global "Afropolitans" (re)defines the idea of African identity. See Taiye Selasi, "Bye Bye Babar," *LIP Magazine*, March 3, 2005, https://thelip.robertsharp.co.uk/2005/03/03/bye-bye-barbar/.
16. Phetogo Tshepo Mahasha, "Art Criticism: Is the Prefix 'Afro-' (as in 'Afro-futurism') Arresting Our Imagination and Manifesto Salesmanship?," This Is Africa, July 24, 2013, https://thisisafrica.me.
17. Oulimata Gueye, in Nadine Hounkpatin, "Images, Narrative, and Identities: 'Dare to Invent the Future,'" in *Connecting Afro Futures: Fashion × Hair × Design*, ed. Claudia Banz, Cornelia Lund, and Beatrace Angut Oola (Bielefeld, Germany: Kerber, 2019), 81.
18. Phatsimo Sunstrum, "Afro-mythology," 114.
19. Bristow, "Afro-Futurism to Post African Futures," 169.
20. Nnedi Okorafor, "Africanfuturism Defined," *Nnedi's Wahala Zone* (blog), October 19, 2019.
21. Muller, "Futures Forestalled," 77. Though not country-specific, a publication that is closer to Muller's suggestion and which exemplifies the advantages of privileging language over nationality is Isaac Vincent Joslin, *Afrofuturisms: Ecology, Humanity, and Francophone Cultural Expressions in Africa* (Athens: Ohio University Press, 2023).
22. For example, see Hugh Charles O'Connell, "'Everything Is Changed by Virtue of Being Lost': African Futurism between Globalization and the Anthropecene in Tade Thompson's *Rosewater*," *Extrapolation* 61, no.1/2 (2020): 109–30; Wole Talabi, ed., *Africanfuturism: An Anthology* (Madison, WI: Brittlepaper, 2020); Toyin Falola, "African Futurism," in *Decolonizing African Knowledge: Autoethnography and African Epistemologies* (Cambridge: Cambridge University Press, 2022); and Hodapp, "Fashioning Africanfuturism."
23. For example, see Naima J. Keith and Zoé Whitley, eds., *The Shadows Took Shape* (New York: Studio Museum in Harlem, 2013); Reynaldo Anderson and Charles E. Jones, eds., *Afrofuturism 2.0: The Rise of Astro-Blackness* (Lanham, MD: Lexington Books, 2016); Reynaldo Anderson and Clinton R. Fluker, eds., *The Black Speculative Arts Movement: Black Futurity, Art+Design* (Lanham, MD: Lexington Books, 2019); and Philip Butler, ed., *Critical Black Futures: Speculative Theories and Explorations* (Singapore: Palgrave Macmillan, 2021).

24. For example, see Alondra Nelson, ed., "Afrofuturism," special issue, *Social Text* 20, no. 2 (2002); Tobias C. van Veen, ed., "Afrofuturism," special issue, *Dancecult* 5, no. 2 (2013); Aisha Matthews, ed., "Afrofuturism," special issue, *MOSF Journal of Science Fiction* 2, no. 2 (2018); Lonny Brooks et al., eds., "When Is Wakanda: Afrofuturism and Dark Speculative Futurity," special issue, *Journal of Future Studies* 24, no. 2 (2019); Myrtle Jones, ed., "Defining and Redefining Afrofuturism through the Arts," special issue, *Third Stone* 1, no. 1 (2019); Eva Ulrike Pirker and Judith Rahn, eds., "Afrofuturism's Transcultural Trajectories," special issue, *Critical Studies in Media Communication* 37, no. 4 (2020); and Isiah Lavender III and Lisa Yaszek, eds., "Beyond Afrofuturism," special issue, *Extrapolation* 61, no. 1/2 (2020).
25. "Who Is African," African Speculative Fiction Society, accessed February 1, 2023, https://www.africansfs.com/join/who-is-african.
26. Felwine Sarr, *Afrotopia*, trans. Drew S. Burk and Sarah Jones-Boardman (Minneapolis: University of Minnesota Press, 2019).
27. Phatsimo Sunstrum, "Afro-mythology," 114.
28. Ekow Eshun, "There Is a Desire among Black People to Make the World Over," *Dezeen*, April 9, 2018, https://www.dezeen.com.
29. Jonathan Dotse, "We Know We Will," in *African Futures: Thinking about the Future through Word and Image*, ed. Lien Heidenreich-Seleme and Sean O'Toole (Bielefeld, Germany: Kerber, 2016), 33.
30. Phatsimo Sunstrum, "Afro-mythology," 116.

CHAPTER 1: FROM AFRICA IN WESTERN SPECULATIVE EXPRESSION TO AFRICANFUTURIST IMAGININGS

1. Yohana Desta, "*Black Panther* Is Officially a $1 Billion Hit," *Vanity Fair*, March 11, 2018. For examples of scholarly discourse on the film as it relates to Afrofuturism, see Beschara Karam and Mark Kirby-Hirst, "Guest Editorial for Themed Section *Black Panther* and Afrofuturism: Theoretical Discourse and Review," *Image & Text* 33 (2019): 1–15; Myron T. Strong and K. Sean Chaplin, "*Black Panther* and Afrofuturism," *Contexts* 18, no. 2 (2019): 58–59; Lonny Brooks et al., eds., "When Is Wakanda: Afrofuturism and Dark Speculative Futurity," special issue, *Journal of Future Studies* 24, no. 2 (2019): 1–4; and Renée T. White and Karen A. Ritzenhoff, eds., *Afrofuturism in Black Panther: Gender, Identity, and the Re-making of Blackness* (Lanham, MD: Lexington Books, 2021).
2. Ainehi Edoro, in Steve Paulson, "'Africanfuturism' and Dreaming of Bigger, Bolder African Futures: A Conversation with Science Fiction Author Nnedi Okorafor and Literary Scholar Ainehi Edoro," Wisconsin Public Radio, December 10, 2022, https://www.wpr.org/wakanda-africanfuturism-dreaming-african-futures-black-panther-ttbook.
3. Chiagozi Fred Nwonwu, in Kufre Usanga, "The Steady Rise of African Speculative Fiction: Interview with Chiagozie Fred Nwonwu," *African Literature Today* 39 (2021): 158.

4. Nnedi Okorafor, "Africanfuturism Defined," *Nnedi's Wahala Zone* (blog), October 19, 2019.
5. John Rieder, *Colonialism and the Emergence of Science Fiction* (Middletown, CT: Wesleyan University Press, 2008), 4.
6. Rieder, 5–6.
7. Rob Latham, introduction to *The Oxford Handbook of Science Fiction* (Oxford: Oxford University Press, 2014), 1–6.
8. Rieder, *Colonialism*, 15–21; Sheryl Vint and Mark Bould, "There Is No Such Thing as Science Fiction," in *Reading Science Fiction*, ed. James Gunn, Marleen S. Barr, and Matthew Candelaria (New York: Palgrave Macmillan, 2009), 43–51.
9. Michelle Louise Clarke, "Torque Control," in "African and Afrodiasporic Science Fiction," special issue, *Vector* 289 (2019): 6; Kodwo Eshun, "Further Considerations on Afrofuturism," *CR: The New Centennial Review* 3, no.2 (2003): 294.
10. Eshun, "Further Considerations," 291–92.
11. Mark Dery, "Black to the Future: Interviews with Samuel R. Delany, Greg Tate, and Tricia Rose," in "Flame Wars: The Discourse of Cyberculture," ed. Mark Dery, special issue, *South Atlantic Quarterly* 92, no.4 (1993): 736.
12. Ruth Mayer, "'Africa as an Alien Future': The Middle Passage, Afrofuturism, and Postcolonial Waterworlds," *Amerikastudien / American Studies* 45, no.4 (2000): 556.
13. Ytasha Womack, *Afrofuturism: The World of Black Sci-Fi and Fantasy Culture* (Chicago: Chicago Review Press, 2013), 80.
14. Okorafor, "Africanfuturism Defined."
15. Mohale Mashigo, "Afrofuturism Is Not for Africans Living in Africa," *Johannesburg Review of Books* 2, no. 10 (2018), https://johannesburgreviewofbooks.com.
16. Bonaventure Soh Bejeng Ndikung, "The Incantation of the Disquieting Muse" (unpublished essay, 2015), quoted in Lien Heidenreich-Seleme and Sean O'Toole, eds., *African Futures: Thinking about the Future through Word and Image* (Bielefeld, Germany: Kerber, 2016), 221.
17. Mark Dery, in Tiffany E. Barber et al., "25 Years of Afrofuturism and Black Speculative Thought: Roundtable with Tiffany E. Barber, Reynaldo Anderson, Mark Dery, Sheree Renée Thomas," *Topia: Canadian Journal of Cultural Studies* 39 (Spring 2018): 139.
18. Tegan Bristow, in Kelly Berman, "Just Don't Call Us Afrofuturist," Design Indaba, June 11, 2015, https://www.designindaba.com.
19. Fabrice Monteiro, in Evan D. Williams, "Fabrice Monteiro," Africanah, May 10, 2020, https://africanah.org.
20. Nest Collective, "Hey Kinnara!," February 28, 2018, comment on Nest Collective, "We Need Prayers—Episode 05: This One Went to Market," https://www.facebook.com/NestCollective/videos/997944340357257.

21. Amirah Mercer, "Performa 17: The Nest Collective Explores Afrofuturism, Black Silence and Protest in Film," OkayAfrica, November 14, 2017, https://www.okayafrica.com.
22. Paula Callus, "Shifting Cultural Capital: Kenyan Arts in Digital Spaces," in *Digital Entrepreneurship in Sub-Saharan Africa: Challenges, Opportunities and Prospects*, ed. Nasiru D. Taura, Elvira Bolat, and Nnamdi O. Madichie (Cham, Switzerland: Palgrave McMillan, 2010), 133–34.
23. Nnedi Okorafor, in Lloyd Chéry, "Nnedi Okorafor: 'Les Africains sont des conteurs extraordinaires,'" Culture, *Le Point*, July 10, 2018.
24. Andile Dyalvane, email message to author, August 16, 2021.
25. Jacque Njeri, in Christa Dee, "Jacque Njeri on Her 'MaaSci' Series," Bubblegumclub, September 8, 2017, https://bubblegumclub.co.za.
26. Oscar Macharia, in Amy Frearson, "Afrofuturism Is 'Creating a Different Narrative for Africa' Say Creatives," *Dezeen*, April 6, 2018, https://www.dezeen.com.
27. Tegan Bristow, "From Afro-Futurism to Post African Futures," *Technoetic Arts: A Journal of Speculative Research* 12, no. 2/3 (2014): 170.
28. Peter J. Maurits, "On the Emergence of African Science Fiction," in *The Evolution of African Fantasy and Science Fiction*, ed. Francesca T. Barbini (Edinburgh: Luna Press, 2018), 10–22.
29. For example, see Oulimata Gueye, "Africa and Science Fiction: Wanuri Kahiu's 'Pumzi,'" December 16, 2013, interview, YouTube video, 10:15, https://www.youtube.com/watch?v=SWMtgD9O6PU; Mark Bould, "African SF: Introduction," *Paradoxa* 25 (2013): 7–15; Namwalli Serpell, "Africa Has Always Been Sci-fi: On Nnedi Okorafor and a New Generation of Afrofuturists," Literary Hub, April 1, 2016, https://lithub.com; Moradewun Adejunmobi, "Introduction: African Science Fiction," *Cambridge Journal of Postcolonial Literary Inquiry* 3, no. 3 (2016): 265–72; Geoff Ryman, "21 Today: The Rise of African Speculative Fiction," *Manchester Review* 18 (July 2017), http://www.themanchesterreview.co.uk; Chiagozie Fred Nwonwu, "But Africans Don't Do Speculative Fiction!?," *Perspectives Africa*, December 4, 2018, https://za.boell.org/en/2018/12/04/africans-dont-do-speculative-fiction; Tade Thompson, "Please Stop Talking about the 'Rise' of African Science Fiction," Literary Hub, September 19, 2018, https://lithub.com/; Jane Bryce, "African Futurism: Speculative Fictions and 'Rewriting the Great Book,'" *Research in African Literatures* 50, no. 1 (2019): 1–19; and Alan Muller, "Futures Forestalled . . . for Now: South African Science Fiction and Futurism," *Current Writing: Text and Reception in Southern Africa* 34, no. 1 (2022): 77–84.
30. Matthew Omelsky, "African Science Fiction Makes a Comeback: A Review of AfroSF," *Brittle Paper*, January 25, 2013, https://brittlepaper.com; Mark Bould, "If Colonialism Was the Apocalypse, What Comes Next?," *Los Angeles Review of Books*, August 5, 2015.

31. Dilman Dila, "Is Science Fiction Really Alien to Africa?," *Dilman Dila* (blog), July 22, 2015.
32. Chinelo Onwualu, "African Science Fiction and Literature," *Vector* 289 (2019): 20.
33. Kodwo Eshun, "Continental Afrofutures Lecture One: Laingian Science Fiction," The Showroom, February 27, 2016, audio recording, 2:30:52, https://www.theshowroom.org/library/continental-afrofutures-lecture-one-laingian-science-fiction.
34. See Gavin Steingo, "African Afro-futurism: Allegories and Speculations," *Current Musicology* 99/100 (2017): 45–75; Bryce, "African Futurism"; Mwenya B. Kabwe, "*Astronauts Afrikanus:* Performing African Futurism," in *Acts of Transgression: Contemporary Live Art in South Africa*, ed. Jay Pather and Catherine Boulle (Johannesburg: Wits University Press, 2019), 286–308; and Hugh Charles O'Connell, "'Everything Is Changed by Virtue of Being Lost': African Futurism between Globalization and the Anthropocene in Tade Thompson's *Rosewater*," *Extrapolation* 61, no.1/2 (2020): 109–30.
35. Fatimah Tuggar, "Methods, Making and West African Influences in the Work of Fatimah Tuggar," *African Arts* 50, no.4 (2017): 13.
36. Tendai Huchu, in Eilidh Akilade et al., "Scottish BAME Writers Network: Afrofuturism—Present Realities, Possible Futures," August 21, 2021, interview, Edinburgh International Book Festival, https://www.edbookfest.co.uk/media-gallery/item/scottish-bame-writers-network-afrofuturism-present-realities-possible-futures.
37. Okorafor, "Africanfuturism Defined"; Wanuri Kahiu, "Sunday Feature: Louisa Egbunike and Sean Williams," interview, *BBC 3*, October 29, 2017, https://www.bbc.co.uk/.
38. For the trajectory of Mbewe's terminology, see Rafeeat Aliyu and Masiyaleti Mbewe, "Moving Past Afrofuturism," *Perspectives Africa*, December 4, 2018, https://za.boell.org/2018/12/04/moving-past-afrofuturism; Moshood, "The Masiyaleti Mbewe 'Skyscraper' Is Ready to Create Art on Every Floor," *Let's Be Brief*, August 1, 2019, https://www.letsbebrief.co.uk; Masiyaleti Mbewe, "Problematising Afrofuturism: What's in a Name?," August 13, 2020, YouTube video, 27:00, https://www.youtube.com/watch?v=tO5Cnn-HQKw (video removed by Mbewe).
39. Masiyaleti Mbewe, email message to author, July 21, 2021.
40. Masiyaleti Mbewe, email message to author, July 21, 2021.
41. See Bill Ashcroft, Gareth Griffiths, and Helen Tiffin, "Decolonization," in *Post-colonial Studies*, 3rd ed. (London: Taylor & Francis Group, 2013), 73–77.
42. Maurits, "On the Emergence," 10.
43. Toyin Falola, "African Futurism," in *Decolonizing African Knowledge: Autoethnography and African Epistemologies* (Cambridge: Cambridge University Press, 2022), 597.

44. Mashigo, "Afrofuturism Is Not for Africans."
45. On African Futurism and decolonization, also see Tegan Bristow, "Post African Futures: Positioning the Globalised Digital within Contemporary Decolonising and Cultural Practices in Africa," *Critical African Studies* 9, no. 3 (2017): 281–301; Kabwe, "*Astronauts Afrikanus.*"
46. Huchu, in Akilade et al., "Scottish BAME Writers Network."
47. Nest Collective, foreword to *Not African Enough: A Fashion Book by the Nest Collective* (Nairobi: Nest Arts, 2017), 55.
48. Ivor W. Hartmann, introduction to *Afro SF: Science Fiction by African Writers* (Johannesburg: Story Time, 2012), 7.
49. Felwine Sarr, *Afrotopia*, trans. Drew S. Burk and Sarah Jones-Boardman (Minneapolis: University of Minnesota Press, 2019), 116.
50. Sammy Baloji, in "Sammy Baloji: The Past in Front of Us," Louisiana Channel, June 30, 2015, interview, video, https://channel.louisiana.dk/video/sammy-baloji-past-front-us.
51. Kahiu, "Sunday Feature."
52. Abdourahman L. Waberi, *In the United States of Africa*, trans. David Ball and Nicole Ball (Lincoln: University of Nebraska Press, 2009), 97.
53. Ashcroft, Griffiths, and Tiffin, "Metonymic Gap," 152–53.

CHAPTER 2: EXPLORING SPACE AND TIME

1. Mark Dery, "Black to the Future: Interviews with Samuel R. Delany, Greg Tate, and Tricia Rose," in "Flame Wars: The Discourse of Cyberculture," ed. Mark Dery, special issue, *South Atlantic Quarterly* 92, no. 4 (1993): 736.
2. For an overview of Nkoloso's program, see Namwalli Serpell, "The Zambian 'Afronaut' Who Wanted to Join the Space Race," *New Yorker*, March 11, 2017.
3. John Mbiti, "The Concept of Time," in *African Religions and Philosophy*, 2nd rev. ed. (Oxford: Heinemann, 1990), 15–28; Johan Cilliars, "The Kairos of Karos: Revisiting Notions of Temporality in Africa," *Stellenbosch Theological Journal* 4, no. 1 (2018): 113–32.
4. Felwine Sarr, *Afrotopia*, trans. Drew S. Burk and Sarah Jones-Boardman (Minneapolis: University of Minnesota Press, 2019), x.
5. Nuotama Frances Bodomo, in Adwoa Afful, "The Afronauts," The Awl, January 29, 2016, https://www.theawl.com.
6. Vulindela P. E. Nyoni, "Diaspora in Dialogue: Zimbabwean Artists in South Africa," *South African Journal of Philosophy* 37, no. 4 (2018): 414.
7. Gerald Machona, in Raimi Gbadamosi, "Gerald Machona in Conversation with Raimi Ghadamosi," in *[Working Title] 2013*, ed. Emma Laurence (Johannesburg: Goodman Gallery, 2014), 56.
8. Jacque Njeri, email message to author, August 16, 2021.
9. Jacque Njeri, email message to author, August 16, 2021.

10. Njeri, in "This Kenyan Artist Is Giving Science Fiction a Much-Needed Reimagining," Now This News, August 22, 2017, https://www.facebook.com/watch/?v=1557960030960782.
11. Keziah Jones, in Stevie Chick, "Captain Rugged—the Hero Lagos Deserves," *The Guardian*, February 6, 2014.
12. Keziah Jones, "Afronewave," track 1 on *Captain Rugged*, Because Records, 2014, compact disc.
13. Keziah Jones and Native Maqari, introduction to *Captain Rugged* (Bologna, Italy: Damiani, 2013), no page.
14. Keziah Jones, "Captain Rugged," track 8 on *Captain Rugged*, Because Records, 2014, compact disc.
15. Masiyaleti Mbewe, email message to author, July 21, 2021.
16. Masiyaleti Mbewe, email message to author, July 21, 2021.
17. Masiyaleti Mbewe, email message to author, July 21, 2021.
18. Martha Mukaiwa, "Mbewe's 'Afrofuturist Village' Inclusive and Inspired," *The Namibian*, March 2, 2018.
19. Gerald Machona, "Imagine|Nation: Mediating 'Xenophobia' through Visual and Performance Art," in *Kabbo ka Muwala: The Girl's Basket*, ed. Raphael Chikukwa (Berlin: Revolver Publishing, 2016), 68.
20. Njeri, in Christa Dee, "Jacque Njeri on Her 'MaaSci' Series," Bubblegumclub, September 8, 2017, https://bubblegumclub.co.za.

CHAPTER 3: CREATING WORLDS

1. Ritch Calvin, "The Environmental Dominant in Wanuri Kahui's *Pumzi*," in *The Liverpool Companion to World Science Fiction Film*, ed. Sonja Fritzsche (Liverpool: Liverpool University Press, 2014), 30.
2. Mark Dery, "Black to the Future: Interviews with Samuel R. Delany, Greg Tate, and Tricia Rose," in "Flame Wars: The Discourse of Cyberculture," ed. Mark Dery, special issue, *South Atlantic Quarterly* 92, no. 4 (1993): 180.
3. Ekow Eshun, "There Is a Desire among Black People to Make the World Over," *Dezeen*, April 9, 2018, https://www.dezeen.com.
4. Felwine Sarr, *Afrotopia*, trans. Drew S. Burk and Sarah Jones-Boardman (Minneapolis: University of Minnesota Press, 2019), 107.
5. Justin Izzo, "Historical Reversibility as Ethnographic Afrofuturism: Abdourahman Waberi's Alternative Africa," *Paradoxa* 27 (2015): 162.
6. Abdourahman Waberi, *In the United States of Africa*, trans. David Ball and Nicole Ball (Lincoln: University of Nebraska Press, 2009), 106.
7. Waberi, in Pascale Richard, "On Being a Francophone Writer with Abdourahman Waberi," November 13, 2020, in *La Culture Oui, But Why?*, podcast, 26:40.
8. Transcendental Blackness, "Black Science Fiction—Wanuri Kahiu," September 4, 2011, interview, YouTube video, 12:46, https://www.youtube.com/watch?v=uJ_vL2j8m1Q.

9. Delinda Collier, "The Seed and the Field," in *Media Primitivism: Technological Art in Africa* (Durham, NC: Duke University Press, 2020), 192.
10. Wanuri Kahiu, in Calvin, "Environmental Dominant," 23.
11. Kahiu, in Cath Clarke, "Meet the Director of the Kenyan Lesbian Romance Who Sued the Government Who Banned It," *The Guardian*, April 12, 2019.
12. Sarah Suzuki, "Kingelez Visionanaire," in *Bodys Isek Kingelez*, ed. Rebecca Roberts (New York: Museum of Modern Art, 2018), 20; Rita Reif, "ARTS/ARTIFACTS: Fanciful Dreams of Africa's Past and Future," *New York Times*, August 15, 1993.
13. Chika Okeke-Agulu, "On Kingelez's Audacious Objects," in Roberts, *Bodys Isek Kingelez*, 35.
14. Bodys Isek Kingelez, in Ben Davis, "Congolese Artist Bodys Isek Kingelez's Most Ambitious Work Is an Intricate Dream City: Here's How to Understand It," Artnet News, June 26, 2018, https://news.artnet.com.
15. Kingelez, in Dirk Dumon, dir., *Kingelez: Kinshasa, une ville repensée* (Brussels: Piksa, 2004), 110 min.
16. Kingelez, "Artist's Statement," in *Perspectives 145: "Bodys Isek Kingelez"* (Houston: Contemporary Arts Museum, 2005), 6.
17. Kingelez, 9.
18. Mary Sibande, in Christine Eyene, "Interview with Mary Sibande," *Eye on Art* (blog), December 13, 2013.
19. Sibande, in Shraddha Nair, "South African Artist Mary Sibande Discusses *Sophie*, Her Alter Ego," STIRworld, October 17, 2020, https://www.stirworld.com.
20. Sibande, in Nadia Sesay, "These African Women Artists Discuss Using Art as a Language of Resistance to Patriarchy," OkayAfrica, November 3, 2017, https://www.okayafrica.com/.
21. Sibande, in Maya Jaggi, "Mary Sibande: 'If South Africans Didn't Get Angry, Nothing Would Get Done,'" Financial Times, October 3, 2019, https://www.ft.com/.
22. Kingelez, "Artist's Statement," 9.
23. Kahiu, "Afrofuturism in Popular Culture: Wanuri Kahiu at TEDxNairobi," September 14, 2012, YouTube video, 15:11, https://www.youtube.com/watch?v=PvxOLVaV2YY.
24. Adwoa Afful, "The Afronauts," The Awl, January 29, 2016, https://www.theawl.com; Jacque Njeri, email message to author, August 16, 2021.
25. Eyene, "Interview with Mary Sibande."
26. Kahiu, "Afrofuturism."

CHAPTER 4: TECHNOLOGY AND THE DIGITAL DIVIDE

1. Mark Dery, "Black to the Future: Interviews with Samuel R. Delany, Greg Tate, and Tricia Rose," in "Flame Wars: The Discourse of Cyberculture," ed. Mark Dery, special issue, *South Atlantic Quarterly* 92, no. 4 (1993): 180.

2. Jonathan Dotse, "We Know We Will," in *African Futures: Thinking about the Future through Word and Image*, ed. Lien Heidenreich-Seleme and Sean O'Toole (Bielefeld, Germany: Kerber, 2016), 33.
3. Felwine Sarr, *Afrotopia*, trans. Drew S. Burk and Sarah Jones-Boardman (Minneapolis: University of Minnesota Press, 2019), 70.
4. Tendai L. Huchu, in Helen Cousins and Paulino Doogson-Katiyo, "Zimbabweanness Today: An Interview with Tendai Huchu," *African Literature Today* 34 (2016): 207.
5. Tendai L. Huchu, email message to author, April 26, 2022.
6. Tendai L. Huchu, email message to author, April 26, 2022.
7. On metonymic gap, see Bill Ashcroft, Gareth Griffiths, and Helen Tiffin, *Post-colonial Studies*, 3rd ed. (London: Taylor & Francis Groups, 2013), 152–53.
8. Andile Dyalvane, email message to author, August 16, 2021.
9. Andile Dyalvane, email message to author, August 16, 2021.
10. Andile Dyalvane, email message to author, August 16, 2021.
11. Matthais Ziegler, "Imiso Ceramics—Docks Table," in *Making Africa: A Continent of Contemporary Design*, ed. Mateo Kries and Amelie Klein (Weil am Rhein, Germany: Vitra, 2015), 206.
12. Monika Thakur, "Docks Table Black Reflects Cityscape of Cape Town with Tetris-Like Ceramics," *Homecrux Magazine*, October 18, 2014.
13. Dyalvane in Emily Besa, "Andile Dyalvane of Imiso Ceramics," Six Degrees Berlin, April 24, 2020, http://www.sixdegrees.berlin.
14. Will Fenstermaker, "'I Had to Fight to Show What I Could Do': How Elias Sime Emerged as One of Africa's Leading Contemporary Artists," *Artnet News*, March 25, 2020, https://news.artnet.com.
15. Elias Sime, in Ugochukwu-Smooth C. Nzewi, "Art, Life, and Emotion: Elias Sime's Affective Objects," in *Elias Sime: Tightrope*, ed. Tracy L. Adler (Munich: DelMonico Books-Prestel, 2019), 52.
16. Sime, in Katy Donoghue, "Elias Sime," *Whitewall* 53 (Spring 2019): 90, 92.
17. Donoghue, 90.
18. Karen E. Milbourne, "Personal Touch: Vital Materialism in the Work of Elias Sime," in *Elias Sime: Tightrope*, ed. Tracy L. Adler (Munich: DelMonico Books-Prestel, 2019), 77.
19. Enid Schildkrout, "The Art of Adornment," in *African Reflections: Art from Northeastern Zaire*, ed. Enid Schildkrout and Curtis Keim (Seattle: University of Washington Press, 1990), 127.
20. Kamuanga Ilunga, in Audrey Bauer, "Des petits meurent dans ces trous pour qu'on puisse avoir des téléphones," *Usbek & Rica*, December 30, 2017, https://usbeketrica.com/.
21. Cayla McNally, "Fighting for the Freedom of a Future Age: Afrofuturism and the Posthuman Body" (master's thesis, Lehigh University, 2014), 7.

22. Kamuanga Ilunga in Gerard Houghton, "A Conversation with Eddy Kamuanga Ilunga," in *Eddy Kamuanga Ilunga: Fragile Responsibility* (London: October Gallery, 2018), 7.
23. Daryl Maxwell, "Interview with an Author: T.L. Huchu," *Los Angeles Public Library* (blog), August 5, 2021.
24. Houghton, "Conversation," 3.
25. Tendai L. Huchu, email message to author, April 26, 2022.
26. Tendai L. Huchu, email message to author, April 26, 2022.
27. Tendai L. Huchu, email message to author, April 26, 2022.

CHAPTER 5: SANKOFA AND REMIX

1. W. Bruce Willis, *The Adinkra Dictionary* (Washington, DC: Pyramid Complex, 1998), 188–89.
2. Marc Dery, "Black to the Future: Interviews with Samuel R. Delany, Greg Tate, and Tricia Rose," in "Flame Wars: The Discourse of Cyberculture," ed. Mark Dery, special issue, *South Atlantic Quarterly* 92, no. 4 (1993): 180. Also see Christel N. Temple, "The Emergence of Sankofa Practice in the United States: A Modern History," *Journal of Black Studies* 41, no. 1 (2010): 127–50.
3. Felwine Sarr, *Afrotopia*, trans. Drew S. Burk and Sarah Jones-Boardman (Minneapolis: University of Minnesota Press, 2019), 25.
4. Martin Irvine, "Remix and the Dialogic Engine of Culture: A Model for Generative Combinatoriality," in *The Routledge Companion to Remix Studies*, ed. Eduardo Navas, Owen Gallagher, and xtine burrough (London: Routledge, 2015), 25.
5. Ahmed Khaled Towfik, *Utopia*, trans. Chip Rossetti (Doha: Bloomsbury Qatar Foundation Publishing, 2011), 109.
6. Towfik, in Cheryl Morgan, "Ahmed Khaled Towfik Interview," *Locus Magazine*, March 2012, 28.
7. Sofia Samatar, review of *Utopia*, by Ahmed Khaled Towfik, Strange Horizons, November 28, 2011, http://strangehorizons.com.
8. Towfik, in Hala Khalaf, "Emirates Lit Fest 2017: Egyptian Author Ahmed Khaled Towfik on the Dissemination of Arabic Science Fiction," *The National*, March 7, 2017.
9. Akinseye Brown, *Sannkofamaan: Pet the Beast II* (Lagos: Vortex Comics, 2016), 23.
10. Somto Ajuluchukwu, email message to author, October 23, 2021.
11. Akinseye Brown, email message to author, August 24, 2021.
12. Akinseye Brown, email message to author, August 24, 2021.
13. Somto Ajuluchukwu, email message to author, October 23, 2021.
14. Ronald Rael, *Earth Architecture* (New York: Princeton Architectural Press, 2009), 174.
15. Francis Kéré, "Gando Primary School," *A.MAG International Architecture Technical Magazine*, November 2019, 13.
16. Francis Kéré, "Gando, Burkina Faso Primary School," *UME* 21 (2007): 14.

17. Francis Kéré, "School in Gando," *Architectural Design* 82, no.6 (2012): 71.
18. Bogumil Jewsiewicki, "Denial and Challenge of Modernity: Suffering, Recognition, and Dignity in Photographs by Sammy Baloji," in *Suffering, Art and Aesthetics*, ed. Ratiba Hadj-Moussa and Michael Nijhawan (New York: Palgrave Macmillan, 2014), 58.
19. Bogumil Jewsiewicki, "The Beautiful Time: Photography by Sammy Baloji," in *The Beautiful Time: Photography by Sammy Baloji* (New York: Museum for African Art, 2010), 10.
20. Sammy Baloji, in Kristian Vistrup Madsen, "Sammy Baloji—Interview: 'I'm Not Interested in Colonialism as a Thing of the Past, but in the Continuation of That System,'" *Studio International*, February 2, 2019.
21. Baloji, in "Sammy Baloji: The Past in Front of Us," Louisiana Channel, June 30, 2015, interview, video, https://channel.louisiana.dk/video/sammy-baloji-past-front-us.
22. Joana Choumali, in Daniela Mericio, "Joana Choumali: The Threads of Hope," *Photolux Magazine*, July 9, 2020.
23. Choumali, in Thomas Page, "Through Traditional Clothes, African Women Connect to Their Roots," CNN, June 9, 2016.
24. Choumali, in Kate Sierzputowski, "Joana Choumali Embroiders iPhone Photographs as a Healing Meditation," Colossal, April 4, 2018, https://www.thisiscolossal.com/.
25. Ajuluchukwu, in Su Opperman, "Vortex, Inc Nigeria: Somto Ajuluchukwu Talks African Comic Culture with Su Opperman," *Art Africa*, June 28, 2016, https://artafricamagazine.org/.
26. "Our Expertise," Kéré Architecture, accessed October 1, 2021, https://www.kerearchitecture.com/expertise.
27. Akinseye Brown, email message to author, August 24, 2021.

CHAPTER 6: MYTHMAKING

1. Pamela Phatsimo Sunstrum, "Afro-mythology and African Futurism: The Politics of Imagining, and Methodologies for Contemporary Creative Research Practices" *Paradoxa* 25 (2013): 116.
2. Felwine Sarr, *Afrotopia*, trans. Drew S. Burk and Sarah Jones-Boardman (Minneapolis: University of Minnesota Press, 2019), 80–85.
3. Chiagozie Fred Nwonwu, "Masquerade Stories," in *Afro SF: Science Fiction by African Writers*, ed. Ivor W. Hartmann (Johannesburg: Story Time, 2012), 262.
4. Nwonwu, in Geoff Ryman, "Mazi Chiagozie Nwonwu," Strange Horizons, May 31, 2018, http://strangehorizons.com/.
5. Ryman.
6. Jude I. Onebunne, "Critical Appreciation of *MManwu* (Masquerade) in Igbo World View (Weltanchunng)," in *NNadbiebube Journal of Philosophy* 3, no.1 (2019): 22–25.
7. Lauren Beukes, *Zoo City* (New York: Mulholland Books, 2010), 60.
8. Tabona Shoko, *Karanga Indigenous Religion in Zimbabwe: Health and Well-Being* (Burlington, VT: Ashgate, 2007), 40.

9. Beukes, *Zoo City*, 209, 361; Arley Sorg, "Miles . . . to Go: A Conversation with Lauren Beukes," *Clarksworld Magazine*, August 2020; and Alex Segura, "The PEN Ten with Lauren Beukes," PEN America, December 1, 2015, https://pen.org/.
10. Beukes, in Geoff Ryman, "Lauren Beukes," Strange Horizons, November 15, 2017, http://strangehorizons.com/.
11. Ryman.
12. For example, because of the Herero Genocide and the fact that her *The Afrofuturist Village* would be shown at the German Goethe-Institut in Windhoek, Namibia, Masiyaleti Mbewe (discussed in chapter 2) had a *sangoma* perform a ritual cleansing outside the space. See Paul Wilson, "The Afrofuturist Village: Masiyaleti Mbewe," *African Arts* 52, no. 3 (2019): 83; Rafeeat Aliyu and Masiyaleti Mbewe, "Moving Past Afrofuturism," *Perspectives Africa*, December 4, 2018, https://za.boell.org/2018/12/04/moving-past-afrofuturism.
13. Lauren Beukes, "Lauren Beukes: Shining Girl," *Locus Magazine*, January 2015, 48.
14. Tessa Pijnaker and Rachel Spronk, "Africa's Legends: Digital Technologies, Aesthetics and Middle-Class Aspirations in Ghanaian Games and Comics," *Critical African Studies* 9, no. 3 (2017): 339.
15. Pijnaker and Spronk, 334.
16. Eyram Tawia and Wesley Kirinya, in "Interview: Leti Arts Comics," Afrika Is Woke, February 17, 2022, https://www.afrikaiswoke.com/.
17. Athi-Patra Ruga, in Helen Jennings, "Athi-Patra Ruga," Nataal, accessed November 15, 2021, http://nataal.com/athi-patra-ruga/.
18. Mary Corrigall, "Unpacking the Azanian Seam," in *Being There: South Africa, a Contemporary Scene*, ed. Suzanne Pagé and Angeline Scherf (Paris: Éditions Dilecta, Fondation Louis Vuitton, 2017), 88.
19. Jennings, "Athi-Patra Ruga."
20. Jill Stoddard, "From Environmental Degradation Comes Art: Q&A with Fabrice Monteiro," IPI Global Observatory, October 28, 2015, https://theglobalobservatory.org/.
21. Fabrice Monteiro, in Zahra Jamshed, "The Prophecy: Photographer Captures Terrifying Vision of Future," CNN, November 17, 2015.
22. Astrup Fearnley Museet, "Interview with Fabrice Monteiro | Alpha Crucis—Contemporary African Art," July 17, 2020, interview, YouTube video, 7:54, https://www.youtube.com/watch?v=YoIjmpsncuc.
23. Stoddard, "Environmental Degradation."
24. Chiagozie Fred Nwonwu, "But Africans Don't Do Speculative Fiction!?," *Perspectives Africa*, December 4, 2018, https://za.boell.org/en/2018/12/04/africans-dont-do-speculative-fiction.
25. Panashe Chigumadzi, "Girls of Afrofuturism: The Future Is in Our Past," *Vanguard*, June 29, 2014.
26. Ruga, in "Athi-Patra Ruga Re-imagining South Africa One Story at a Time," *New African*, January 10, 2018.

27. Monteiro, in Ángel Perea Escobar, "In Conversation with Fabrice Monteiro," *Contemporary and América Latina*, June 1, 2020.
28. Sarr, *Afrotopia*, xiv.

EPILOGUE

1. Jim Chuchu, "Statement at African Futures Festival, Nairobi, 29 October 2015," in *African Futures: Thinking about the Future through Word and Image*, ed. Lien Heidenreich-Seleme and Sean O'Toole (Bielefeld, Germany: Kerber, 2016), 95.
2. Elizabeth Hamilton, "Afrofuturism and the Technologies of Survival," *African Arts* 50, no. 4 (2017): 22.
3. Tegan Bristow, "Cultures of Technology: Digital Technology and New Aesthetics in African Digital Art," *Critical Interventions* 8, no. 3 (2014): 340.
4. Masiyaleti Mbewe, in Michelle Johnson, "'Imagining a Better Place': A Conversation with Masiyaleti Mbewe about Revolutionizing and Constructing Black Futures," *World Literature Today* 96, no. 1 (2022): 21.
5. Jacqueline-Bethel Tchouta Mougoué, ed., "Gender and Sexuality in African Futurism," special issue, *Feminist Africa* 2, no. 2 (2021).
6. Scott Roxborough, "Emagine Content Signs Production Deal with Nigeria's Vortex (Exclusive)," *Hollywood Reporter*, January 18, 2022.
7. Nellie Andreeva, "'Wild Seed' Drama Series Based on Sci-Fi Book in Works at Amazon from Viola Davis and Julius Tennon's JuVee Productions," Deadline, March 26, 2019, https://deadline.com/.

BIBLIOGRAPHY

3F Media. "The Prophecy N°1 by Fabrice Monteiro." Posted October 16, 2016, YouTube video, 3:39. https://www.youtube.com/watch?v=sz4fMKXH_sA.

"5 Minutes with Andile Dyalvane." *Capetownetc*, November 16, 2014.

Adejunmobi, Moradewun. "Introduction: African Science Fiction." *Cambridge Journal of Postcolonial Literary Inquiry* 3, no. 3 (2016): 265–72.

Afful, Adwoa. "The Afronauts." The Awl, January 29, 2016. https://www.theawl.com/.

"AFPR—Meet the Artists: Andile Dyalvane." *Dialogues and Perspectives* (blog), Metropolitan Museum of Art, February 17, 2022.

"Afrofuturism." *Vector*, June 18, 2006. https://vector-bsfa.com/2006/06/18/afrofuturism/.

"Afro-Futurism with Jaque Njeri." *WhiteCollar Magazine*, May 2018, 23–25.

Ajuluchukwu, Somto. "The Revolutionary Power of Comics TEDxTudu." TED, December 14, 2019, video, 22:17. https://www.ted.com/talks/somto_adjuluchukwu_the_revolutionary_power_of_comics.

Akilade, Eilidh, Clementine E. Burnley, Natasha Thembiso Ruwona, and Tendai L. Huchu. "Scottish BAME Writers Network: Afrofuturism—Present Realities, Possible Futures." Edinburgh International Book Festival, August 21, 2021, interview. https://www.edbookfest.co.uk/media-gallery/item/scottish-bame-writers-network-afrofuturism-present-realities-possible-futures.

Akomfrah, John, dir. *The Last Angel of History*. London: Black Audio Film Collective, 1995.

Aliyu, Rafeeat, and Masiyaleti Mbewe. "Moving Past Afrofuturism." *Perspectives Africa*, December 4, 2018. https://za.boell.org/2018/12/04/moving-past-afrofuturism.

Al Jazeera English. "The Stream—The Rise of Dystopian Art." February 15, 2017, interview, YouTube video, 35:20. https://www.youtube.com/watch?v=JQpdYT3jByM.

Anderson, David M. *Maasai: People of Cattle*. San Francisco: Chronicle Books, 1995.

Anderson, Reynaldo. "Afrofuturism 2.0 and the Black Speculative Arts Movement: Notes on a Manifesto." *Obsidian* 42, no.1–2 (2016): 228–36.

Anderson, Reynaldo, and Clinton R. Fluker, eds. *The Black Speculative Arts Movement: Black Futurity, Art+Design*. Lanham, MD: Lexington Books, 2019.

Anderson, Reynaldo, and Charles E. Jones, eds. *Afrofuturism 2.0: The Rise of Astro-Blackness*. Lanham, MD: Lexington Books, 2016.

Andreeva, Nellie. "'Wild Seed' Drama Series Based on Sci-Fi Book in Works at Amazon from Viola Davis and Julius Tennon's JuVee Productions." Deadline, March 26, 2019. https://deadline.com/.

Arigbabu, Ayodele, ed. *Lagos 2060: Exciting Sci-Fi Stories from Nigeria*. Lagos: DADA Books, 2013.

Armillas-Tiseyra, Magalí. "Afronauts: On Science Fiction and the Crisis of Possibility." In "African Science Fiction," special issue, *Cambridge Journal of Postcolonial Literary Inquiry* 3, no.3 (2016): 273–90.

Arndt, Susan. "Human*Tree and the Un/Making of FutureS: A Posthumanist Reading of Wanuri Kahiu's *Pumzi*." In *Future Scenarios of Global Cooperation—Practices and Challenges*, edited by Nora Dahlhaus and Daniela Essen Weisskopf, 127–37. Duisburg, Germany: Käte Hamburger Kolleg / Centre for Global Cooperation Research, 2017.

Ashcroft, Bill, Gareth Griffiths, and Helen Tiffin. *Post-colonial Studies*. 3rd ed. London: Taylor & Francis Groups, 2013.

Ashinze, Kennedy. "Keziah Jones: In Transit." *Globetrotter Magazine*, September 8, 2020.

Astrup Fearnley Museet. "Interview with Fabrice Monteiro|Alpha Crucis—Contemporary African Art." July 17, 2020, interview, YouTube video, 7:54. https://www.youtube.com/watch?v=YoIjmpsncuc.

"Athi-Patra Ruga Re-imagining South Africa One Story at a Time." *New African*, January 10, 2018.

"Azania." Marvel Fandom Database. Accessed December 1, 2021. https://marvel.fandom.com/wiki/Azania.

Babatunde, Abosede Omowumi. "Oil, Environmental Conflict and the Challenges of Sustainable Development in the Niger Delta." *Journal of Peacebuilding & Development* 9, no.2 (2014): 77–82.

Baloji, Sammy. "Colonial Extractivism and Epistemic Geologies in the Congo." *Funambulist*, May 1, 2021.

Barber, Tiffany E., Reynaldo Anderson, Mark Dery, and Sheree Renée Thomas. "25 Years of Afrofuturism and Black Speculative Thought: Roundtable with Tiffany E. Barber, Reynaldo Anderson, Mark Dery, Sheree Renée Thomas." *Topia: Canadian Journal of Cultural Studies* 39 (Spring 2018): 136–44.

Battestini, Simon P.X. "Nsibidi." In *The Nsukka Artists and Nigerian Contemporary Art*, edited by Simon Ottenburg, 63–71. Washington, DC: Smithsonian National Museum of African Art in association with University of Washington Press, 2002.

Bauer, Audrey. "Des petits meurent dans ces trous pour qu'on puisse avoir des téléphones." *Usbek & Rica*, December 30, 2017. https://usbeketrica.com/.
Berman, Kelly. "Just Don't Call Us Afrofuturist." Design Indaba, June 11, 2015. https://www.designindaba.com/.
Besa, Emily. "Andile Dyalvane of Imiso Ceramics." Six Degrees Berlin, April 24, 2020. http://www.sixdegrees.berlin/.
Beukes, Lauren. "Lauren Beukes: Shining Girl." *Locus Magazine*, January 2015, 6–7, 48–50.
———. *Zoo City*. New York: Mulholland Books, 2010.
Bisschoff, Lizelle. "African Cyborgs." *Interventions* 22, no. 5 (2020): 606–23.
Bodomo, Nuotama Frances, dir. *Afronauts*. New York: Afronauts Film, 2014.
Bould, Mark. "African SF: Introduction." *Paradoxa* 25 (2013): 7–15.
———. "If Colonialism Was the Apocalypse, What Comes Next?" *Los Angeles Review of Books*, August 5, 2015.
Bourdillon, Michael. *The Shona Peoples*. 3rd rev. ed. Gweru, Zimbabwe: Mambo Press, 2004.
Bourland, W. Ian. "Afronauts: Race in Space." *Third Text* 34, no. 2 (2020): 209–29.
Bradshaw, Katie. "Frances Bodomo." *Bomb Magazine*, July 9, 2013.
Bristow, Tegan. "Cultures of Technology: Digital Technology and New Aesthetics in African Digital Art." *Critical Interventions* 8, no. 3 (2014): 331–41.
———. "From Afro-Futurism to Post African Futures." *Technoetic Arts: A Journal of Speculative Research* 12, no. 2/3 (2014): 167–73.
———. "Post African Futures: Positioning the Globalised Digital within Contemporary Decolonising and Cultural Practices in Africa." *Critical African Studies* 9, no. 3 (2017): 281–301.
———. "We Want the Funk: What Is Afrofuturism to Africa?" In *The Shadows Took Shape*, edited by Naima J. Keith and Zoé Whitley, 81–87. New York: Studio Museum in Harlem, 2013.
Brooks, Lonny, Reynaldo Anderson, Douglas Taylor, and Nicholas Baham, eds. "When Is Wakanda: Afrofuturism and Dark Speculative Futurity." Special issue, *Journal of Future Studies* 24, no. 2 (2019).
Brown, Akinseye. *Sannkofamaan: Pet the Beast I*. Lagos: Vortex Comics, 2016.
———. *Sannkofamaan: Pet the Beast II*. Lagos: Vortex Comics, 2016.
Brown, Andrew. "Performing Blackness in the 'Rainbow Nation': Athi-Patra Ruga's *The Future White Women of Azania*." *Women and Performance: A Journal of Feminist Theory* 27, no. 1 (2017): 67–80.
Bryce, Jane. "African Futurism: Speculative Fictions and 'Rewriting the Great Book.'" *Research in African Literatures* 50, no. 1 (2019): 1–19.
Buelens, Frans, and Danny Cassimon. "The Industrialization of the Belgian Congo." In *Colonial Exploitation and Economic Development: The Belgian Congo and the Netherlands Indies Compared*, edited by Ewout Frankema and Frans Buelens, 229–50. London: Routledge, 2013.

Burns, Scott. "M-Pesa and the 'Market-Led' Approach to Financial Inclusion." *Economic Affairs* 38, no. 3 (2018): 406–21.

Butler, Philip, ed. *Critical Black Futures: Speculative Theories and Explorations*. Singapore: Palgrave Macmillan, 2021.

Callus, Paula. "Shifting Cultural Capital: Kenyan Arts in Digital Spaces." In *Digital Entrepreneurship in Sub-Saharan Africa: Challenges, Opportunities and Prospects*, edited by Nasiru D. Taura, Elvira Bolat, and Nnamdi O. Madichie, 125–43. Cham, Switzerland: Palgrave McMillan, 2010.

Calvin, Ritch. "The Environmental Dominant in Wanuri Kahui's *Pumzi*." In *The Liverpool Companion to World Science Fiction Film*, edited by Sonja Fritzsche, 21–35. Liverpool: Liverpool University Press, 2014.

Chéry, Lloyd. "Nnedi Okorafor: 'Les Africains sont des conteurs extraordinaires.'" Culture, *Le Point*, July 10, 2018.

Chick, Stevie. "Captain Rugged—the Hero Lagos Deserves." *The Guardian*, February 6, 2014.

Chigumadzi, Panashe. "Girls of Afrofuturism: The Future Is in Our Past." *Vanguard*, June 29, 2014.

Chuchu, Jim. "Statement at African Futures Festival, Nairobi, 29 October 2015." In Heidenreich-Seleme and O'Toole, *African Futures*, 95.

Church, Scott H. "A Rhetoric of Remix." In *The Routledge Companion to Remix Studies*, edited by Eduardo Navas, Owen Gallagher, and xtine burrough, 43–53. London: Routledge, 2015.

Cilliars, Johan. "The Kairos of Karos: Revisiting Notions of Temporality in Africa." *Stellenbosch Theological Journal* 4, no. 1 (2018): 113–32.

Clarke, Cath. "Meet the Director of the Kenyan Lesbian Romance Who Sued the Government Who Banned It." *The Guardian*, April 12, 2019.

Clarke, Michelle Louise. "Torque Control." In "African and Afrodiasporic Science Fiction," special issue, *Vector* 289 (2019): 2–14.

Coetzee, Carli. "Afro-Superheroes: Prepossessing the Future." *Journal of African Cultural Studies* 28, no. 3 (2016): 241–44.

Cole, Herbert M. "Introduction: The Mask, Masking, and Masquerade in Africa." In *I Am Not Myself: The Art of African Masquerade*, 15–17. Los Angeles: Museum of Cultural History, University of California, 1985.

Cole, Herbert M., and Chike C. Aniakor. *Igbo Arts: Community and Cosmos*. Los Angeles: Museum of Cultural History, University of California, 1984.

Cole, Herbert M., and Doran H. Ross. *The Arts of Ghana*. Los Angeles: Museum of Cultural History, University of California, 1977.

Collier, Delinda. *Media Primitivism: Technological Art in Africa*. Durham, NC: Duke University Press, 2020.

Coombes, Annie E. *History after Apartheid: Visual Culture and Public Memory in a Democratic South Africa*. Durham, NC: Duke University Press, 2003.

Corrigall, Mary. "Unpacking the Azanian Seam." In *Being There: South Africa, a Contemporary Scene*, edited by Suzanne Pagé and Angeline Scherf, 87–92. Paris: Éditions Dilecta, Fondation Louis Vuitton, 2017.

Cousins, Helen, and Paulino Doogson-Katiyo. "Zimbabweanness Today: An Interview with Tendai Huchu." *African Literature Today* 34 (2016): 200–210.

Davis, Ben. "Congolese Artist Bodys Isek Kingelez's Most Ambitious Work Is an Intricate Dream City: Here's How to Understand It." Artnet News, June 26, 2018. https://news.artnet.com/.

Davis, Jalondra A. "Utopia and the Gendered Past in Pauline Hopkins' *Of One Blood; or, The Hidden Self*." *MOSF Journal of Science Fiction* 3, no.1 (2019): 7–20.

Dax, Mpingana. "Venture into the Afrofuturistic Village." YouTube video, 6:06. https://www.youtube.com/watch?v=PG9f7-mh44s.

Dee, Christa. "Jacque Njeri on Her 'MaaSci' Series." Bubblegumclub, September 8, 2017. https://bubblegumclub.co.za/.

Dery, Mark. "Black to the Future: Interviews with Samuel R. Delany, Greg Tate, and Tricia Rose." In "Flame Wars: The Discourse of Cyberculture," ed. Mark Dery, special issue *South Atlantic Quarterly* 92, no.4 (1993): 735–78.

"Design in Dialogue #80: Andile Dyalvane." Interview by Glenn Adamson, Friedman Benda, December 9, 2020. Video, 1:23:05. December 22, 2020. https://www.designboom.com/design/andile-dyalvane-ceramic-friedman-benda-design-in-dialogue-12-22-2020/.

Desta, Yohana. "*Black Panther* Is Officially a $1 Billion Hit." *Vanity Fair*, March 11, 2018.

Dila, Dilman. "Is Science Fiction Really Alien to Africa?" *Dilman Dila* (blog), July 22, 2015.

Dodd, Alexandra. "Dressed to Thrill: The Victorian Postmodern and Counter-Archived Imaginings in the Work of Mary Sibande." *Critical Arts: A Journal for Cultural Studies* 24, no.3 (2010): 467–74.

Donoghue, Katy. "Elias Sime." *Whitewall* 53 (Spring 2019): 90–95.

Dorman, Nadine, ed. *Terra Incognita: New Short Speculative Stories from Africa*. South Africa: Short Story Day Africa, 2015.

Dotse, Jonathan. "We Know We Will." In Heidenreich-Seleme and O'Toole, *African Futures*, 23–34.

Dumon, Dirk, dir. *Kingelez: Kinshasa, une ville repensée*. Brussels: Piksa, 2004. 110 min.

Dunne, Carey. "Senegal's Trash Transformed into Afrofuturist Haute Couture." Hyperallergic, October 27, 2015. https://hyperallergic.com/.

Dutton, Jacqueline. "Flipping the Script on Africa's Future: *In the United States of Africa* by Abdourahman A. Waberi." *Spaces of Utopia: An Electronic Journal* 2nd series, no.1 (2012): 34–55.

Egbunike, Louisa Uchum, and Chimalum Nwankwo. "Science and Speculative Fiction—What Is *Past* and *Present* . . . and What Is *Future?*" *African Literature Today* 39 (November 2021): 1–12.

Elia, Adriano. "The Languages of Afrofuturism." *Lingue e Linguaggi* 12 (2014): 83–96.

El-Zein, Amira. *Islam, Arabs, and the Intelligent World of the Jinn*. Syracuse, NY: Syracuse University Press, 2009.

Eshun, Ekow. "There Is a Desire among Black People to Make the World Over." *Dezeen*, April 9, 2018. https://www.dezeen.com/.

Eshun, Kodwo. "Continental Afrofutures Lecture One: Laingian Science Fiction." The Showroom, February 27, 2016, audio recording, 2:30:54. https://www.theshowroom.org/library/continental-afrofutures-lecture-one-laingian-science-fiction.

———. "Further Considerations on Afrofuturism." *CR: The New Centennial Review* 3, no. 2 (2003): 291–302.

Eyene, Christine. "Interview with Mary Sibande." *Eye on Art* (blog), December 13, 2013.

Falola, Toyin. "African Futurism." In *Decolonizing African Knowledge: Autoethnography and African Epistemologies*, 595–622. Cambridge: Cambridge University Press, 2022.

Fendler, Ute. "Superheroes for Africa?" In "African Artistic Practices and New Media, II," special issue, *Africa Today* 65, no. 1 (2018): 86–105.

Fenstermaker, Will. "'I Had to Fight to Show What I Could Do': How Elias Sime Emerged as One of Africa's Leading Contemporary Artists." Artnet News, March 25, 2020. https://news.artnet.com/.

Fondation Louis Vuitton. "Keziah Jones Interprets Prince's Tube 'Joy in Repetition.'" March 8, 2018, YouTube video, 2:08. https://www.youtube.com/watch?v=Nz5TgDyITAE.

Frearson, Amy. "Afrofuturism Is 'Creating a Different Narrative for Africa' Say Creatives." *Dezeen*, April 6, 2018. https://www.dezeen.com/.

Gaunt, Jeremy. "Meet Nigeria's Captain Rugged." Reuters, February 26, 2014. https://www.reuters.com/.

Gbadamosi, Raimi. "Gerald Machona in Conversation with Raimi Ghadamosi." In *[Working Title] 2013*, edited by Emma Laurence, 54–59. Johannesburg: Goodman Gallery, 2014.

Geothe-Institut Subsaharan Africa. "African Futures Festival / Johannesburg, Lagos, Nairobi." July 28, 2016, YouTube video, 29:04. https://www.youtube.com/watch?v=Un4ut2fGlI.

Godby, Michael, J. B. Peires, and Rod Hooper-Box. *Battleground: Charles Bell's Drawings of the War of the Axe, 1846, in Historical Context and in Relation to Recent Representations of the Frontier / Wars of Dispossession*. Cape Town: Primavera Publishing, 2015.

Groves, Zoë. "Urban Migrants and Religious Networks: Malawians in Colonial Salisbury, 1920 to 1970." *Journal of Southern African Studies* 38, no. 3 (2012): 491–511.

Gueye, Oulimata. "Africa and Science Fiction: Wanuri Kahiu's 'Pumzi.'" December 16, 2013, interview, YouTube video, 10:15. https://www.youtube.com/watch?v=SWMtgD9O6PU.

Gunkel, Henriette, and kara lynch, eds. *We Travel the Space Ways: Black Imagination, Fragments and Diffractions*. Bielefeld, Germany: Transcript, 2019.

Halmark, Terry. "Oil and Violence in the Niger Delta Isn't Talked about Much, but It Has a Global Impact." *Forbes*, February 13, 2017.

Hamilton, Elizabeth. "Afrofuturism and the Technologies of Survival." *African Arts* 50, no. 4 (2017): 18–23.

Hartmann, Ivor W. "Introduction." In *Afro SF: Science Fiction by African Writers*, edited by Ivor W. Hartmann, 6–7. Johannesburg: Story Time, 2012.

Hatfield, Zack. "Interview: Elias Sime." *Artforum*, September 3, 2019.

Heidenreich-Seleme, Lien, and Sean O'Toole, eds. *African Futures: Thinking about the Future through Word and Image*. Bielefeld, Germany: Kerber, 2016.

Hennlich, Andrew J. "'Touched by an Angel' (of History) in Athi-Patra Ruga's *The Future White Women of Azania*." In *Acts of Transgression: Contemporary Live Art in South Africa*, edited by Jay Pather and Catherine Boulle, 309–31. Johannesburg: Wits University Press, 2019.

Hodapp, James. "Fashioning Africanfuturism: African Comics, Afrofuturism, and Nnedi Okorafor's *Shuri*." *Journal of Graphic Novels and Comics* 13, no. 4 (2022): 606–19.

Houghton, Gerard. "A Conversation with Eddy Kamuanga Ilunga." In *Eddy Kamuanga Ilunga: Fragile Responsibility*, 6–14. London: October Gallery, 2018.

Hounkpatin, Nadine. "Images, Narrative, and Identities: 'Dare to Invent the Future.'" In *Connecting Afro Futures: Fashion × Hair × Design*, edited by Claudia Banz, Cornelia Lund, and Beatrace Angut Oola, 81–82. Bielefeld, Germany: Kerber, 2019.

Huchu, Tendai L. "Egoli." In *Africanfuturism: An Anthology*, edited by Wole Talabi, 1–7. Madison, WI: Brittlepaper, 2020.

"Interview: Leti Arts Comics." Afrika Is Woke, February 17, 2022. https://www.afrikaiswoke.com/.

Irvine, Martin. "Remix and the Dialogic Engine of Culture: A Model for Generative Combinatoriality." In *The Routledge Companion to Remix Studies*, edited by Eduardo Navas, Owen Gallagher, and xtine burrough, 15–42. London: Routledge, 2015.

Izzo, Justin. "Historical Reversibility as Ethnographic Afrofuturism: Abdourahman Waberi's Alternative Africa." *Paradoxa* 27 (2015): 161–82.

Jaggi, Maya. "Mary Sibande: 'If South Africans Didn't Get Angry, Nothing Would Get Done.'" Financial Times, October 3, 2019, https://www.ft.com/.

Jamshed, Zahra. "The Prophecy: Photographer Captures Terrifying Vision of Future." CNN, November 17, 2015.

Jennings, Helen. "Athi-Patra Ruga." Nataal. Accessed November 15, 2021. http://nataal.com/athi-patra-ruga/.

Jewsiewicki, Bogumil. *The Beautiful Time: Photography by Sammy Baloji*. New York: Museum for African Art, 2010.

———. "Denial and Challenge of Modernity: Suffering, Recognition, and Dignity in Photographs by Sammy Baloji." In *Suffering, Art and Aesthetics*, edited by Ratiba Hadj-Moussa and Michael Nijhawan, 51–74. New York: Palgrave Macmillan, 2014.

Johnson, Michelle. "'Imagining a Better Place': A Conversation with Masiyaleti Mbewe about Revolutionizing and Constructing Black Futures." *World Literature Today* 96, no.1 (2022): 20–23.

Jones, Keziah. *Captain Rugged*. Because Records, 2014, compact disc.

———. "Mon univers n'est que contradictions et paradozes." *Centre Pompidou Magazine*, June 29, 2021.

Jones, Keziah, and Native Maqari. *Captain Rugged*. Bologna, Italy: Damiani, 2013.

Jones, Myrtle, ed. "Defining and Redefining Afrofuturism through the Arts." Special issue, *Third Stone* 1, no.1 (2019).

Joslin, Isaac Vincent. *Afrofuturisms: Ecology, Humanity, and Francophone Cultural Expressions in Africa*. Athens: Ohio University Press, 2023.

Juzga, Maria. "Documentary *The Prophecy* / Dakar, Senegal." Posted on August 9, 2015. YouTube video, 18:51. https://www.youtube.com/watch?v=mZI_i-LauzY.

Kabwe, Mwenya B. "*Astronautus Afrikanus:* Performing African Futurism." In *Acts of Transgression: Contemporary Live Art in South Africa*, edited by Jay Pather and Catherine Boulle, 286–308. Johannesburg: Wits University Press, 2019.

Kahiu, Wanuri. "Afrofuturism in Popular Culture: Wanuri Kahiu at TEDxNairobi." TED, September 14, 2012, YouTube video, 15:11. https://www.youtube.com/watch?v=PvxOLVaV2YY.

———, dir. *Pumzi*. South Africa: Inspired Minority Pictures, 2009.

———. "Sunday Feature: Louisa Egbunike and Sean Williams." *BBC 3*, October 29, 2017, interview. https://www.bbc.co.uk/.

Kane, Djenaba. "Cyrus Kabiru: From Dreamer to Visionary." In "AfroFuturism," special issue, *AFRIKADAA* 5 (June 2013): 90–93.

Karam, Barbara, and Mark Kirby-Hirst. "Guest Editorial for Themed Section *Black Panther* and Afrofuturism: Theoretical Discourse and Review." *Image & Text* 33 (2019): 1–15.

Keith, Naima J., and Zoé Whitley, eds. *The Shadows Took Shape*. New York: Studio Museum in Harlem, 2013.

Kéré, Francis. "Gando, Burkina Faso Primary School." *UME* 21 (2007): 14–21.

———. "Gando Primary School." *A.MAG International Architecture Technical Magazine*, November 2019, 13–22.

———. "School in Gando." *Architectural Design* 82, no.6 (2012): 66–71.

Khalaf, Hala. "Emirates Lit Fest 2017: Egyptian Author Ahmed Khaled Towfik on the Dissemination of Arabic Science Fiction." *The National*, March 7, 2017.

Kilolo, Moses, ed. *Jalada 2: Afrofuture(s)*. Nairobi: Jalada Africa, 2005. https://jaladaafrica.org/2015/01/14/jalada-02-afrofutures/.

Kingelez, Bodys Isek. "Artist's Statement." In *Perspectives 145: "Bodys Isek Kingelez,"* 2–9. Houston: Contemporary Arts Museum, 2005.

Kisangani, Emizet F. *Historical Dictionary of the Democratic Republic of the Congo*. 4th ed. Lanham, MD: Rowman & Littlefield, 2016.

Klein, Alyssa. "Nigerian Superheroes Set to Take Over the Comic Book World." OkayAfrica, March 14, 2016. https://www.okayafrica.com/.

Kniaź, Lidia. "Capturing the Future Back in Africa: Afrofuturist Media Ephemera." *Extrapolation* 61, no.1/2 (2020): 53–68.

Kwan, Jacklin. "Your Old Electronics Are Poisoning People at This Toxic Dump in Ghana." *Wired*, November 26, 2020.

Lagae, John, and Kim DeRaedt. "Building for 'l'Authenticité': Eugène Palumbo and the Architecture of Mobutu's Congo." *Journal of Architectural Education* 68, no.2 (2014): 178–89.

Latham, Rob, ed. *The Oxford Handbook of Science Fiction*. Oxford: Oxford University Press, 2014.

Lavender, Isiah, III. *Afrofuturism Rising: The Literary Prehistory of a Movement*. Columbus: Ohio State University Press, 2019.

Lavender, Isiah, III, and Lisa Yaszek, eds. "Beyond Afrofuturism." Special issue, *Extrapolation* 61, no.1/2 (2020).

Lebling, Robert. *Legends of the Fire Spirits: Jinn and Genies from Arabia to Zanzibar*. London: I.B. Tauris, 2010.

Leiman, Leila. "FNB Joburg Art Fair: Cyrus Kabiru / Afrofuturism." 10and5, August 24, 2015. https://10and5.com/.

Lepik, Andres, and Ayça Beygo, eds. *Francis Kéré: Radically Simple*. Berlin: Hatje Cantz Verlag, 2016.

Likaka, Osumaka. *Rural Society and Cotton in Colonial Zaire*. Madison: University of Wisconsin Press, 1997.

Lopez Cassell, Dessane. "Parsing the Real and Unreal Stories of the Zambian Space Academy." Hyperallergic, September 4, 2019. https://hyperallergic.com/.

Louisiana Channel. "Sammy Baloji: The Past in Front of Us." Louisiana Channel, June 30, 2015, interview, video. https://channel.louisiana.dk/video/sammy-baloji-past-front-us.

Macaulay, Scott. "Frances Bodomo." *Filmmaker Magazine*, September 22, 2014.

Macharia, Osborne. "Ilgelunot." *Osborne Macharia*. Accessed February 1, 2022. https://k63.studio/#/ilgelunot/.

Machona, Gerald. "ImagineNation: Mediating 'Xenophobia' through Visual and Performance Art." In *Kabbo ka Muwala: The Girl's Basket*, edited by Raphael Chikukwa, 58–73. Berlin: Revolver Publishing, 2016.

Mahasha, Phetogo Tshepo. "Art Criticism: Is the Prefix 'Afro' (as in 'Afrofuturism') Arresting Our Imagination and Manifesto Salesmanship?" This Is Africa, July 24, 2013. https://thisisafrica.me/.

Mantz, Jeffrey W. "From Digital Divides to Creative Destruction: Epistemological Encounters in the Regulation of the 'Blood Mineral' Trade in the Congo." *Anthropological Quarterly* 91, no.2 (2018): 525–49.

Marshall, Colin. "Meet 'The Afronauts': An Introduction to Zambia's Forgotten 1960s Space Program." Open Culture, March 4, 2020. https://www.openculture.com/.

Mashigo, Mohale. "Afrofuturism Is Not for Africans Living in Africa." *Johannesburg Review of Books* 2, no.10 (2018). https://johannesburgreviewofbooks.com/.

Matthews, Aisha, ed. "Afrofuturism." Special issue, *MOSF Journal of Science Fiction* 2, no.2 (2018).

Maurits, Peter J. "On the Emergence of African Science Fiction." In *The Evolution of African Fantasy and Science Fiction*, edited by Francesca T. Barbini, 1–28. Edinburgh: Luna Press, 2018.

Maxwell, Daryl. "Interview with an Author: T.L. Huchu." *Los Angeles Public Library* (blog), August 5, 2021.

Mayer, Ruth. "'Africa as an Alien Future': The Middle Passage, Afrofuturism, and Postcolonial Waterworlds." *Amerikastudien / American Studies* 45, no.4 (2000): 555–66.

Mazzoleni, Florent. "Afro-Futurism and African Electronic Music." In *African Records*, 92–98. Contonou, Benin: Fondation Zinsou, 2015.

Mbewe, Masiyaleti. "Afrofuturism: Re-writing the African Narrative at TEDxUniversityofNamibia." December 31, 2015, YouTube video, 6:05. https://www.youtube.com/watch?v=IW1eUuZaF20.

———. "Problematising Afrofuturism: What's in a Name?" August 13, 2020, YouTube video, 27:00. https://www.youtube.com/watch?v=tO5Cnn-HQKw (video removed by Mbewe).

———. "What Afrofuturism Teaches Us about Environmental Feminism." Sister Namibia, December 3, 2020. https://sisternamibia.org/.

Mbiti, John. "The Concept of Time." In *African Religions and Philosophy*, 2nd rev. ed., 15–28. Oxford: Heinemann, 1990.

McNally, Cayla. "Fighting for the Freedom of a Future Age: Afrofuturism and the Posthuman Body." Master's thesis, Lehigh University, 2014.

McTernan, Billie A. "Eddy Kamuanga Ilunga." *Art Africa*, December 2016. https://artafricamagazine.org/.

Mercer, Amirah. "Performa 17: The Nest Collective Explores Afrofuturism, Black Silence and Protest in Film." OkayAfrica, November 14, 2017. https://www.okayafrica.com/.

Mericio, Daniela. "Joana Choumali: The Threads of Hope." *Photolux Magazine*, July 9, 2020.

Milbourne, Karen E. "Personal Touch: Vital Materialism in the Work of Elias Sime." In *Elias Sime: Tightrope*, edited by Tracy L. Adler, 63–81. Munich: DelMonico Books-Prestel, 2019.

"Model Update: Tove Kangotue." *Monochrome Magazine*, April 20, 2018. http://monochromemagazine.net/2018/04/20/model-update-tove-kangotue/.

Monks, Kieron. "M-Pesa: Kenya's Mobile Money Success Story Turns 10." CNN, February 24, 2017.

Morgan, Cheryl. "Ahmed Khaled Towfik Interview." *Locus Magazine*, March 2012, 28.

Moshood. "The Masiyaleti Mbewe 'Skyscraper' Is Ready to Create Art on Every Floor." *Let's Be Brief*. August 1, 2019. https://www.letsbebrief.co

.uk/the-masiyaleti-mbewe-skyscraper-is-ready-to-create-art-on-every-floor/.

Mougoué, Jacqueline-Bethel Tchouta, ed. *African Feminism* 2, no. 2 (2021). https://feministafrica.net/.

Mukaiwa, Martha. "Mbewe's 'Afrofuturist Village' Inclusive and Inspired." *The Namibian*, March 2, 2018.

Mukan, Hauwa R. "Nigeria's First Superhero: Keziah Jones Is 'Captain Rugged.'" OkayAfrica, July 29, 2013. https://www.okayafrica.com/.

Mukhtar, Idris. "The Kenyan Artist Who Is Taking the Maasai to Space." CNN, August 28, 2017.

Muller, Allan. "Futures Forestalled... for Now: South African Science Fiction and Futurism." *Current Writing: Text and Reception in Southern Africa* 34, no. 1 (2022): 75–87.

Nair, Shraddha. "South African Artist Mary Sibande Discusses *Sophie*, Her Alter Ego." STIRworld, October 17, 2020. https://www.stirworld.com/.

Ndikung, Bonaventure Soh Bejeng. "The Incantation of the Disquieting Muse." In Heidenreich-Seleme and O'Toole *African Futures*, 221.

Nelson, Alondra, ed. "Afrofuturism." Special issue, *Social Text* 20, no. 2 (2013).

———. "Afrofuturism: Past-Future Visions." *Colorlines* 3, no. 1 (2000): 34–37.

———. "Introduction: Future Texts." Special issue, *Social Text* 20, no. 2 (2002): 1–15.

Nest Collective. Foreword to *Not African Enough: A Fashion Book by the Nest Collective*, 49–71. Nairobi: Nest Arts, 2017.

———. "Patricia Kihoro, Sheba Hirst, and Njoki Ngumi." Facebook video, 28:18. March 5, 2018. https://www.facebook.com/NestCollective/videos/1001068396711518/.

———. "We Need Prayers—Episode 05: This One Went to Market." Facebook video, 4:52. February 28, 2018. https://www.facebook.com/NestCollective/videos/997944340357257.

Northrup, David. *Beyond the Bend in the River: African Labor in Eastern Zaire, 1865–1940*. Athens: Ohio University Center for International Studies, 1988.

Nugent, Gabriella. "Mining Time in Sammy Baloji's *Mémoire*." *African Arts* 52, no. 3 (2019): 62–71.

Nwonwu, Chiagozie Fred. "But Africans Don't Do Speculative Fiction!?" *Perspectives Africa*. December 4, 2018. https://za.boell.org/en/2018/12/04/africans-dont-do-speculative-fiction.

———. "Masquerade Stories." In *Afro SF: Science Fiction by African Writers*, edited by Ivor W. Hartmann, 249–67. Johannesburg: Story Time, 2012.

Nyoni, Vulindela P.E. "Diaspora in Dialogue: Zimbabwean Artists in South Africa." *South African Journal of Philosophy* 37, no. 4 (2018): 410–22.

Nzewi, Ugochukwu-Smooth C. "Art, Life, and Emotion: Elias Sime's Affective Objects." In *Elias Sime: Tightrope*, edited by Tracy L. Adler, 39–57. Munich: DelMonico Books-Prestel, 2019.

———. "Emotional Objects and Human Traces: Elias Sime in Conversation with Ugochukwu-Smooth C. Nzewi." In *Second Careers: Two Tributaries in African Art*, 111–17. Cleveland: Cleveland Museum of Art, 2019.

Oboe, Annalisa. "Sculptural Eyewear and *Cyberfemmes:* Afrofuturist Arts." *From the European South* 4 (2019): 31–44.

Obuobi, Sharon. "Joana Choumali When I Start a Piece I Can't Tell How and When It Will End." WePresent, November 16, 2020. https://wepresent.wetransfer.com/.

O'Connell, Hugh Charles. "'Everything Is Changed by Virtue of Being Lost': African Futurism between Globalization and the Anthropecene in Tade Thompson's *Rosewater*." *Extrapolation* 61, no.1/2 (2020): 109–30.

Okeke-Agulu, Chika. "On Kingelez's Audacious Objects." In *Bodys Isek Kingelez*, edited by Rebecca Roberts, 33–36. New York: Museum of Modern Art, 2018.

Okorafor, Nnedi. "Africanfuturism Defined." *Nnedi's Wahala Zone* (blog), October 19, 2019.

———. "Is Africa Ready for Science Fiction?" *Nnedi's Wahala Zone* (blog), August 12, 2009.

Okoro, Dike. "African Futurist Themes and Fantasy in Modern African Speculative Fiction." In Anderson and Fluker, *The Black Speculative Arts Movement*, 91–105.

———. "The Art of Writing and the Writer's World: A Conversation between Lauren Beukes and Dike Okoro." In *Futurism and the African Imagination: Literature and Other Arts*, edited by Dike Okoro, 83–88. London: Routledge, 2022.

Omelsky, Mathew. "African Science Fiction Makes a Comeback: A Review of AfroSF." *Brittle Paper*, January 25, 2013. https://brittlepaper.com/.

Onebunne, Jude I. "Critical Appreciation of *MManwu* (Masquerade) in Igbo World View (Weltanchunng)." *NNadbiebube Journal of Philosophy* 3, no.1 (2019): 20–34.

Onwualu, Chinelo. "African Science Fiction and Literature." *Vector* 289 (2019): 20–23.

Opoku-Agyemang, Kwabena. "Lost/Gained in Translation: *Oware 3D*, *Ananse: The Origin* and Questions of Hegemony." *Journal of Gaming and Virtual Worlds* 7, no.2 (2015): 155–16.

Opperman, Su. "Vortex, Inc Nigeria: Somto Ajuluchukwu Talks African Comic Culture with Su Opperman." *Art Africa*, June 28, 2016. https://artafricamagazine.org/.

Otieno, Eric. "Afronauts Are Forever | The Enduring Cultural Legacy of The 'Zambia Space Program.'" *Griot* (blog), January 12, 2020.

"Our Expertise." Kéré Architecture. Accessed October 1, 2021. https://www.kerearchitecture.com/expertise.

Pagé, Suzanne, and Angeline Scherf. "Introduction." In *Being There: South Africa, a Contemporary Scene*, edited by Suzanne Pagé and Angeline Scherf, 7–13. Paris: Éditions Dilecta, Fondation Louis Vuitton, 2017.

Page, Thomas. "Through Traditional Clothes, African Women Connect to Their Roots." CNN, June 9, 2016.

Pagès-El Karoui, Delphine. "*Utopia* or the Anti-Tahrir: The Worst of All Worlds in the Fiction of A.K. Towfik." *EchoGéo* 13 (2013): 1–7.

Parrish, Amy. "Responding to Tragedy with Art and Hope." *Lens Culture*, July 18, 2020.

Patterson, Kate. "Meet the Filmmaker: Frances Bodomo." Sloan Science & Film, May 6, 2015. http://scienceandfilm.org/.

Paulson, Steve. "'Africanfuturism' and Dreaming of Bigger, Bolder African Futures: A Conversation with Science Fiction Author Nnedi Okorafor and Literary Scholar Ainehi Edoro." Wisconsin Public Radio, December 10, 2022. https://www.wpr.org/wakanda-africanfuturism-dreaming-african-futures-black-panther-ttbook.

Perea Escobar, Ángel. "In Conversation with Fabrice Monteiro." *Contemporary and América Latina*, June 1, 2020.

Pijnaker, Tessa, and Rachel Spronk. "Africa's Legends: Digital Technologies, Aesthetics and Middle-Class Aspirations in Ghanaian Games and Comics." *Critical African Studies* 9, no.3 (2017): 327–49.

Pirker, Eva Ulrike, and Judith Rahn, eds. "Afrofuturism's Transcultural Trajectories." Special issue, *Critical Studies in Media Communication* 37, no.4 (2020).

Rael, Ronald. *Earth Architecture*. New York: Princeton Architectural Press, 2009.

Rea, Naomi. "'It Was a Sort of Therapy for Me': Joana Choumali, the First African to Win Europe's Top Photography Award, on Her Emotive Work." Artnet News, November 14, 2019. https://news.artnet.com/.

Reid, Tiana. "Light Years: The MET's Afrofuturist Period Room Thinks Inside the Box." *Artforum*, December 2, 2021.

Reif, Rita. "ARTS/ARTIFACTS: Fanciful Dreams of Africa's Past and Future." *New York Times*, August 15, 1993.

Rettová, Alena. "Sci-fi and Afrofuturism in the Afrophone Novel: Writing the Future and the Possible in Swahili and Shona." *Research in African Literatures* 48, no.1 (2017): 158–82.

Richard, Pascale. "On Being a Francophone Writer with Abdourahman Waberi." November 13, 2020. In *La Culture Oui, But Why?* Podcast, 26:40.

Richardson, Jared. "Attack of the Boogeywoman: Visualizing Black Women's Grotesquerie in Afrofuturism." *Art Papers* 36, no.6 (2012): 19–22.

Rieder, John. *Colonialism and the Emergence of Science Fiction*. Middletown, CT: Wesleyan University Press, 2008.

Robles, Fanny. "Jacque Njeri: Life after MaaSci." Africultures, May 7, 2019. http://africultures.com/.

Rodney, Seph. "Love and Craftsmanship in the Relationship between Machines and Humanity." Hyperallergic, September 17, 2019. https://hyperallergic.com/.

Roxborough, Scott. "Emagine Content Signs Production Deal with Nigeria's Vortex (Exclusive)." *Hollywood Reporter*, January 18, 2022.

Ryman, Geoff. "21 Today: The Rise of African Speculative Fiction." *Manchester Review* 18 (July 2017), http://www.themanchesterreview.co.uk/.

———. "Lauren Beukes." Strange Horizons, November 15, 2017. http://strangehorizons.com/.

———. "Mazi Chiagozie Nwonwu." Strange Horizons, May 31, 2018. http://strangehorizons.com/.

Saitoti, Tepilit Ole, and Carol Beckwith. *Maasai*. New York: Abradale Press / Harry N. Abrams, 1993.

Salgado, Gabriela. "Tradition and Modernity in Eddy Kamuanga's Mangbetu Series." In *Eddy Kamuanga Ilunga*, 3–4. London: October Gallery, 2016.

Salkowitz, Rob. "Nigerian Comics Serve Afrofuturism Direct from the Source." *Forbes*, November 30, 2020.

Samatar, Sofia. Review of *Utopia*, by Ahmed Khaled Towfik. Strange Horizons, November 28, 2011. http://strangehorizons.com/.

———. "Toward a Planetary History of Afrofuturism." *Research in African Literatures* 48, no. 4 (2017): 175–91.

Sarr, Felwine. *Afrotopia*. Translated by Drew S. Burk and Sarah Jones-Boardman. Minneapolis: University of Minnesota Press, 2019.

Schildkrout, Enid. "The Art of Adornment." In *African Reflections: Art from Northeastern Zaire*, edited by Enid Schildkrout and Curtis Keim, 123–41. Seattle: University of Washington Press, 1990.

Segura, Alex. "The PEN Ten with Lauren Beukes." PEN America, December 1, 2015. https://pen.org/.

Selasi, Taiye. "Bye Bye Babar." *LIP Magazine*, March 3, 2005. https://thelip.robertsharp.co.uk/.

Serpell, Namwalli. "Africa Has Always Been Sci-Fi: On Nnedi Okorafor and a New Generation of Afrofuturists." Literary Hub, April 1, 2016. https://lithub.com/.

———. "The Zambian 'Afronaut' Who Wanted to Join the Space Race." *New Yorker*, March 11, 2017.

Sesay, Nadia. "These African Women Artists Discuss Using Art as a Language of Resistance to Patriarchy." OkayAfrica, November 3, 2017. https://www.okayafrica.com/.

Shoko, Tabona. *Karanga Indigenous Religion in Zimbabwe: Health and Well-Being*. Burlington, VT: Ashgate, 2007.

Sides, Kirk Bryan. "Seed Bags and Storytelling: Modes of Living and Writing after the End in Wanuri Kahiu's *Pumzi*." *Critical Philosophy of Race* 7, no. 1 (2019): 107–23.

Siegenthaler, Fiona. "Playing Around with Money: Currency as a Contemporary Artistic Medium in Urban Africa." *Critical Interventions* 10, no. 2 (2016): 135–53.

Sierzputowski, Kate. "Joana Choumali Embroiders iPhone Photographs as a Healing Meditation." Colossal, April 4, 2018. https://www.thisiscolossal.com/.

———. "New Sculptural Eyewear Produced from Salvaged Street Metal and Found Objects by Cyrus Kabiru." Colossal, March 24, 2017. https://www.thisiscolossal.com/.

SMAC Gallery. "Cyrus Kabiru: C-stunners and Black Mamba." SMAC Gallery. Accessed May 1, 2022. https://www.smacgallery.com/exhibitions-archive-3/c-stunners-%26-black-mamba.

Sorg, Arley. "Miles… to Go: A Conversation with Lauren Beukes." *Clarksworld Magazine*, August 2020.

"Specs Appeal: The Artist Creating Amazing Eyewear from Rubbish." BBC, November 5, 2018.

Steingo, Gavin. "African Afro-futurism: Allegories and Speculations." *Current Musicology* 99/100 (2017): 45–75.

Stielau, Anna. "Towards a Queer Futurity: The Utopian Impulse in the Work of Athi-Patra Ruga and Milumbe Haimbe." *Agenda* 29, no. 1 (2015): 127–39.

Stoddard, Jill. "From Environmental Degradation Comes Art: Q&A with Fabrice Monteiro." IPI Global Observatory, October 28, 2015. https://theglobalobservatory.org/.

Stone, Bryony. "Photographer Fabrice Monteiro's Fear-Inducing Prophecy of West Africa's Future." It's Nice That, June 5, 2017. https://www.itsnicethat.com/.

Strong, Myron T., and K. Sean Chaplin. "*Black Panther* and Afrofuturism." *Contexts* 18, no. 2 (2019): 58–59.

Sunstrum, Pamela Phatsimo. "Afro-mythology and African Futurism: The Politics of Imagining." *Paradoxa* 25 (2013): 113–29.

"Supremacists [Earth 616]." Marvel Fandom Database. Accessed December 1, 2021. https://marvel.fandom.com/wiki/Supremacists_(Earth-616).

Sutton, Benjamin. "Finding Jesus, 'YOUR MOM,' and Other Surprises at the 2016 Armory Show." Hyperallergic, March 2, 2016. https://hyperallergic.com/.

Suzuki, Sarah. "Kingelez Visionanaire." In *Bodys Isek Kingelez*, edited by Rebecca Roberts, 9–30. New York: Museum of Modern Art, 2018.

Talabi, Wole, ed. *Africanfuturism: An Anthology*. Madison, WI: Brittlepaper, 2020.

Temple, Christel N. "The Emergence of Sankofa Practice in the United States: A Modern History." *Journal of Black Studies* 41, no. 1 (2010): 127–50.

Thakur, Monika. "Docks Table Black Reflects Cityscape of Cape Town with Tetris-Like Ceramics." *Homecrux Magazine*, October 18, 2014.

"This Kenyan Artist Is Giving Science Fiction a Much-Needed Reimagining." Now This News, August 22, 2017. https://www.facebook.com/watch/?v=1557960030960782.

Thompson, Tade. "Please Stop Talking about the 'Rise' of African Speculative Fiction." Literary Hub, September 19, 2018. https://lithub.com/.

Thorpe, S. A. *African Traditional Religions: An Introduction*. Pretoria: University of South Africa, 1994.

Towfik, Ahmed Khaled. *Utopia*. Translated by Chip Rossetti. Doha: Bloomsbury Qatar Foundation Publishing, 2011.

Transcendental Blackness. "Black Science Fiction—Wanuri Kahiu." Transcendental Blackness, September 4, 2011, interview, YouTube video, 12:46. https://www.youtube.com/watch?v=uJ_vL2j8m1Q.

Traoré, Jacqueline. "This Kenyan Artist Imagines Sending the Maasai People into Space." OkayAfrica, July 18, 2017. https://www.okayafrica.com/.

"The True Ananse Synopsis." Leti Arts, June 21, 2013. http://www.letiarts.com/.

Tuggar, Fatimah. "Methods, Making and African Influences in the Work of Fatimah Tuggar." *African Arts* 50, no. 4 (2017): 12–17.

Usanga, Kufre. "The Steady Rise of African Speculative Fiction: Interview with Chiagozie Fred Nwonwu." *African Literature Today* 39 (2021): 156–60.

VanBeurden, Sarah. "A New Congo Crisis?" *Origins: Current Events in Historical Perspective* 11, no. 4 (2018). https://origins.osu.edu/article/new-congo-crisis.

Van Veen, Tobias C., ed. "Afrofuturism." Special issue, *Dancecult* 5, no. 2 (2013).

Vint, Sheryl, and Mark Bould. "There Is No Such Thing as Science Fiction." In *Reading Science Fiction*, edited by James Gunn, Marleen S. Barr, and Matthew Candelaria, 43–51. New York: Palgrave Macmillan, 2009.

Vistrup Madsen, Kristian. "Sammy Baloji—Interview: 'I'm Not Interested in Colonialism as a Thing of the Past, but in the Continuation of That System.'" *Studio International*, February 2, 2019.

Waberi, Abdourahman. "Abdourahman Waberi." November 14, 2013. Library of Congress, Conversations with African Poets and Writers, video, 1:04:36. https://www.loc.gov/item/webcast-6207.

———. *In the United States of Africa*. Translated by David Ball and Nicole Ball. Lincoln: University of Nebraska Press, 2009.

Wachira, James. "Wangari Maathai's Environmental Afrofuturist Imaginary in Wanuri Kahiu's *Pumzi*." *Critical Studies in Media Communication* 37, no. 4 (2020): 324–36.

Walters, Tracey. *Not Your Mother's Mammy: The Black Domestic Worker in Transatlantic Women's Media*. New Brunswick, NJ: Rutgers University Press, 2021.

Wellin Museum of Art. "Elias Sime: Tightrope." Posted September 2, 2019. YouTube video, 8:22. https://www.youtube.com/watch?v=K7Vm8JXYQ3E.

"What Feminism Looks Like in an AfroFuturistic Village with Masiyaleti Mbewe." *Monochrome Magazine*, March 30, 2018.

White, Renée T., and Karen A. Ritzenhoff, eds. *Afrofuturism in "Black Panther": Gender, Identity, and the Re-making of Blackness*. Lanham, MD: Lexington Books, 2021.

"Who Is African." African Speculative Fiction Society Webpage. Accessed February 1, 2023. https://www.africansfs.com/join/who-is-african.

Williams, Evan D. "Fabrice Monteiro." *Africanah*, May 10, 2020. https://africanah.org/.

Willis, W. Bruce. *The Adinkra Dictionary.* Washington, DC: Pyramid Complex, 1998.

Wilson, Paul. "The Afrofuturist Village: Masiyaleti Mbewe." *African Arts* 52, no.3 (2019): 83–85.

———. "The Afronaut and Retrofuturism in Africa." *ASAP/Journal* 4, no.1 (2019): 139–66.

Womack, Ytasha. *Afrofuturism: The World of Black Sci-Fi and Fantasy Culture.* Chicago: Chicago Review Press, 2013.

Yaszek, Lisa. "Afrofuturism, Science Fiction, and the History of the Future." *Socialism and Democracy* 20, no.3 (2006): 41–60.

———. "An Afrofuturist Reading of Ralph Ellison's *Invisible Man.*" *Rethinking History* 9, no.2/3 (2005): 297–313.

———. "Race in Science Fiction: The Case of Afrofuturism and New Hollywood." In *A Virtual Introduction to Science Fiction*, edited by Lars Schmeink. Web. 2013. http://virtual-sf.com/wp-content/uploads/2013/08/Yaszek.pdf.

Yeung, Peter. "The Toxic Effects of Electronic Waste in Accra, Ghana." Bloomberg, May 29, 2019. https://www.bloomberg.com/.

Youngquist, Paul. *A Pure Solar World: Sun Ra and the Birth of Afrofuturism.* Austin: University of Texas Press, 2016.

"The Zambian Space Programme." Royal Museums Greenwich. Accessed June 9, 2023. https://www.rmg.co.uk/stories/topics/zambian-space-programme.

Zeiger, Mimi. "Take Care." *Artforum International* 58, no.1 (2019): 234–41.

Ziegler, Matthais. "Imiso Ceramics—Docks Table." In *Making Africa: A Continent of Contemporary Design*, edited by Mateo Kries and Amelie Klein, 206. Weil am Rhein, Germany: Vitra, 2015.

INDEX

adinkra, 107, 113, 115, 130, 142, 145, 153, 157
Africa: colonialism and, 12, 20–21, 32–35, 37–38, 41–42, 45, 51–52, 55, 60, 63, 65, 67–68, 74, 82, 87, 89, 97–100, 102, 105, 108, 118, 122–23, 129–31, 133, 137, 145, 147–48, 160, 164; Western views of, 2, 4–6, 8, 10, 12, 19–28, 30–36, 38–39, 42, 52, 60, 67, 75, 82, 85–86, 97, 103, 118, 128–29, 136, 141, 143, 152, 154–55, 159–60, 164
African Americans, 1, 8, 12, 15–16, 21–23, 37, 40–41, 63, 85, 107, 116, 160
Africanfuturism: as decolonization, 12, 32–34, 129, 155, 161; definitions of, 8–9; origins of, 8, 12
Africans: children, 50–51, 57, 59, 89, 99, 118, 122, 129, 144, 150, 153; women, 15, 36–37, 43–45, 48–50, 57, 59, 69–71, 76–83, 87–89, 97–100, 102, 109–11, 113, 118, 122, 124, 137–41, 146–49, 157, 164; youth, 30, 44, 51, 109–12, 129, 138, 145
Afrocentrism, 4, 6, 63, 68, 75
Afrofuturism, 1–15, 19–40, 54–58, 60–61, 67, 75, 79, 81–82, 85, 103, 105, 128, 153–54, 155, 159, 160–61; African perceptions of, 5–13, 19–20, 24–29, 31–33, 35, 39, 56, 58, 61, 67, 79, 81–82, 103, 105, 128, 154–55, 159, 160–61; definitions of, 2–5, 8, 11–12, 15, 21, 23, 25, 67; origins of, 1–2, 4–5, 7, 11–16, 21, 23, 32, 38, 40, 57, 63, 160
afronaut, 14, 37, 42, 43–48, 58–61
Ajuluchukwu, Somtochukwu, 112–13, 116, 128–30, 153–54, 163–64
Akan, 16–17, 36–37, 107, 113, 115, 126, 142–45, 153
albinism, 54–57, 140

alienation, 13–14, 48, 56–57
aliens, 17, 23–24, 37, 40–41, 57, 128, 133–37, 148, 152, 163
Ananse, 17, 36, 58, 142–45, 153, 162
android, 37, 57, 99
animals, 49, 138–40, 145, 147, 156
apartheid, 78–79, 81, 140–41, 146, 154, 160, 162
architecture, 11, 13, 52–53, 74–75, 84, 89, 116–19, 128
Authenticité, 72, 84, 121
Azania, 146–49, 154–55, 157

Baloji, Sammy, 16, 35, 57, 80, 102, 119–23, 127–31, 162
Benin, 149
Beukes, Lauren, 17, 36, 102, 138–41, 153–56, 162
Black Panther, 1–2, 8, 19, 27–28, 51, 154, 162
Bodomo, Nuotama Frances, 13, 23–24, 43–45, 48, 57–61, 81
body, 3, 55, 69, 71, 79, 97, 99, 102, 109, 113, 124, 136, 145–46, 150, 153
body arts, 16, 97, 99, 101, 162
Bopape, Dineo Sheshe, 25, 161
Botha, Peter William, 140
Bristow, Tegan, 7–8, 15, 29
Brown, Akinseye, 16, 37, 58, 112–16, 127–30, 153–54, 163
Burkina Faso, 80, 102, 116–18
Butler, Octavia E., 4, 159, 164

cautionary tale(s), 18, 82, 122, 128, 156
Chewa, 48
Choumali, Joana, 16, 102, 123–31
Chuchu, Jim, 159
coltan, 16, 99–102, 104–5. *See also* natural resources

197

comic books, 11, 16–17, 19, 33, 36–37, 40, 52, 58, 87–88, 112–16, 127–30, 137–38, 141–46, 153–55, 162–64
copper, 100, 121, 128. *See also* natural resources
cyborgs, 16, 37, 49, 57, 99, 102, 104, 121

Delany, Samuel R., 1, 4
Democratic Republic of the Congo, 16, 35–36, 72–75, 83, 97–102, 104–5, 119–23, 128, 130–31, 162–63
Dery, Mark, 1–2, 4–5, 7–8, 11–16, 21, 23, 25, 32, 40, 57, 63
digital art, 14, 48–51, 58–59, 61
digital divide, 15, 23, 85, 105. *See also* technology
Djibouti, 64, 67
djinns, 150–53, 155, 158
Dogon, 6, 23, 40, 156
Dotse, Jonathan, 15, 86, 104
Doulsy, 151–52
Dyalvane, Andile, 15, 27, 90–93, 101–5
dystopia, 36, 65, 70–71, 74, 80, 82, 109–10, 112, 138, 141

ecofeminism, 71
Egypt, 6, 16, 23, 109–12, 129–30, 156, 161–62
environment, 2, 7, 14–15, 19, 23, 25, 37, 62–64, 69–71, 82–85, 88, 90, 92, 93, 96, 108, 130, 160; built, 15, 53, 63, 72–75, 81, 84, 116, 118; issues of, 17, 36, 38, 69–71, 80, 82, 113, 128, 149–52, 154, 156; rural, 15, 56, 63–64, 72, 75, 82–83, 87–88, 90, 101, 104, 118; urban, 14–15, 17, 26, 52–53, 63–64, 72–76, 80, 82–83, 90, 92–93, 95, 102, 116, 119, 121, 138–41, 155, 162
Eshun, Ekow, 14, 63, 83
Eshun, Kodwo, 22, 30
Ethiopia, 57, 93–96, 101–5

film, 11, 13–15, 23–24, 26–28, 31–33, 36, 43–45, 51, 53, 54, 56–61, 68–71, 80–84, 105, 119, 154, 158, 161

Gécamines (Union Minière du Haut Katanga), 119–23
gender, 11, 44, 49–50, 54, 63, 71, 79, 146–48, 153–55, 163
Ghana, 8, 22, 29, 43, 58, 63–64, 66, 86, 107, 115, 130, 141–42, 144–45, 152–53, 157, 162–63

health, 151; healing and, 36, 54, 126–27, 141, 153, 155; mental, 126–27, 129

Huchu, Tendai L., 15, 31, 34, 36, 87–90, 101–5, 162

Igbo, 17, 23, 134–38, 153, 156–57
Ivory Coast, 16, 124–27, 130

Jones, Keziah, 14, 51–54, 57–59, 61

Kabiru, Cyrus, 27–28
Kahiu, Wanuri, 14–15, 28, 31, 36, 57, 68–71, 80–84, 154, 164
Kamuanga Ilunga, Eddy, 15–16, 37, 57, 80, 97–106
Kenya, 14, 26, 28–29, 31, 42, 48–51, 57–59, 68–71, 81–82, 86, 128, 142, 145, 154, 162–63
Kéré, (Diébédo) Francis, 16, 80–81, 102, 116–19, 127–30
Kikuyu, 36, 50, 70, 81, 83
Kingelez, Bodys Isek, 15, 57, 72–76, 80, 82–83, 102
Kirinya, Wesley, 142, 145
Kyungu wa Kumwanza, Gabriel, 122

labor, 35–37, 80, 93, 97, 99–102, 105, 118–19, 121, 123, 125, 128; mining, 16, 88, 99–100, 102–3, 105, 113, 119–23, 130–31, 152, 162
language(s), 8, 27–28, 32, 35–36, 46, 54, 64, 66, 70–71, 87–90, 107, 109, 133–34, 137, 140, 145; graphic, 38, 107, 113, 115, 130, 135, 142, 145, 153, 157
Leti Arts, 17, 36, 58, 128, 141–45, 153–55, 162

Maathai, Wangari, 70, 84
Macharia, Oscar, 28
Machona, Gerald, 13–14, 45–48, 57–60, 153, 160
Malawi, 48
Maqari, Native, 52–53
mask, 113–14, 135–36, 144, 153
masquerades, 23, 38, 48, 60, 113, 134–38, 144, 153, 155, 157, 162
Mbewe, Masiyaleti, 14, 32, 54–59, 61, 153–54, 161, 163
Mbiti, John, 11, 42
metonymic gap, 36, 90
Metropolitan Museum of Art, 103, 105
Mining Union of Upper Katanga. *See* Gécamines (Union Minière du Haut Katanga)
Monteiro, Fabrice, 17, 25–26, 80, 128, 149–56, 158
Mungoshi, Charles, 89–90